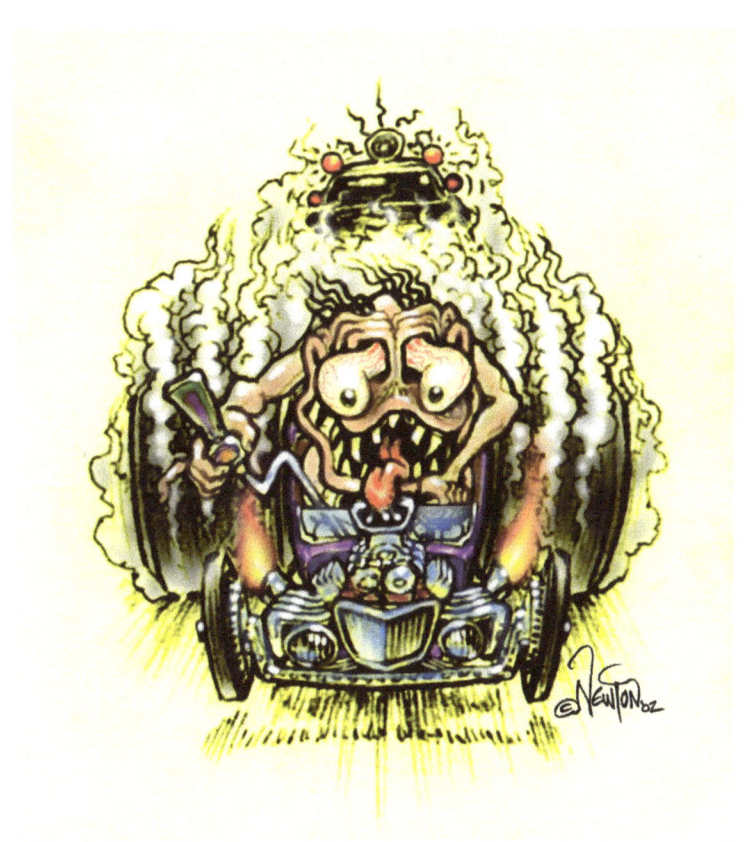

HOW TO DRAW
CRAZY CARS & MAD MONSTERS
LIKE A PRO

THOM TAYLOR & ED "NEWT" NEWTON

motorbooks

Brimming with creative inspiration, how-to projects, and useful information to enrich your everyday life, Quarto Knows is a favorite destination for those pursuing their interests and passions. Visit our site and dig deeper with our books into your area of interest: Quarto Creates, Quarto Cooks, Quarto Homes, Quarto Lives, Quarto Drives, Quarto Explores, Quarto Gifts, or Quarto Kids.

First published in 2006 by Motorbooks, an imprint of The Quarto Group, 100 Cummings Center, Suite 265-D, Beverly, MA 01915, USA. T (978) 282-9590 F (978) 283-2742 QuartoKnows.com

© 2006 by Thom Taylor & Ed Newton

All rights reserved. No part of this book may be reproduced in any form without written permission of the copyright owners. All images in this book have been reproduced with the knowledge and prior consent of the artists concerned, and no responsibility is accepted by producer, publisher, or printer for any infringement of copyright or otherwise, arising from the contents of this publication. Every effort has been made to ensure that credits accurately comply with information supplied. We apologize for any inaccuracies that may have occurred and will resolve inaccurate or missing information in a subsequent reprinting of the book.

Motorbooks titles are also available at discount for retail, wholesale, promotional, and bulk purchase. For details, contact the Special Sales Manager by email at specialsales@quarto.com or by mail at The Quarto Group, Attn: Special Sales Manager, 100 Cummings Center, Suite 265-D, Beverly, MA 01915, USA.

ISBN-13: 978-0-7603-2471-4

Editor: Dennis Pernu
Designer: Kou Lor

Front cover: With all of the chrome detailed and some white gouache highlights added, the Thom Taylor sequence detailed in Chapter Eight is basically completed.

Frontispiece: For this one-point perspective Ed Newton placed the vanishing point right in the middle of the drawing just below the police cruiser. Even the smoke is trailing off in the direction of that perspective point. This setup can make for a very dramatic composition.

Back cover: Whether your interests lie in classic hot rod "monster art" or simply in creating caricatures of your favorite vehicles, the principles and examples offered by award-winning car designer Thom Taylor and legendary kustom culture figure Ed Newton will have you on the road to some gnarly drawings.

About the Authors
Renowned car designer Thom Taylor is an inductee into the *Hot Rod Magazine* Hall of Fame and has designed cars for industry-leading builders such as Boyd Coddington and Roy Brizio, for SO-CAL Speed Shop, and for individuals such as rocker Eric Clapton, actor Tim Allen, and ZZ Top front man Billy F Gibbons. Thom has also had signature die-cast lines with manufacturers Racing Champions/Ertl, Revell, and Testors. Thom is the author of Motorbooks' *How to Draw Cars Like a Pro* and *How to Draw Choppers Like a Pro*. He lives in Southern California.

Ed Newton began working at Roth Studios in the early 1960s after leaving the Art Center College of Design. "Newt" has designed a number of show cars over the years, including many of "Big Daddy" Roth's feature cars, bikes, model kits, and most of his early T-shirts. In 1999, Mattel marketed a set of Hot Wheels collectibles called Ed Newton's Lowboyz™. Newt today lives in Dublin, Ohio.

Contents

	Introduction	6
Chapter One	**A Quick History**	9
Chapter Two	**Tools & Media**	14
Chapter Three	**Perspective**	27
Chapter Four	**Proportion**	44
Chapter Five	**Ellipses & Axes**	57
Chapter Six	**Technique, Sketching & Line Quality**	66
Chapter Seven	**Light Source, Shadows & Reflections**	90
Chapter Eight	**Color & Chrome**	102
Chapter Nine	**Smoke, Flies, Warts, Drool & Bloodshot Eyes**	114
Chapter Ten	**Composition & Movement**	127
Chapter Eleven	**Computers**	133
	Ed Newton Bio	138
	Appendix	142
	Index	143

Introduction

It was never my intention to do a how-to book about drawing monsters in hot rods. Originally, I wanted to write about the art and other works of Ed Newton. Ed was the man behind all of the great monster images, advertising, and some show cars coming out of Ed "Big Daddy" Roth's Maywood, California, Roth Studios from the early 1960s until the end of the decade. Then Newt flew over to Roach Studios in Columbus, Ohio, where he created hundreds of cool designs for shirts and whatnot for many years. When his freelance career took off with the advent of the computer era, he continued to create great art and designs for everyone from movie studios to computer game makers, both by hand and computer.

I thought there would be a lot to show and tell, and of course all things Roth seem to be of great interest, so the book would also be an opportunity to talk about that period and dispel some myths about what happened within the hallowed halls of Roth's Maywood madhouse.

After turning me down flat, Motorbooks came back with a couple of alternatives, one of which resulted in this book. The problem was, though I have done three "how to draw" books for Motorbooks, I have not drawn a lot of monsters in cars. I was trained in automotive design, and I have not strayed too far from that discipline.

So there was only one thing to do: team up with the person I consider the master of the genre. I've known Newt for years and always thought he walked on water. That might be the reason I never ventured off into this crazy world of

▼ To provide a little encouragement, I've included my crude attempt from 1968 at creating Ed Newton–like art. We all have to start somewhere, but I hope that with the help of this book your first attempts will be many times better than this!

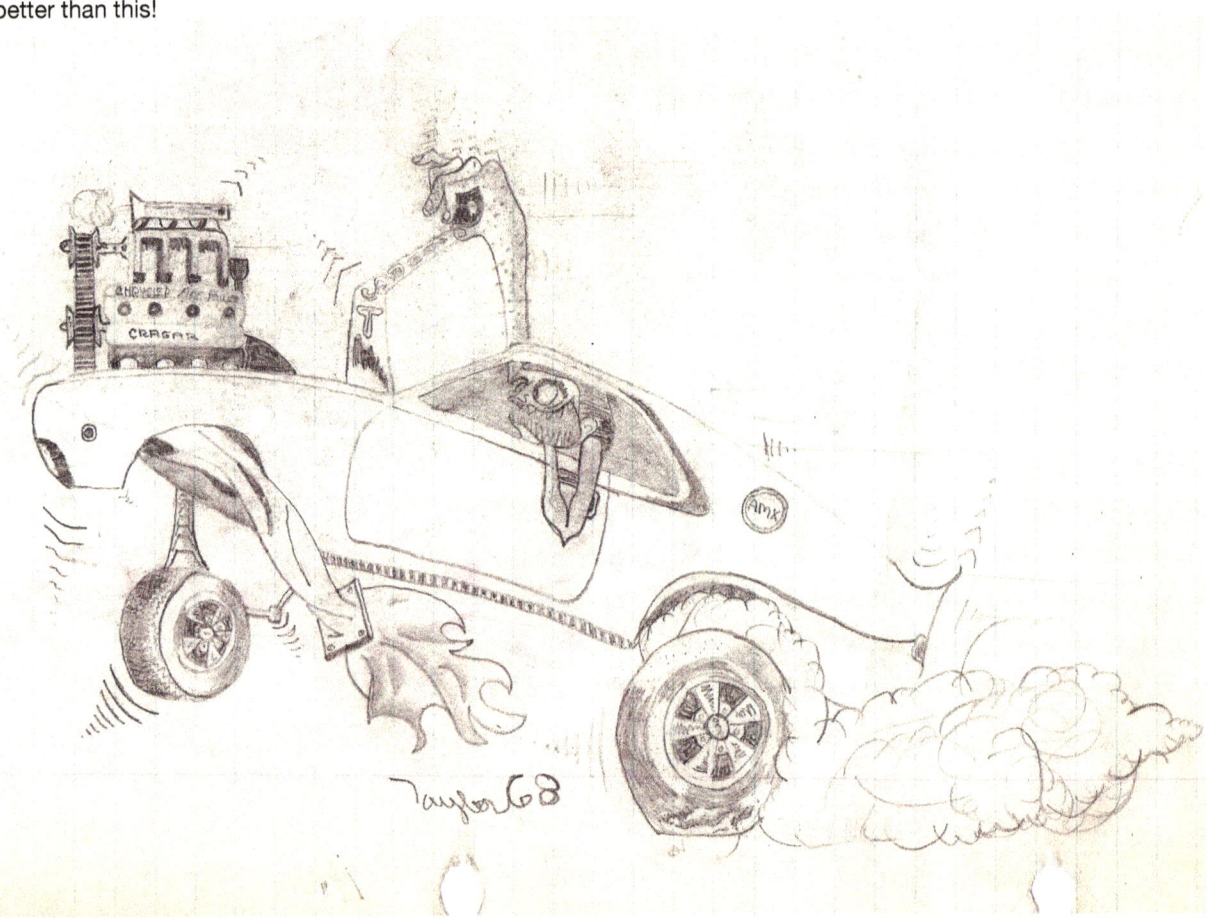

things not from here. I figured who else but Ed could create this type of art?

The thing that has amazed and maybe puzzled me about Newt is how he's stayed in the shadows, rarely discussing or displaying what he conceived over 40 years ago. Some have tried to capitalize on their association with Roth, Von Dutch, and the whole hot rod, Harley, and surf culture throughout the years, but not Newt. He's not shy, but he chooses not to make a big deal about his ties with all of the above. He has always looked ahead, and I think that is where he is most comfortable: looking ahead to his next project or piece of art. For me, that means the man's personality lives up to the greatness of his art.

Now I should mention that the Roth world of the 1960s—but also later after I got to know him in the 1980s—was magical for me, and it greatly influenced me as a kid growing up. You know—all the cars, creatures, art, garments, and other crazy stuff that Roth sold at car shows. In fact, one of the great things about my involvement with hot rods and custom cars has been the opportunity to meet most of the people from behind the scenes of Roth Studios—even befriending some of Roth's sons.

Anyway, Newt was the guy, and he was up for it! So between my attempts at explaining aspects of doing this type of art, combined with Newt's explanations and overall mastery of not only the genre but fine art and commercial art in general, all of the bases should be covered as monsters in crazy cars go.

It may seem like a small niche, but this art has been integral to the hot rod and custom car culture—popular culture, really—since the 1960s. So however you look at it, whether from an artistic viewpoint or a historical one, it has been an enjoyable and entertaining part of a lot of people's lives for decades.

If you're looking for instruction in art of this type you have come to the right place, but I hope that many of you pick up this book as much for the historical information as anything else. In any case, I hope you'll enjoy it all! Now let's draw some mad monsters and crazy cars.

—*Thom Taylor*

• • • • • • • • • •

Creating a monster is a heck of a way to make a living, but when you stick him inside a speeding car, well, that makes all the difference in the world. When I was a kid studying to become an automotive stylist, it never occurred to me that my part-time shirt-painting business would alter my future. It was just a way for me to pay my way through school, and not intended to be the living end in itself.

Let's face it, fads come and go. Fifty years ago, college kids all over the country were trying to see how many of them would fit into a phone booth. Not only did that fad die out, but so did the phone booth. "Back in the day," who would've guessed that painting malignantly motivating monsters in radical rides would stick around longer than the U.S.S.R? Certainly none of us who got paid for releasing our seething, pent-up emotions on paper (or garments). We were just along for the ride, milking the most out of the horsepower wars until the next big thing came along.

When Detroit's muscle cars all took a dump, our power-hungry monsters began their dormant sleep. The suburbs were safe again. Mom and Dad thought they saw the last of those sick and sinful shirts when "Big Daddy" Roth parked his butt in a museum and Stanley Mouse moved to the peace-and-love corner of the country almost 40 years ago. But no. Because you can't keep a good monster down. Now that we've entered a new millennium, the monsters are back, rising from the ashes like a Phoenix of fire and boiling hides!

▶ "Newt the Wizard" zaps into existence the infamous RoachCoach that he designed. The build process actually took eight years and $100,000 in 1970s money. This was possibly the last of the big-ticket, exotic-themed show cars. It was more of a kinetic sculpture than a car, but the concept of morphing an inverted airfoil with a cockroach was not apparent to most.

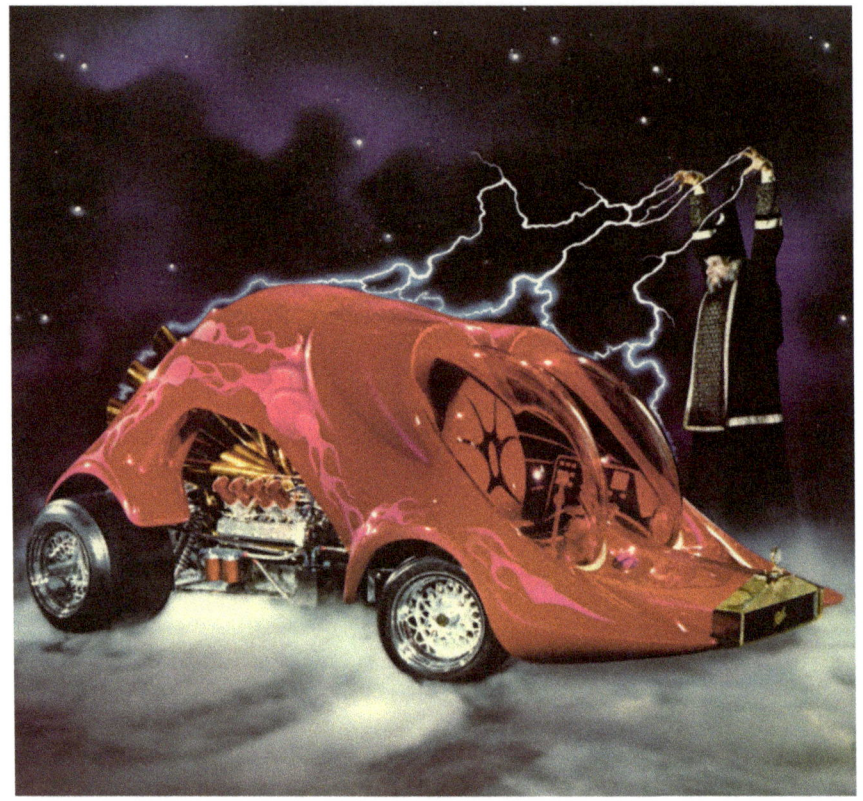

The monster cars with mega wheels have come full circle. Instead of lining wastepaper baskets, the age-tinted, ink-on-paper originals of those old Roth Studios shirt designs are fetching $25,000-plus at West Coast auctions. I guess that in these turbulent days of soaring gas prices and scary suicide bombers, the old-school old folks' shock and disgust at Junior wanting to wear an axe-wielding Wild Child on his shirt pales in comparison. Now we old-timers are crossing our fingers and hoping that the government won't step in and ban the hot new musclebound cars of today. We have sharpened our pencils and reloaded our monster ids with new and vicious vigor.

That's why I jumped at the chance to be involved with Thom's Crazy Cars & Mad Monsters project. He's the go-to guy for cool how-to books on hot rod art, and you know there's going to be fun involved when the subject matter is all about drawing the kind of garbage most parents have hated and feared for years. In fact, I'm so glad to be on board with such wheeled insanity and motoring mayhem that I've dragged out old disgusting drawings so fabulously foul that I wouldn't even show them to my wife. Finally, a chance to share my malevolent mind-wreckers with those who will hopefully not see these images as the lowbrow, anti-art expressions that they are, but as cleverly crafted cartoons filled with just a hint of horribly hideous humor. Bottom line is that it makes no difference if the stuff that we old shirt painters did in the '60s is ever accepted as an "original American artform" or not—it was just great to have a gas of a gig that I wouldn't have missed for the world.

—*Ed Newton*

CHAPTER ONE

A Quick History

By Ed Newton

It's hard to determine what really happened during the Big Bang because nobody was there. There's also no one left who knows exactly how and when the very first mad monster was placed in a crazy car. There's logic, and then there's legend. For our purposes both should have a place in our hearts and minds.

Logic tells us that this image, or image process to be more specific, was evolutionary. There are some things we know for sure. What we consider to be classic monster-in-car designs first existed on a commercially created, hand-airbrushed T-shirt or sweatshirt. It may be possible that such an image first existed on a race car, hot rod, or customized car—but where is that vehicle, or at least a dated photo of it? We know that the earliest artistic designs done in marker or airbrush on garments were surreal images and patterns, car club coats of arms, sponsor

▼ Two sweatshirts airbrushed in the summer of 1962 by Newton at Waikiki. The Corvette design was a popular request based on the April 1961 Sports Illustrated cover art. This design was originally airbrushed by Richard Ash while at Roth Studios in 1960. Ash left Roth in 1961 and immediately went to work for Stanley Mouse, where he did the same design, this time with the car in motion. Newt updated it with a new Corvette per the customer's request. The Outcasts were an early car club.

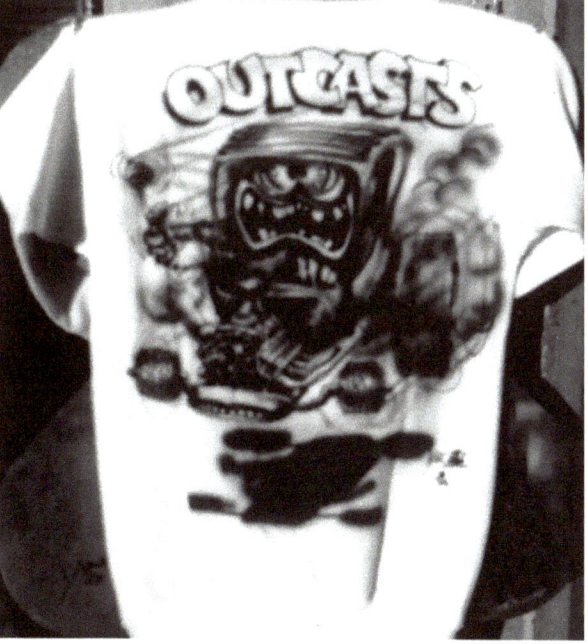

▶ "This is the very first crude—and I mean really crude—notebook sketch I did on the back of an order sheet at a car show in 1964, which ended up spawning my very first Roth shirt design, called Killer Plymouth," says Newt. "It went from this concept to an airbrushed shirt. Then it was interpreted in ink on paper, silk screens were created, and finally the screened design was printed on a shirt."

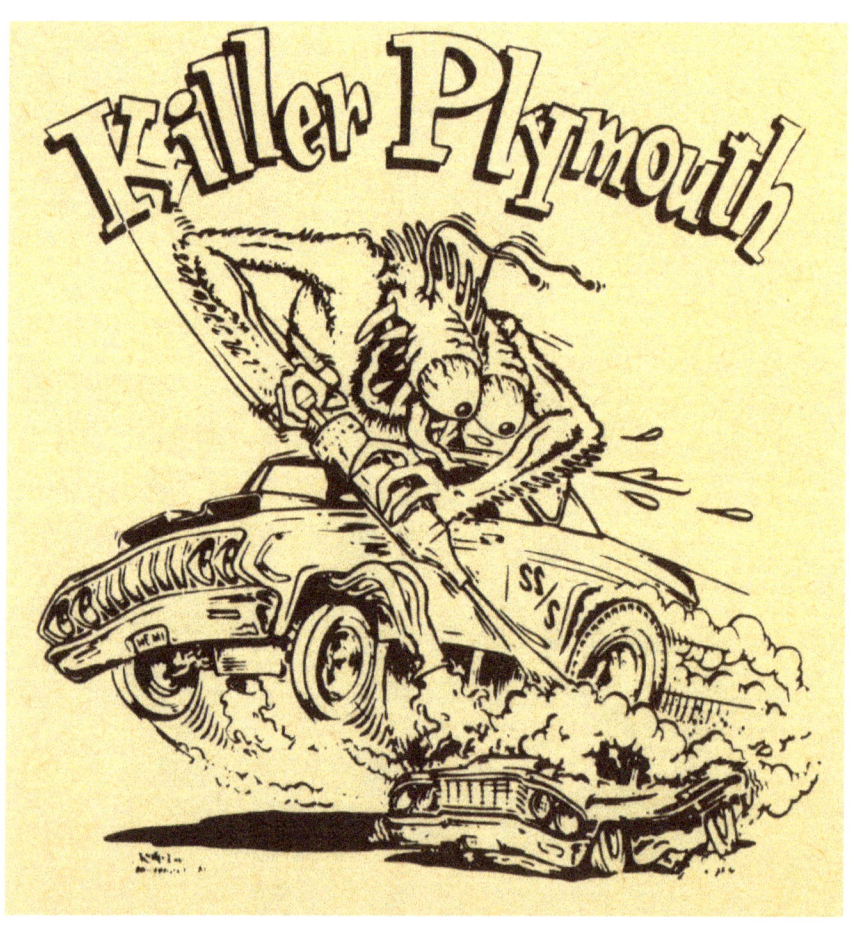

logos, and singular "weirdo" characters. Then someone drew a large personalized caricature of the actual customer or a weirdo looming out of a small rod or custom car low on the shirt, possibly for a car club. Over time, the little car under the weirdo became more predominant and detailed. Since shirt-painting was customer-driven, there's no doubt the next guy in line said, "Do me a shirt like the last one, only make the slicks bigger and smoke 'em." And that's when we got the "flying wheel-stand" format. The rest, shall we say, is history, not mystery.

Legend has it that Von Dutch did the first airbrushed weirdo shirt. We know he embellished his own shirts with freehand images because there are published photos of him wearing these shirts way back in the mid-1950s. Whether he created any for his customers or subsequently invented the weirdo-in-the-car is not clear, but it appears he was the dude that got the hairball rolling.

Legend also has it that "Roth the Crazy Painter" was the first to see commercial possibilities with Dutch's airbrushed-shirt idea. This can't be verified, but whoever sold the first airbrushed-weirdo shirt inspired Roth on his road to riches before he was ever known as "Big Daddy."

In 1957 Roth advertised "Wierd-O-Cals" [sic] by "Roth The Pinstriper" in magazines. These water-slide decals depicted weirdoes and simple pinstripes. "Wierd Shirts" (again misspelled) were first advertised by "The Baron and Roth," Roth's new venture with veteran pinstriper Bud "The Baron" Cozier in 1958. A year later there were airbrushed "Krazy Shirts" advertised by Dean Jeffries—also a Southern California custom painter and pinstriper—and by 1961 Stanley Miller, known as "Mouse," had joined the fray from his digs in Detroit, Michigan.

Finally, when a Roth Studios (the final name Roth gave his business) hand-painted shirt by Richard Ash made the cover of the April 24, 1961, issue of *Sports Illustrated*, the die was cast. No "rod-blooded" kid in America who saw that cover would ever be the same.

These early hand-painted shirts contained lots of weird characters, but none were wilder or more diversified than those from Roth Studios. Ed Roth found some really talented artists to create these images, and it became obvious that most shirt painters who came after were either inspired by the designs seen in Roth ads or were firsthand witnesses of Roth and his accompanying crew creating airbrushed shirts at car shows throughout the country.

Roth had been selling airbrush-rendered shirts as early as 1957, yet eastern rod magazines still touted the technique of using primitive tools such as markers to create weirdo shirts a full year later. By mid-1961 the conversion from airbrushed to silk-screened weirdo shirts was in progress, with the more popular designs available first from both Roth and Mouse. In 1962, Rendina Studios (Detroit) and Mad Mac (Cleveland) were advertising silk-screened weirdo shirts.

As you can imagine, freehand airbrush-painted garments were by and for a younger generation. Von Dutch was in his mid-twenties when he began embellishing his shirts in the mid-1950s. Ed Roth and Dean Jeffries were about that age when they started blowing paint on shirts a few years later. Mouse and Richard Ash, Roth's former shirt painter who had defected to Mouse, were even younger. Guys like me were still in school when we began. In fact in 1960, two summers before Rick Ralston and I started Crazy Shirts of Hawaii, Rick had spent his school vacations painting shirts on Catalina Island off the coast of Southern California (remember the Beach Boys song?) with Gary "The Crazy Arab" Olsen, who was also a former shirt painter at Roth Studios.

What elevated this whole airbrush shirt fad was the dynamics behind the shirts' creation. When people purchased shirts from airbrush artists at fairs and car shows, the customers described what they wanted—then it was up to the artist to create an acceptable image from that verbal data. No preliminaries, just the final art right on the garment. That's why those images became so unique. The artists had to rely on their memories and imaginations to successfully process each request.

▶ Newton works the Oakland Roadster Show in January 1966. Newton did hundreds of shirts like this, and still owns the stool given to him by Ed "Big Daddy" Roth. On the flip side of the beat-up seat, along with the words "Where's Von Dutch??," Roth wrote, "Stolen from Ed Roth." Marlene Benson

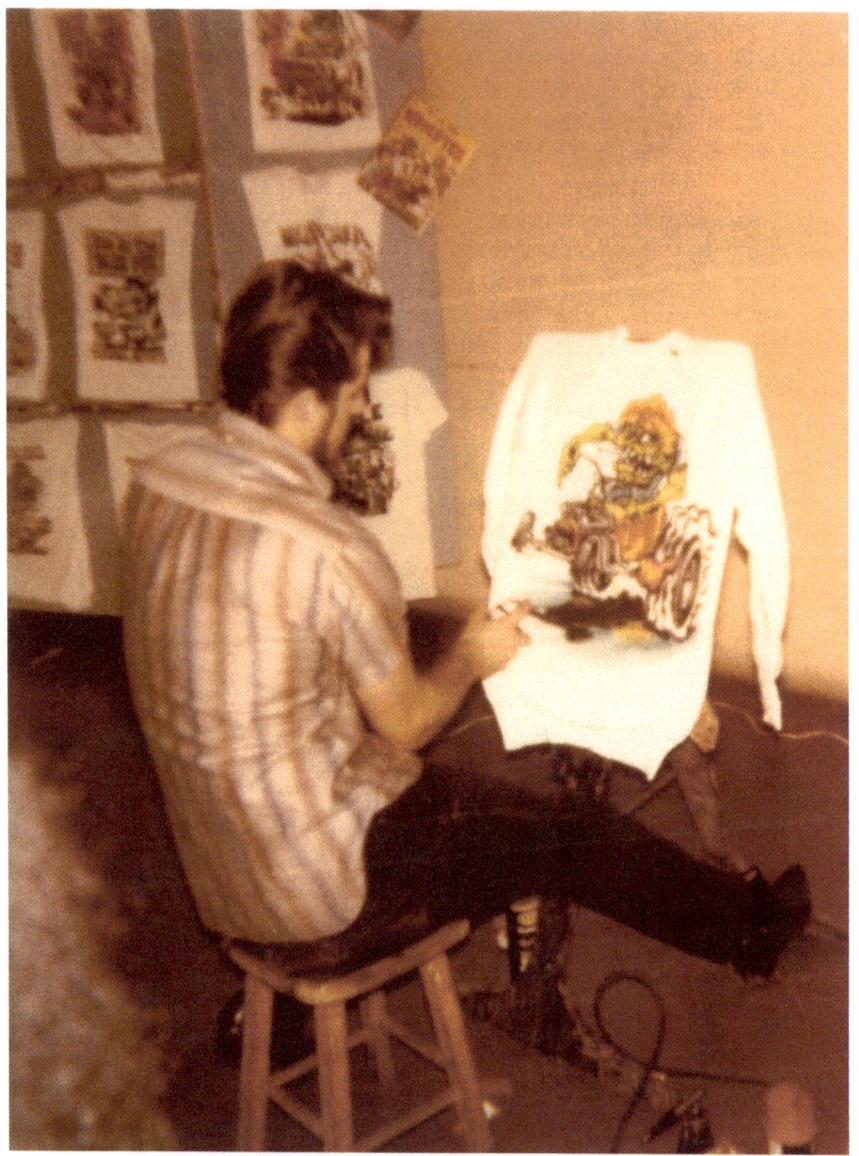

After painting literally hundreds of shirts in such an arena, you can bet the artists found it necessary to challenge and amuse themselves by creating images beyond their customers' desires. As you can also imagine, this led to some really clever, wild-ass designs.

Obviously, a lot of airbrushed shirt monsters were influenced by strange and even shocking artwork from artists well known to kids at that time. Basil Wolverton could be considered the catalyst for weirdo monsters because absolutely no one created more mind-boggling creatures than he. In 1946, Lena the Hyena, one of his cartoon faces used by Al Capp in his syndicated Li'l Abner strip, was pulled from publication by some papers because it was so gross. That's just super-nasty cool! In fact, Basil was the mind behind those bulging sausage eyeballs that mark our classic mad monsters. Style credit also goes to Wally Wood and Jack Davis for their gnarly characters and anarchistic artwork in the original *Mad* comics during the early 1950s.

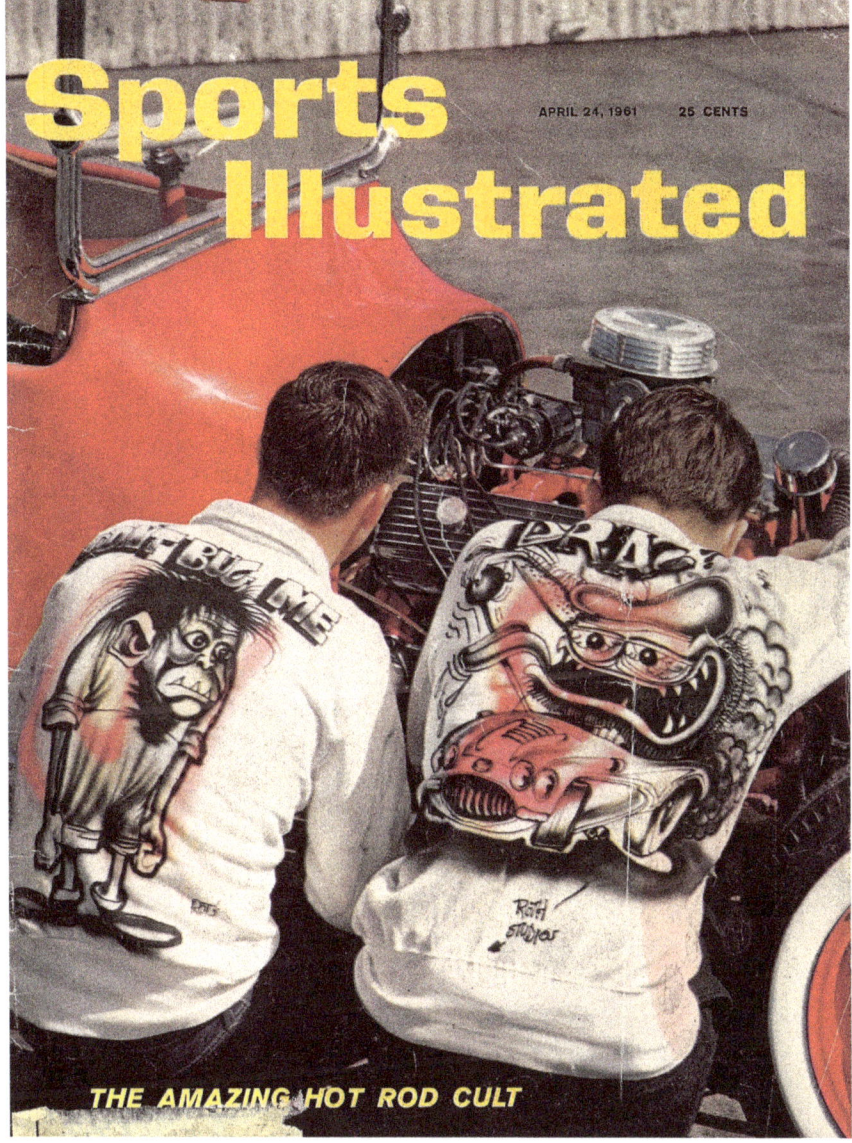

◀ This Sports Illustrated cover featuring Roth employee Doyle Gammell (right) and friend with their airbrushed shirts really spread the weirdo word. The article included color photos of Big Daddy and the Beatnik Bandit, Barris' finned air car, Chili Catallo's deuce coupe, Larry Watson's pink Cadillac, and much more. This was quite a mainstream magazine to be reporting on what was still considered somewhat of a juvenile delinquent–type interest in Southern California. Thom Taylor collection

Although hard to believe today, the general influence of *Mad* (before it became *Mad Magazine*) on youth of the 1950s was monumental. Its catchphrase, "Humor in a Jugular Vein," was entirely appropriate, opening the door to a brand-new kind of cartoon humor previously unavailable to kids. And let's not forget Don Martin's work, which began appearing in *Mad Magazine* during the late 1950s. Suffice it to say that Rat Fink's body looks like a Martin character. Even if these images were not intentionally copied or even consciously recalled during the creation of our beloved 1960s weirdoes, the essence of their appearance was in the shirt painter's mind.

And that's what it's all about. We stand on the monstrous shoulders of giants. So it would be safe to say that anyone who wants to learn how to draw despicable demons piloting wretched rods owes a debt of gratitude to those pioneering minds of the past. We still can't help but love the warped, wacky, wild, and oh-so-weird. May the marriage of malevolent monster and careening car live forever!

CHAPTER TWO

Tools & Media

If you own pencils and paper, then you have the basics to draw anything, right? Actually, many tricks will help make your drawings and sketches easier to do, will help make them look more professional, and will save you time. One "trick" is a comfortable, well-lit work area and equipment that enhances your ability and desire to draw monsters, cars, dogs, flowers, the constellations—pretty much anything you'll want to draw. Be forewarned: Having this equipment without knowing some drawing basics won't help you a bit, just as the best bat, glove, and uniform do not make for the next Derek Jeter. This analogy holds true for computers, too, but more on that later. All this equipment is an aid, not a replacement, for your drawing abilities.

▶ There are so many choices when it comes to drawing utensils that you'll never know what they all do. Different pencils and pens yield different results, so it comes down to how comfortable they feel, the types of lines they create, and their performance in terms of drying, consistency, flow, and endurance. The good part is that they're usually cheap, so experiment with as many as you like!

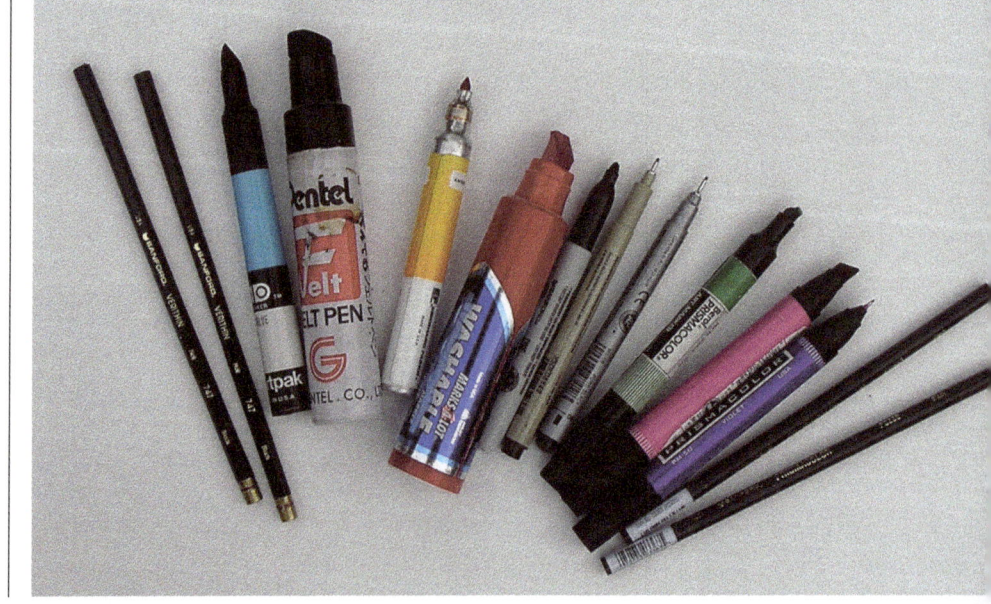

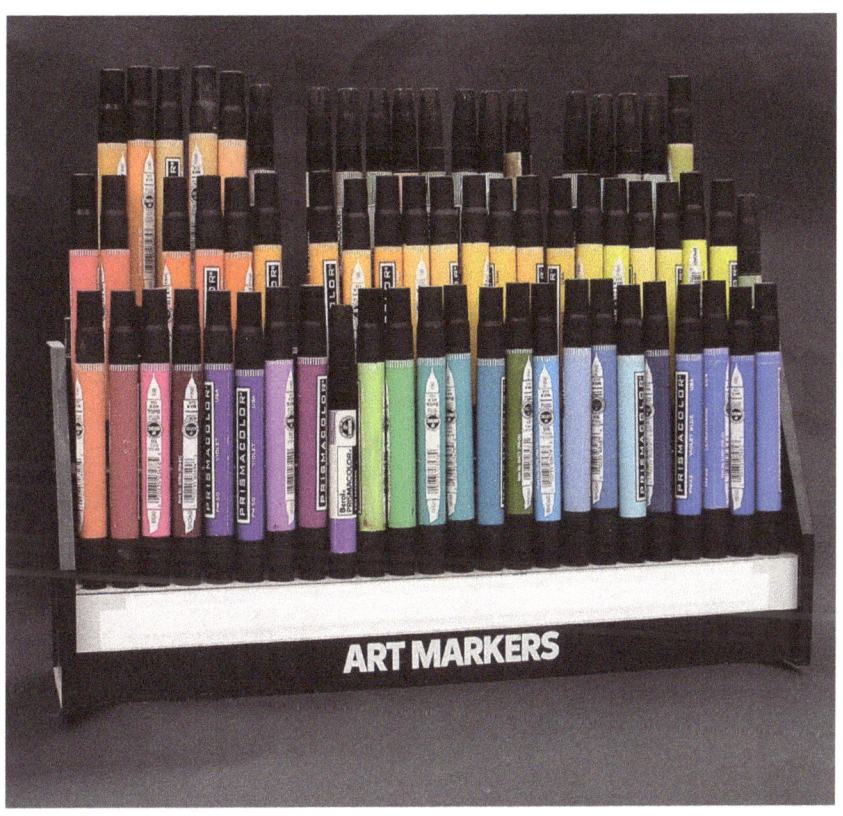

◀ If you're a marker junkie, you'll want the widest range of colors and functions. Different brands of markers have pluses and minuses, so try a few out. In terms of your health and the environment, the alcohol-based markers are better than the chemical-based ones. If your local store is limited in its choices, try the Internet.

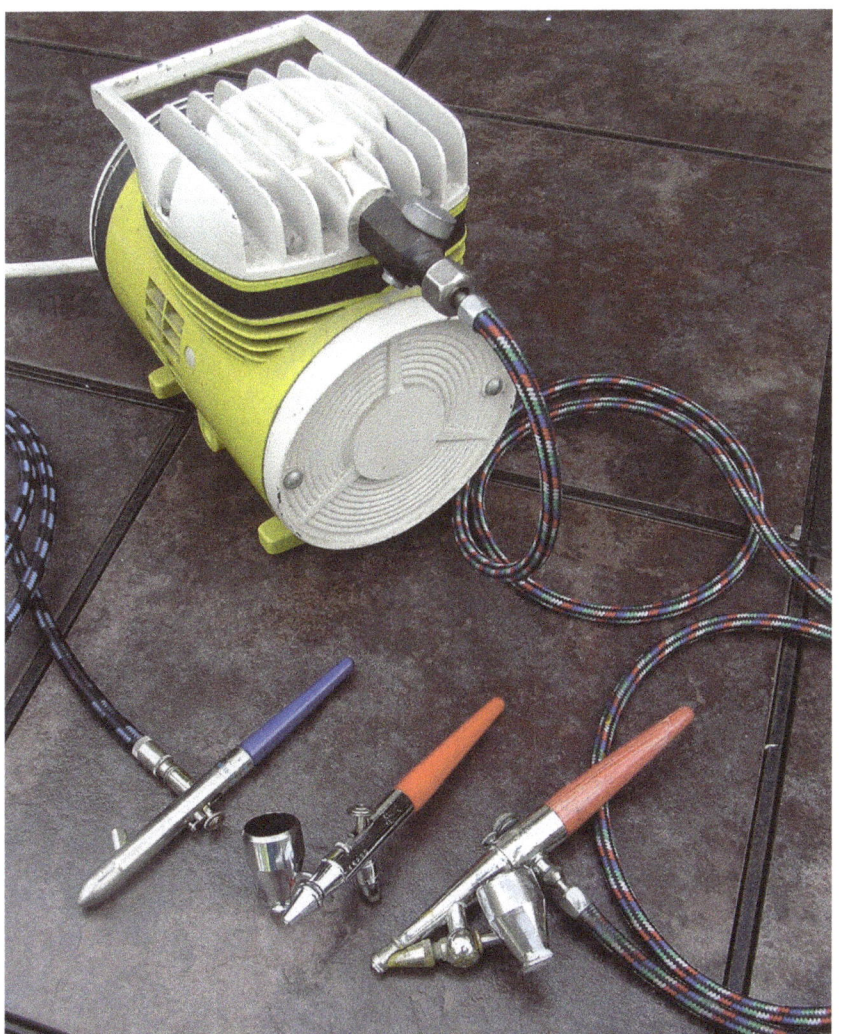

◀ There are two types of airbrushes: external mix, which atomizes the paint outside of the unit just beyond the nozzle, and internal mix, which mixes the paint and air inside of the unit. With water-soluble paints you can use either an internal or external mix because you can clean them easily even if the paint dries a bit inside of the unit. Not so for chemical-based paints or acrylics. If the paint dries up inside an internal mix brush it's done, so use an external unit. Newt has used a slightly modified Paasche VL-3 internal mix with a #5 tip and #3 cone and needle for over 40 years, while I've had a Paasche V-2 internal mix with a modified needle for 25 years. For acrylics and enamels, I have had a Paasche H external mix unit for about as long. A number of books and web sites go into much greater detail about airbrushes and technique, so if your interests tend to go in this direction, use this book as a springboard.

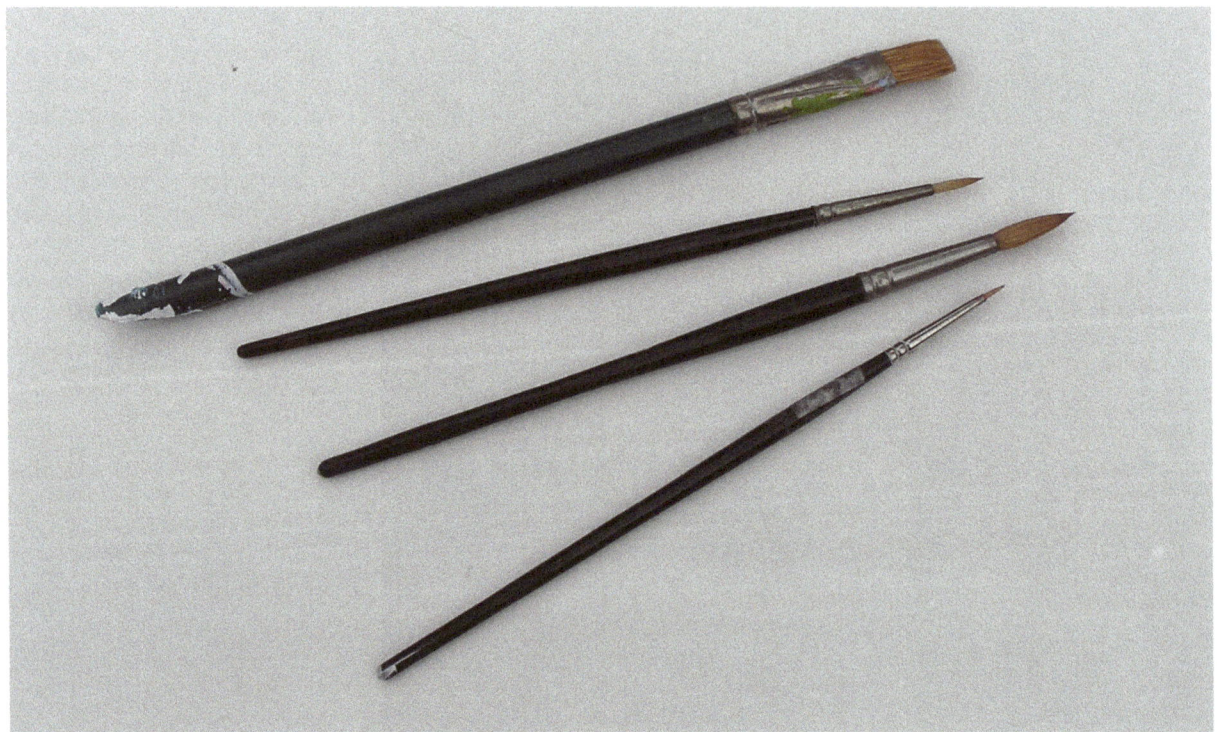

▲ A small assortment of brushes can be used not only for putting highlights into your drawings with white gouache, but also for actually drawing. Examples of this technique are included later on in this book.

Before we get into tools of the trade, you need to determine what style of monster motion you want to try out. If it's an airbrushed shirt or scene on board, then you need to take a look at the whole airbrush universe. We won't do that for you here. Sorry. There are lots of how-to books for budding airbrushers. What we will suggest is that you look at internal-mix airbrushes for finer work (and the better the brush the easier it is to use, so you may want to steer clear of that Mega Mart special).

▶ Sets of ellipse templates are available in 10- to 80-degree measurements, as well as in a range of sizes. Start with the smaller set first, then see where your needs take you. Chapter Five features in-depth explanations of ellipses.

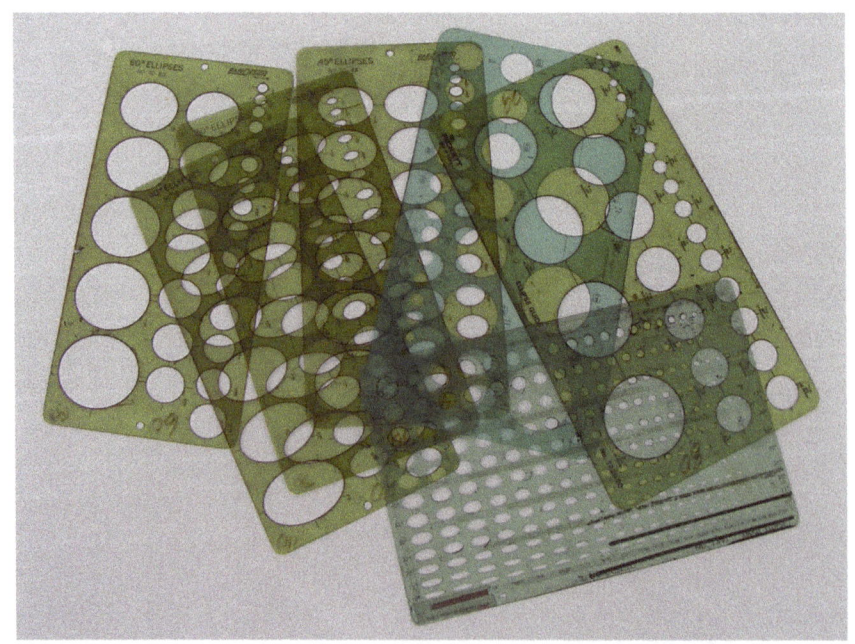

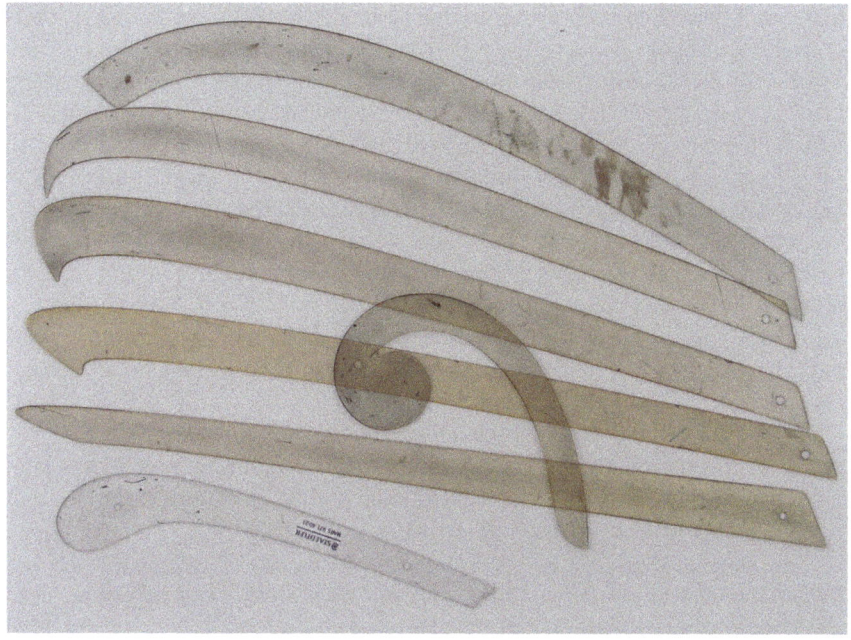

◀ The almost-straight sweep in the photo is the one I use the most. Because I made these particular sweeps, they are not available commercially. Try to find close duplicates.

You'll have to look into a compressor versus a compressed air tank. And for the medium, there are water colors, water color–like dyes, gouache, animation cel paint—all kinds of different liquids you can squeeze through that airbrush. You may want to experiment with each to see what it can and cannot do for you and your painting.

Besides the fair-aired equipment, most of whatever else you'll use will be of a more primitive tool type, like a pencil, marker, brush, or piece of chalk. For

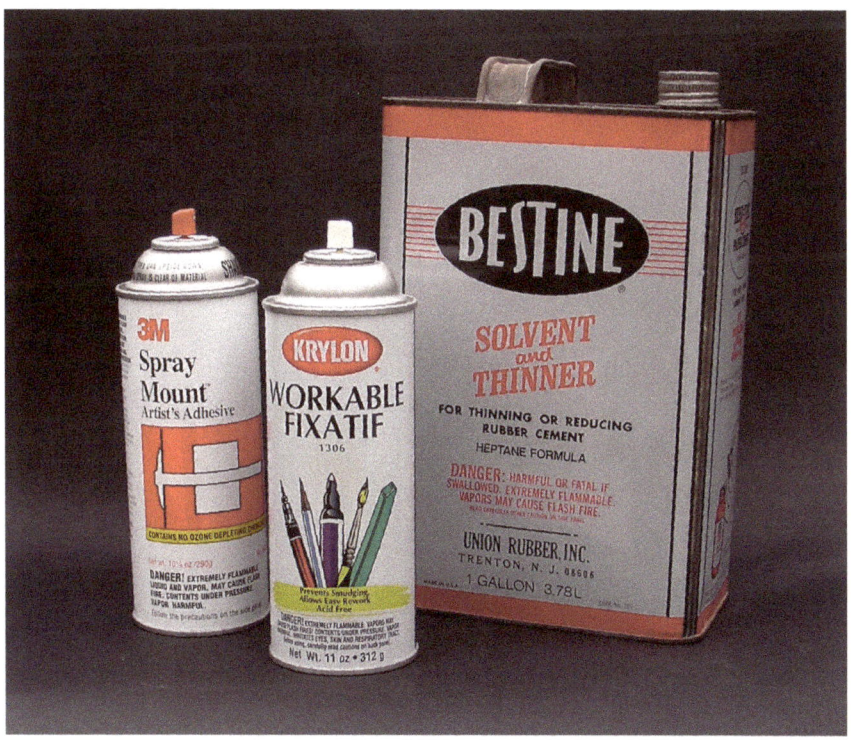

◀ Keep a can of Bestine handy for cleaning dirty sweeps and other instruments you gunk up with marker juice and pencil lead. It can also be used to create interesting backgrounds. A spray bomb of fixative works well to keep pencil or chalk down on your drawings. It also allows you to come back into the sketch later and work on these sprayed areas.

that you'll need a good drawing surface on which to work. A solid table, desk, or drafting or light table is the preferred choice. Whatever your decision, the key word is *sturdy*. Don't settle for one of those wobbly, bottom-of-the-line drafting tables with the hinge-and-catch brackets that have been known to nearly amputate whole arms and hands. Make sure your table's left edge is straight so you can run a T-square along it when you need to square things up on your drawings. If you need a surface that tilts, a drafting table is your best bet.

Whatever drawing surface you work on, have good lighting. I like incandescent lights, but you may wish to combine fluorescent and incandescent lighting, or to work under fluorescent conditions exclusively. Lighting should be even to avoid shadows and hot spots, so more than one light source works best to spread out the light. Let's face it: You have to be able to see what you are doing, so start with a well-lit workspace.

As for your implements of choice, experiment with different types. You may prefer the qualities that a No. 2 lead pencil offers, or a fine-tip pen, or even a ballpoint pen. I know people who sketch with each of them, and they can all produce nice, "juicy" sketches.

If you use any type of wood pencil, you must have an electric pencil sharpener. Taking the time to sharpen a dull pencil after a few strokes is as annoying as an oil-down after a round of drag racing. And in such a circumstance, you are more likely to run with a dull pencil, which will produce a marginal sketch at best. Why do you think they call them dull? Step up and get the electric sharpener so that you can flog away.

▼ You'll not only erase with these pencil-type erasers, you'll also create highlights and reflections by removing drawn or rendered material from your paper or board.

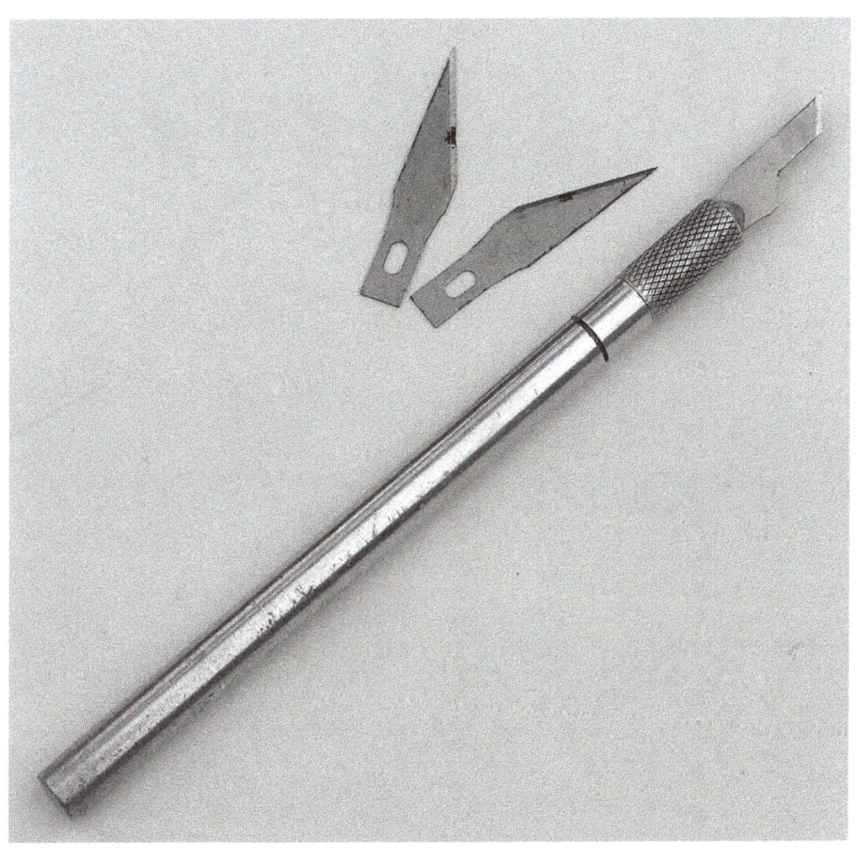

◀ An X-ACTO knife is a must-have item for the budding artist. Different blades give you different types of control. The knife is used to cut masks, scrape chalk for backgrounds, and much more.

◀ Good reference materials in the form of photos, clippings, magazines, and books are essential to expand your knowledge of everything from apples to zombies. In most cases, such references are rich sources for determining reflections, shadows, color, and light. They also can become a basis for going beyond reality once you start experimenting.

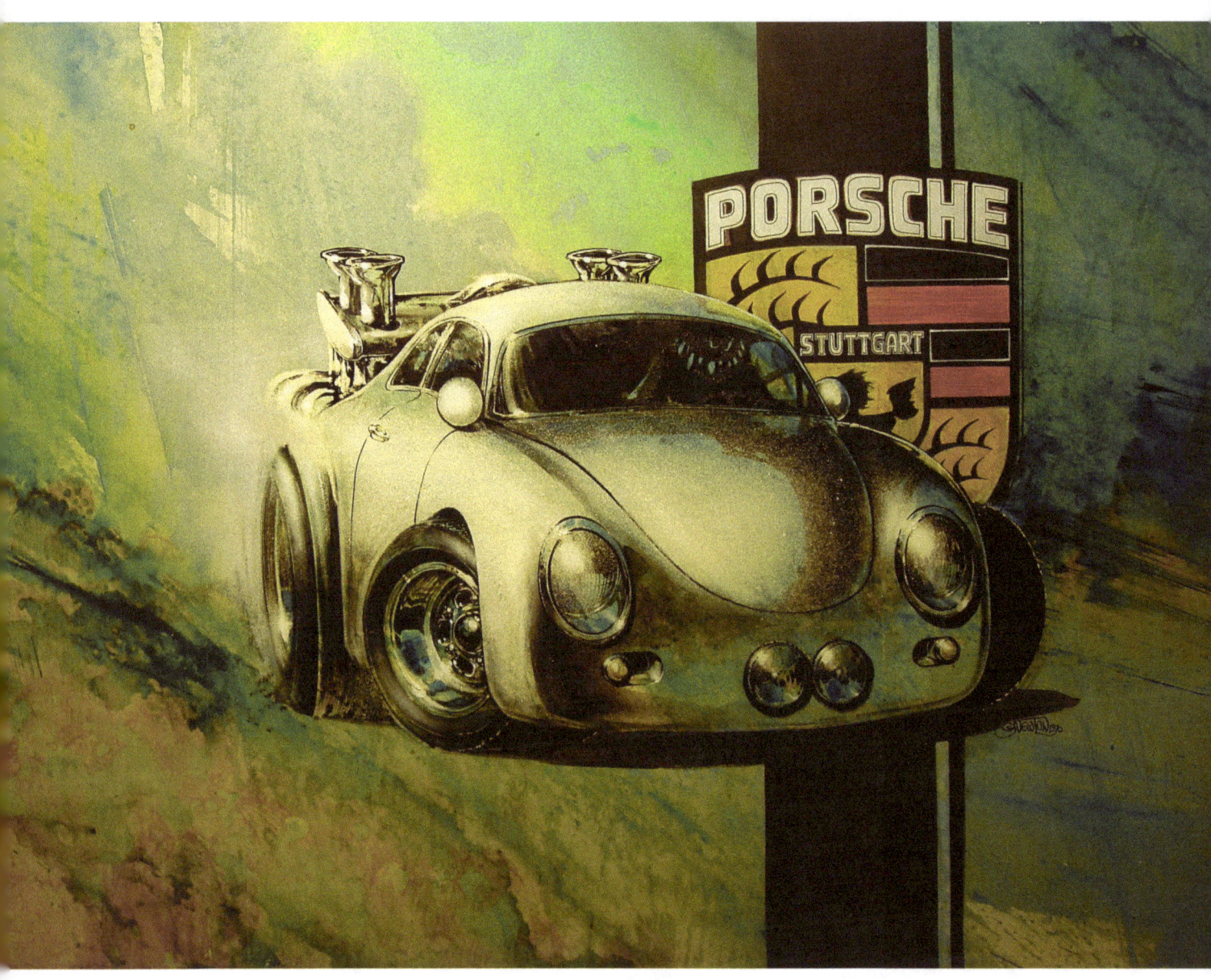

▲ Here's a rare acrylic painting by Newton. Newt has the ability to switch media based on the client's requests, the particulars of a job, or just for fun.

For pencil and pen sketching you may want to look into templates and angles to sweeten up some of those indistinct lines or wobbly circles. Forty-five-degree and 30/60-degree angles come in a variety of sizes; one of each angle will work just fine.

Templates consist not only of the circle and ellipse variety, but also include French curves, or "sweeps." The ellipse templates come in sets ranging from 10 to 80 degrees; 100 degrees is a full circle. Sizes within the range go from 1/4 to 2 inches in the smaller template set. As for French curves and sweeps, they will help in tuning up a line. They should not be used as a replacement for freehand drawing, but as an enhancement. Most art stores carry a range of configurations from which to choose.

Templates and T-squares get dirty. A good solvent or thinner like Bestine dumped on some tissue works great to clean up your smudged and dirty equipment. Do it often while you are in the middle of a drawing. Nothing looks worse than a smeared and dirty drawing caused by filthy hands and equipment. Don't be lazy—keep those hands and tools clean!

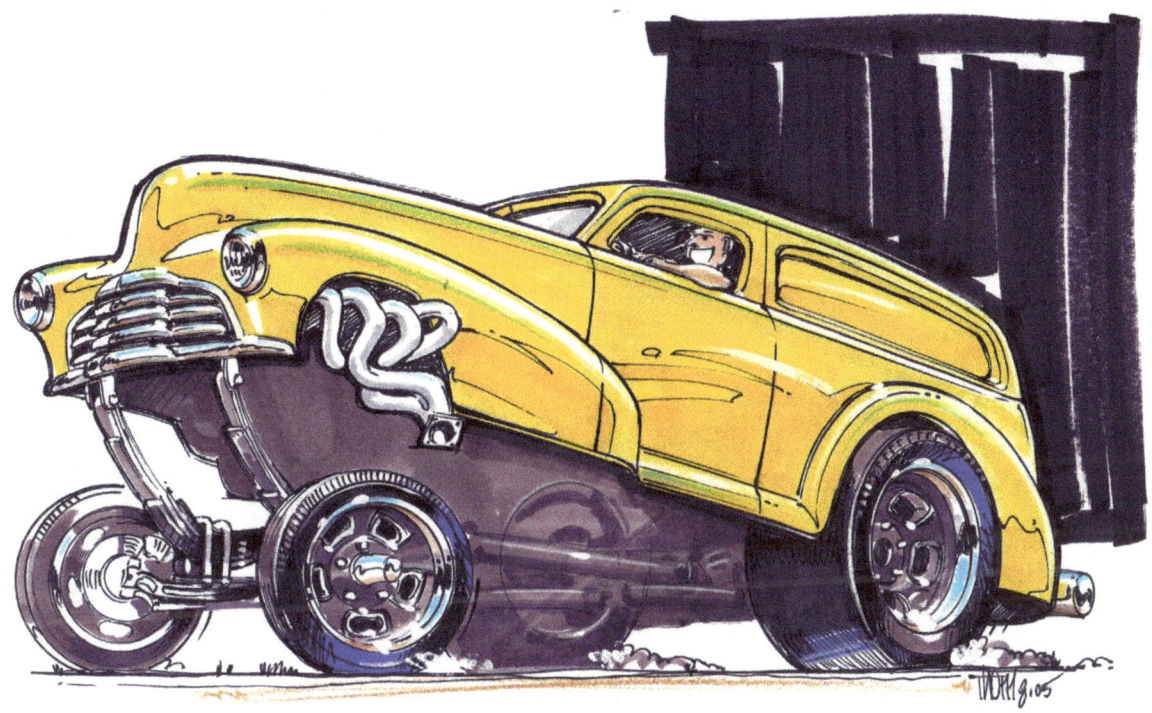

▲ A quick and fun way to draw is with color markers. They provide vivid colors, don't smear, and lay down fairly evenly. I quickly sketched out this gasser in pen and then ran some marker through it to wake it up. If you can only afford a few markers to start out, pick a range of one color as opposed to a "variety pack" with a bunch of circus colors but nothing to help you with blends and reflections.

Other small but necessary items to have on hand are a variety of erasers. I prefer the Pink Pearl and white vinyl type in pencil form. Since you probably will have a specific area you wish to erase, these thinner erasers get in that small area and do the job. The larger Pink Pearl and kneaded gray erasers take no prisoners. Slicing off the end gives you an incredibly sharp edge to erase with, which leads to a crisp erasure. To get that clean slice you will need to purchase an X-ACTO knife. These razor-sharp knives have myriad uses, from cutting eraser ends and matte board to scraping off dirt spots and slicing your fingers, so be careful. They slice through skin as if it were butter!

Masking tape also comes in handy, but I prefer drafting tape. It sticks less so you can get it off your paper or board without destroying your latest creation. But there is also another reason. Some artists use the stuff to mask off an area of the drawing much as you might use Frisket or masking film. (Frisket is a brand of thin vinyl film with an adhesive backing that you cut to a specific shape to protect or isolate an area on which you are working.)

Finally, you'll need something on which to draw. Zillions of paper types and illustration boards are available to suit every desire. Start with a couple of different bond paper tablets at least 9x12 inches or larger. You will find that paper varies in texture, thickness, and shades of white. Some take pencils better; some take markers or chalks better. You'll need to experiment to see which type best fits your particular requirements. The real joy in drawing is to tailor your choices to what works best for you.

When we talk about media we can pretty much run the gamut. If we dismiss scrawling scary images with crayon on construction paper—which is not technically out of the question—we begin with pencil on paper. You can use various weights of paper, vellum for multiple overlays, or "board for the bold." Most concepts are done

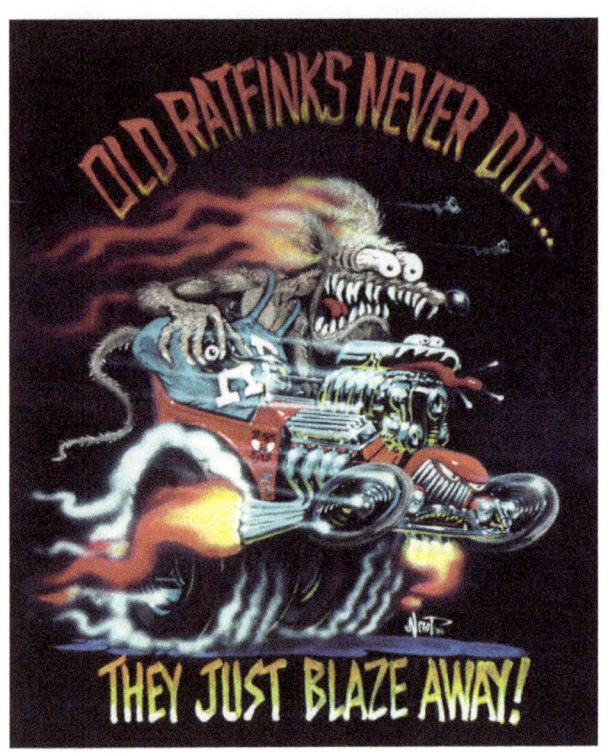

▶ "This art was first conceived as a spur-of-the-moment gouache rendering for me to take and sell at the 1989 Rat Fink Reunion," Newt recalls, "but when Big Daddy took a look he wanted me to create a black-and-white T-shirt design from it. So, contrary to past evolutionary steps for other Roth-era monster art, the color version came first and the black-and-white became the final design."

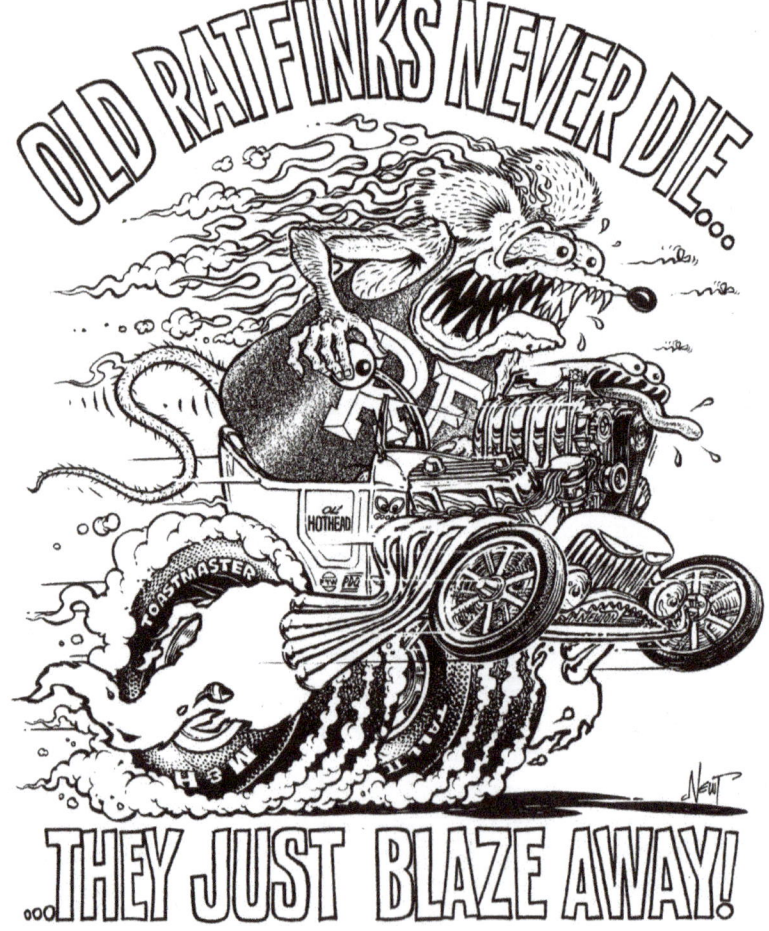

22

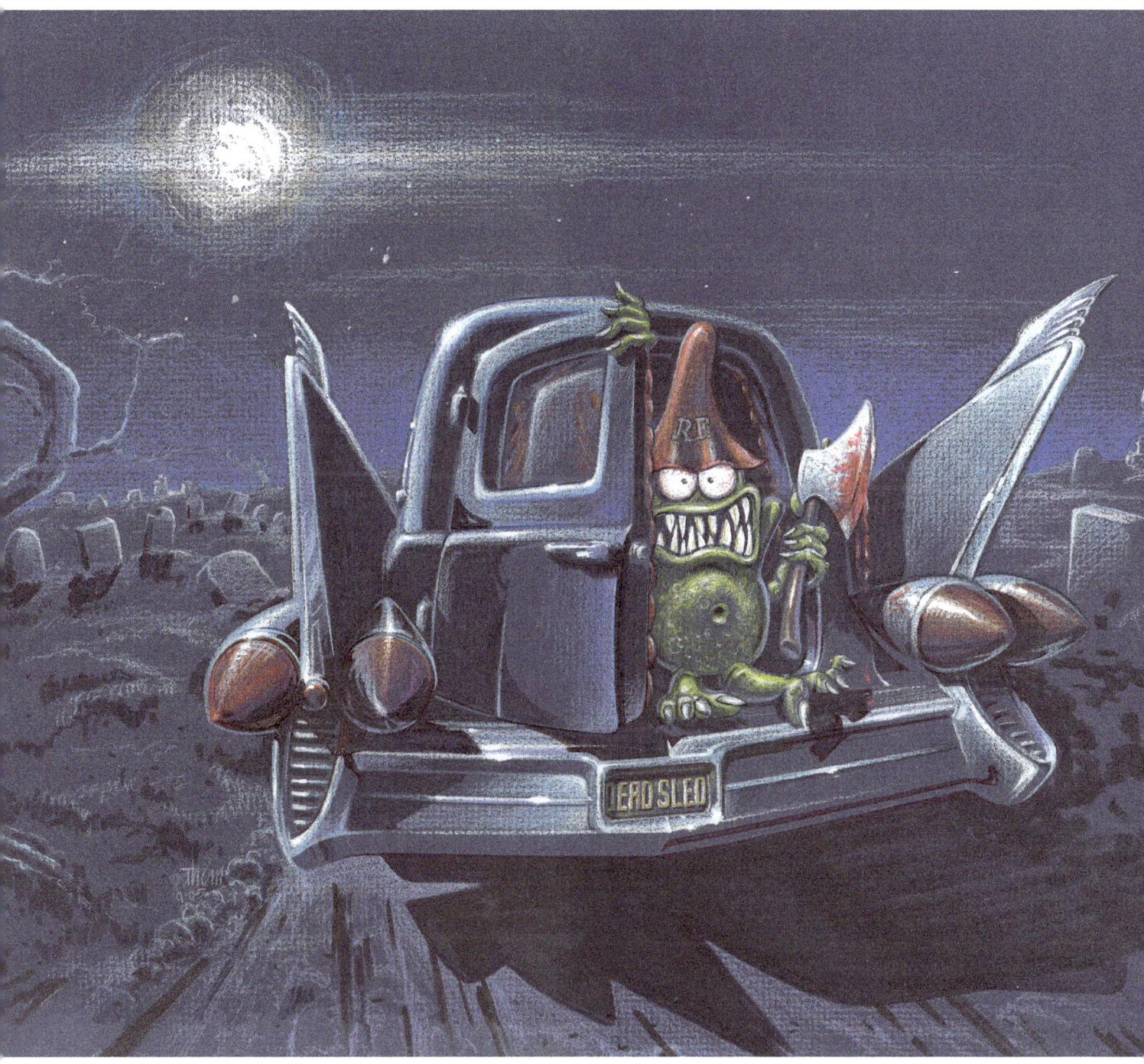

with a trusty pencil. In fact, it's amazing how much you can get out of this lowly graphite stick wrapped in wood. When you develop confidence in your style, pencil lines can mimic even a double-action freehand airbrush on a smaller scale.

With pencil, you can ghost your "cheat lines" to layout boxes or cubes and the positioning of ellipses, cylinders, etc. Then your sketch is looking good, so you can carefully erase the excess line work. After much practice in using the construction-grid technique, you may go right to the hardcore sketch by just imagining the construction grid on the paper, as the pros sometimes do. It might prove easier to do this if you're working small.

▲ The ability to switch off to another medium should be part of your exploration, and a lot of fun. I don't get to do this too often but when I can I like to work in colored pencil on board. This Finky was originally from art that Newt did for an obscure Roth catalog from 1964. I like Finky so much that I used him in the drawing.

▶ Here's another gouache-on-black-board painting by Newt, this time using the black to its fullest, thanks to fluorescent paint. You have to plan what materials and colors will work best to make your art interesting and punchy and to tell the story, if there is one.

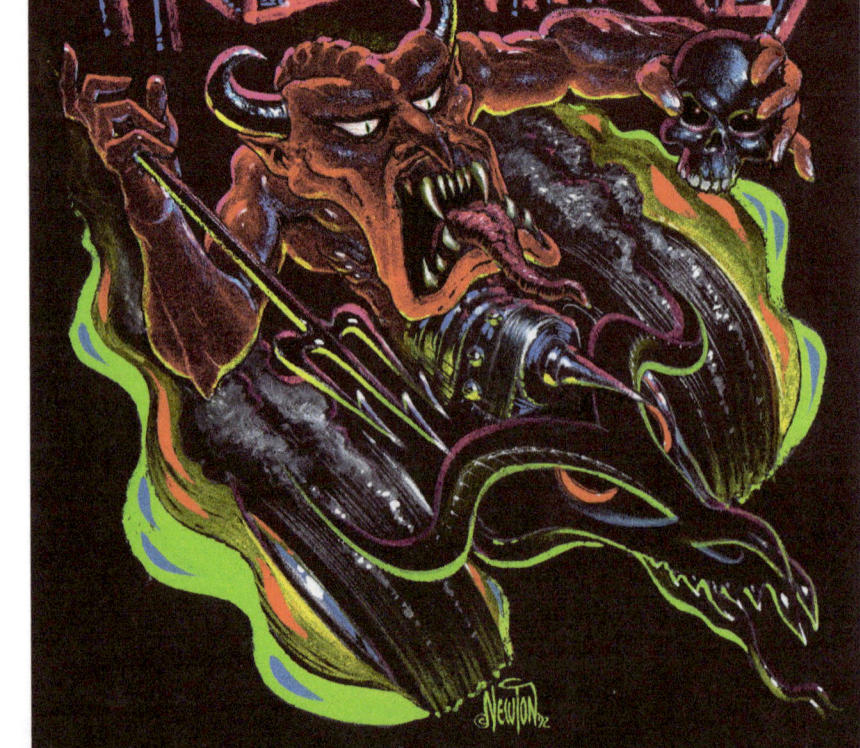

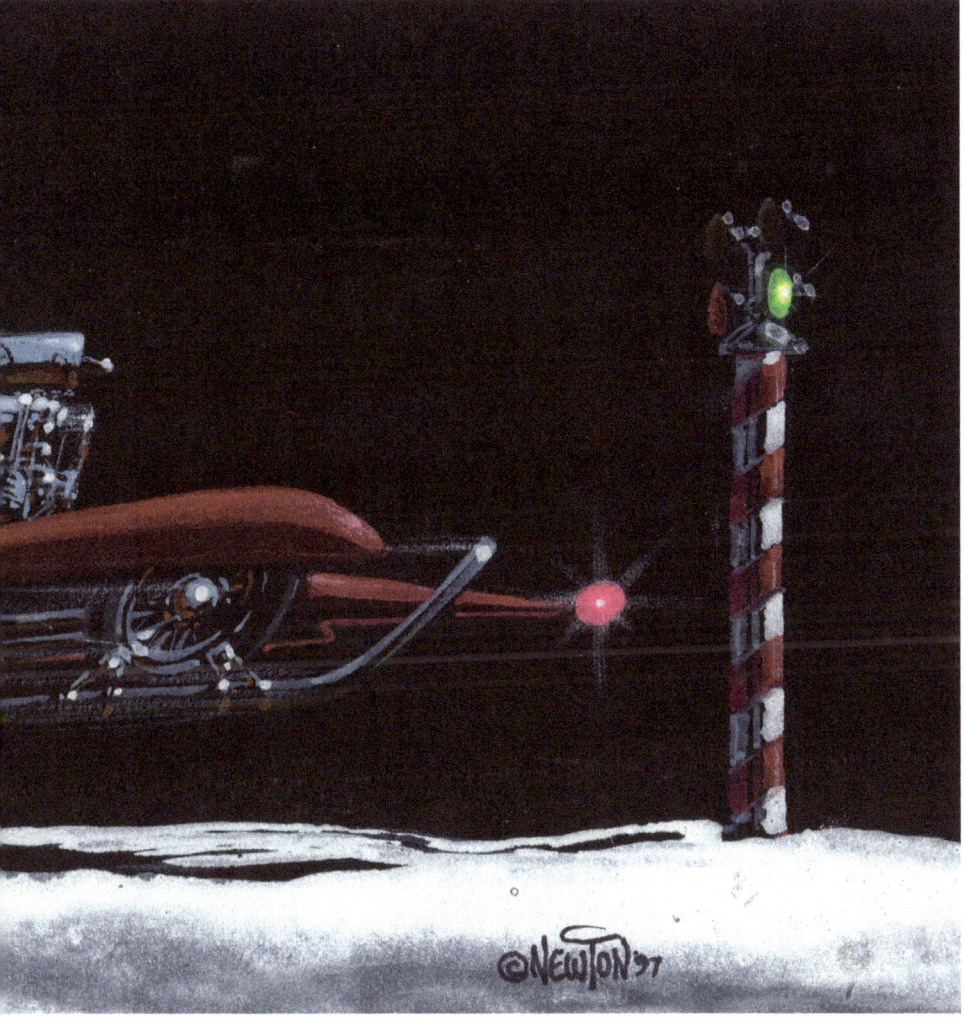

◀ Newt painted Santa and Rudolph the Red-Nosed Snowedster in 1997. This is his gouache technique, with the white snow and chrome making for a punchy painting against the black board. Would this have been as interesting on white board? Probably not—the snow and chrome would be washed out by the background.

Remember, pencil forgives, ink doesn't—especially the heavy-duty waterproof India inks that the pros use. When you're working with ink, whether using a pen or brush, you can't hit a key on your computer to undo the stroke you arched in the wrong direction. True, there's always Wite-Out, a very opaque water-based paint that covers ink well, but white should never be a rendering tool. It should be used sparingly for things like "popping" highlights, or for corrections after you've run out of other options. The reason for this is simple: White-out will give the artist a much rougher surface, and it can smear or dilute your inks or even clog your pens.

Mastery of black-and-white monster-and-car design is strictly retro. Color is another story. It may be wishful thinking to ask every aspiring monster-minded artist to walk before they run, but hey, that's not such a bad idea! If you get really good with the basics using pencil (with a good eraser) and then master the ink process, it will be much easier and more satisfying when you graduate to color.

When we talk about color, we could be talking about anything from merely filling voids in a finished black-and-white drawing to constructing a full-blown oil painting with nothing but color pigments. In fact, the subject of color is a "whole 'nother ballgame" that we will cover in Chapter Eight. However, color theory aside, the choices you make when it comes to your "color graduation" will eventually help define your style.

▲ "I did this ink-on-paper airbrush study for the underground magazine Wild Thing in 1999," says Newt. "It's not a classic monster-in-car combo, but they are cars, and they are monstrous. Maybe the moral here is, 'If you can't beat 'em, beat 'em up!'"

Some artists like to add watercolor fills to their ink-based line work, similar to the way old-school freehand airbrush painters added color to their black line work for T-shirt designs. Some choose thicker water-based One-Shot paints on metal surfaces for their google-eyed art. Any color system will lend another dimension to your mad monster rowing his too-tall shifter into the twenty-first century. So, if you want to pull your crazy monster-car out of the '60s, color it gone in bright, blazing hues.

Perspective

CHAPTER THREE

This will sound crazy, but you need to figure out perspective so that you can throw it away! Yes, this is one of many fundamentals that you'll need to have a good handle on so you can violate it in most of the tortured, twisted, thrusting drawings you'll do in this genre. Yes, you read that right! You see, most every aspect of your crazy car will be distorted and out of perspective. But it is this distortion—this cheating-most-of-the-rules look—that gives your cartoons direction, thrust, movement, and interest. It's fun to try something you're not supposed to do in the real world, and in the process give life and action to whatever it is that you draw. If you don't know how to do it, you won't know how to twist it, right? You have to learn to crawl before you can walk, and so on and so forth, so stick with this.

continued on page 30

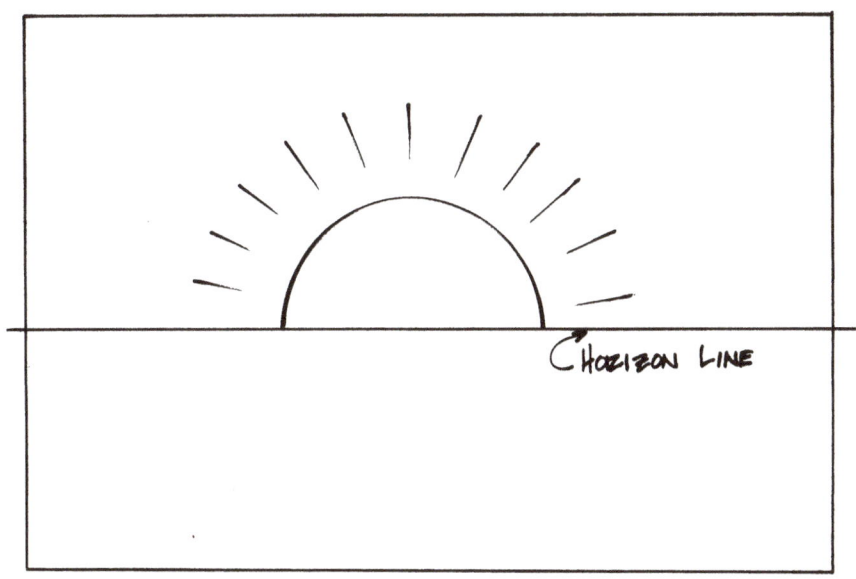

◀ When placing an as-yet-to-be-drawn object on a flat plane, the horizon line will dictate the view, or eye level, of your object. An artist represents linear perspective by pointing all lines in this imaginary space toward a vanishing point. The borders represent the limits to the space we are creating within it, and the rising sun represents the beginning of your journey to drawing cars properly.

▶ Parallel, or one-point, perspective is best illustrated by the converging train tracks. Lines aimed at that point give the object and space the illusion of being three-dimensional. The dotted lines show that convergence.

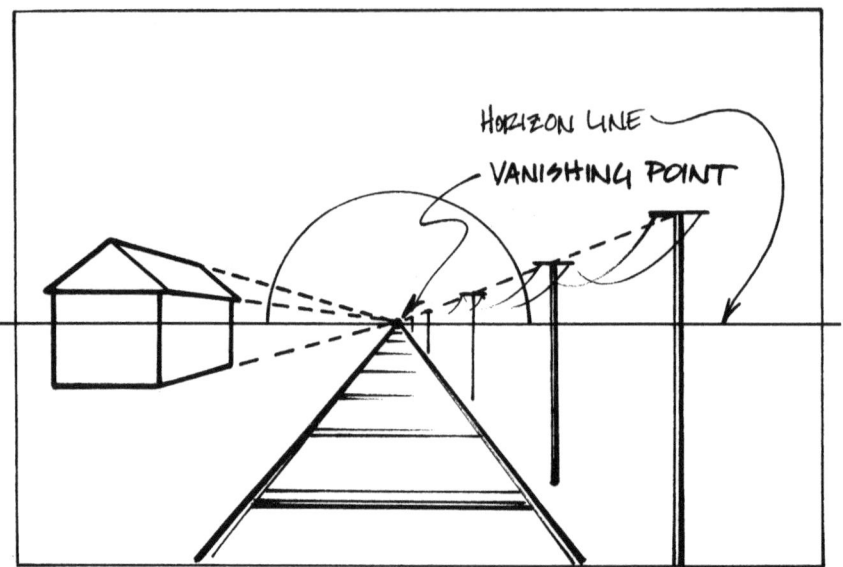

▲ Lines that vanish in two directions illustrate angular, or two-point, perspective. This is a truer simulation of reality than the one-point perspective example and is the setup for virtually all vehicle depictions. As the objects go back into our space, they foreshorten. This means they shorten up because we actually see less as their sides angle away from us.

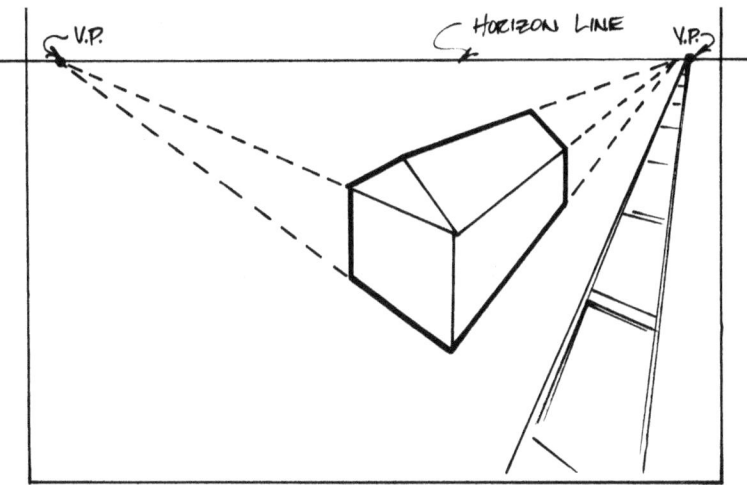

◀ Moving the horizon line to the upper portions of the space we have created yields a higher view than the previous example, which put the eye level right at the horizon line. This higher view is a good perspective to illustrate an interesting feature on the hood of the car. It also allows you to see through the windshield.

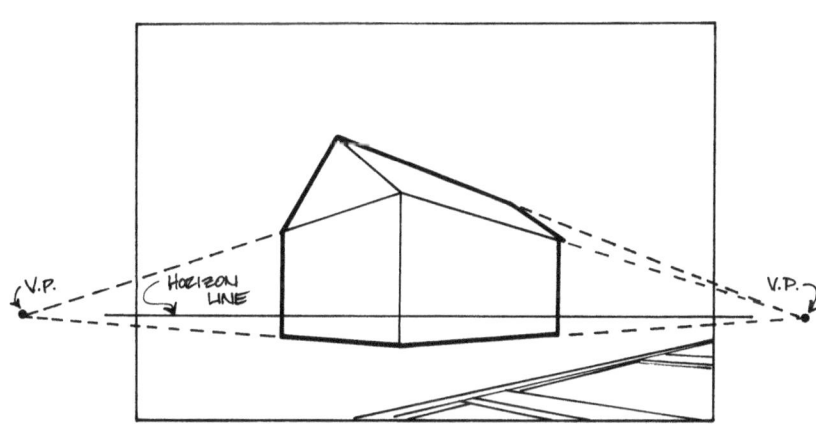

◀ A better solution to perspective may be to place the vanishing points outside the borders of our space. This gives a more realistic view of the object. You may want to practice placement of both the horizon line and vanishing points to see some of the different possible setups.

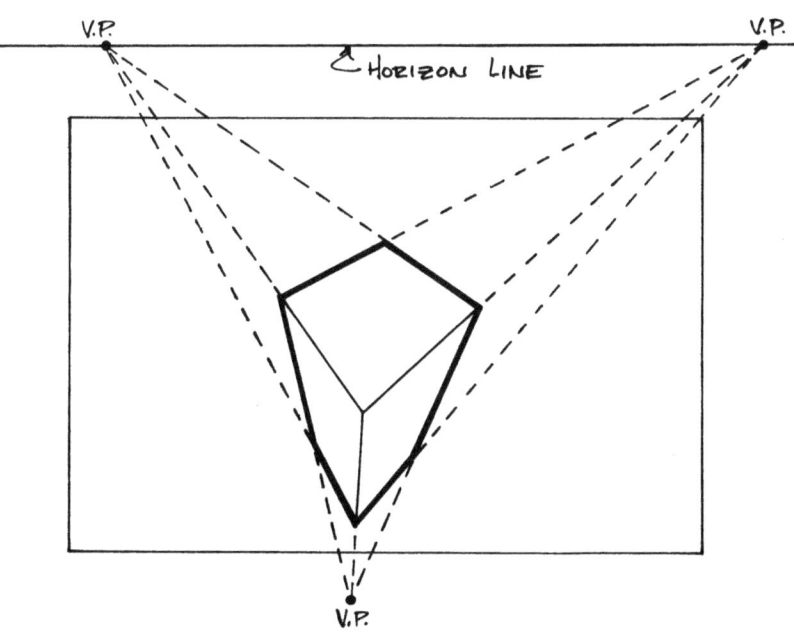

◀ Although not usually applicable to drawing cars, I thought I would at least clue you in on three-point perspective, a trick artists use when trying to give an object the sense of being very large. You see a lot of this used in comic books, where there is a lot of action and drama that needs to be conveyed within the panels of the stories.

▶ A low horizon line gives you a low, or worm's-eye, view of the object. With the vanishing points within the space we have created, the object is given a very forced and extreme look.

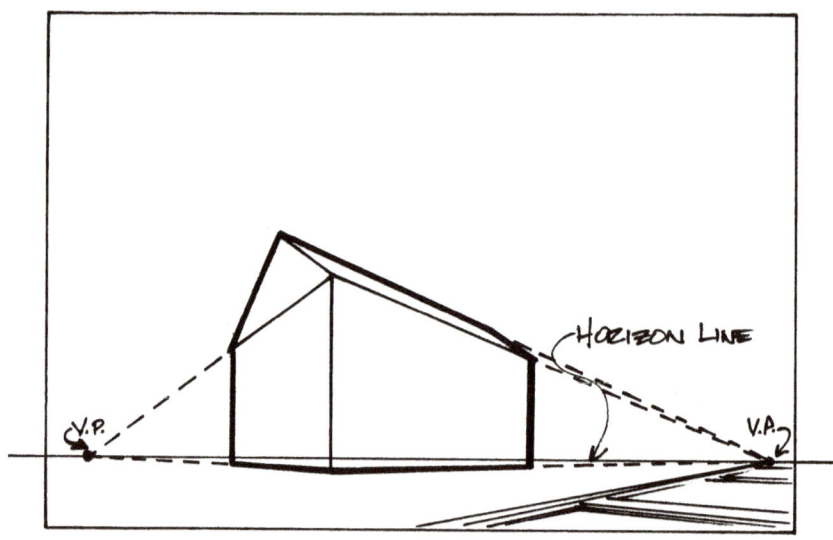

Continued from page 27

We'll supply you with basic steps to learn perspective, but the best thing to do is review this chapter and then use your eyes and brain to visualize what it is you wish to draw. You want this to be fun, but getting mired in the plotting or other methodical processes to determine perspective is boring. So try to visualize what it is you want, then refer to this chapter and apply the rules described.

First you need to make a couple of decisions. You need to select which view of your car you wish to draw. This will determine how much of the front, side, or back you should show. Usually, a "front 3/4 view" is chosen because it shows the most of the car and gives a sense of how it would look in real life. Next you must choose the viewer's angle. Do you want to look down on the car, look up at it from a worm's-eye view, or see it much as you would while walking down the street? From a high vantage point your car will look more toy-like, while from a hands-and-knees view it will look tall and menacing, but you'll also end up seeing a lot of the bottom of the car. The viewer's angle will determine the horizon line and vanishing points.

The horizon line is that point out in the distance where the sky and ground meet. Hypothetically, if it is a clear day and you're looking across an uninterrupted stretch of desert, it is the line in the distance at which the sky meets the ground. The horizon line is not too often seen in real life because it is usually obscured by buildings, trees, walls—you name it. Yet if you are to construct a good drawing

▼ The most successful compositions depict cars in all of their twisted, tortured, wheelie-popping glory. But even with all of the laws of perspective, physics, and reality being violated, there are still some rules to follow. If this green box represents the body of your car, then look at the red lines representing the wheel centerlines (which also are your minor ellipse axes). As the car twists and bends, that centerline follows the twist. But even this rule can be broken in some cases, as we shall see.

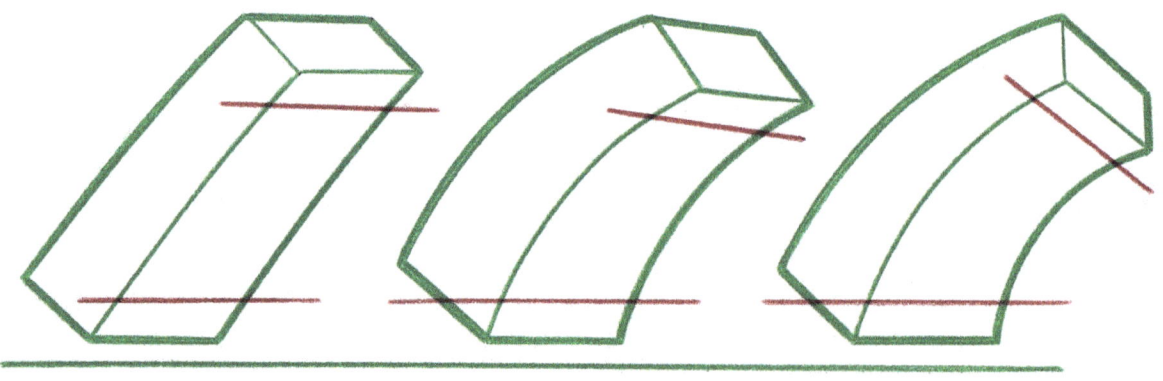

◀ Here's Finky and his scary sedan broken down into simple boxes representing the main components or objects in the drawing. With the horizon line at Finky's big feet, you would assume that the perspective lines are vanishing to it. Since the body and engine are raked, however, they go to different vanishing points than the slicks or Finky himself. See if you can determine where all of the perspective lines are. To see how this drawing fleshes out, got to pages 72–75.

you need to draw or at least visualize this line. In a typical drawing it would probably be placed somewhere around the lower half of the page, and its location will determine how the car is viewed. A low horizon line will result in a view looking up—like a worm's-eye view—and one placed high will result in a view looking down. In between will give you variations of these two extremes.

A vanishing point is where the lines from an object going back into the space you've created in your drawing come together. In a single-point perspective there is only one vanishing point. Visualize a railroad track converging into the distance and that's your perspective point. Two-point perspective is used more often, and the accompanying illustrations will help you better understand it and how it relates to cars and monsters.

Objects in perspective lose detail and value as they go back into the atmosphere of the imaginary space you have created. Atmosphere softens the details and lightens the values. To visually pull an object toward you, adding more detail and value are two of several things you can do to trick the eye. This works in your favor, as it becomes unnecessary to put as much effort into the details of an object farther back in perspective.

Value is the lightness and darkness an object exhibits, either in color or in black and white. Pastel colors, yellow, and white have light values. Orange and most reds, greens, and blues fall into the medium-value category. Purple and the darker blues, reds, greens, browns, and especially black all exhibit dark values.

When combining a furry freak with your hairy hot rod, the two need to tie together in a way that gives a natural movement and/or thrust to the drawing—and they both must be in the same perspective, even if they are going toward different vanishing points. Yes, I know this is confusing! It's easier to show you than to discuss, so look at the examples for a quick lesson in perspective.

Later on we'll show you how to distort perspective to bend, twist, and otherwise strangle cars and monsters to liven them up. So learn this and you can have some fun later in the book.

▶ I wanted this drawing to mimic the twisted, raging Ed Newton style of cartoon, so I first did a rough sketch to establish basic shapes, perspective, and placement of elements of the Fiat altered gone mad! Notice that I played around with the placement of the front wheels and axle.

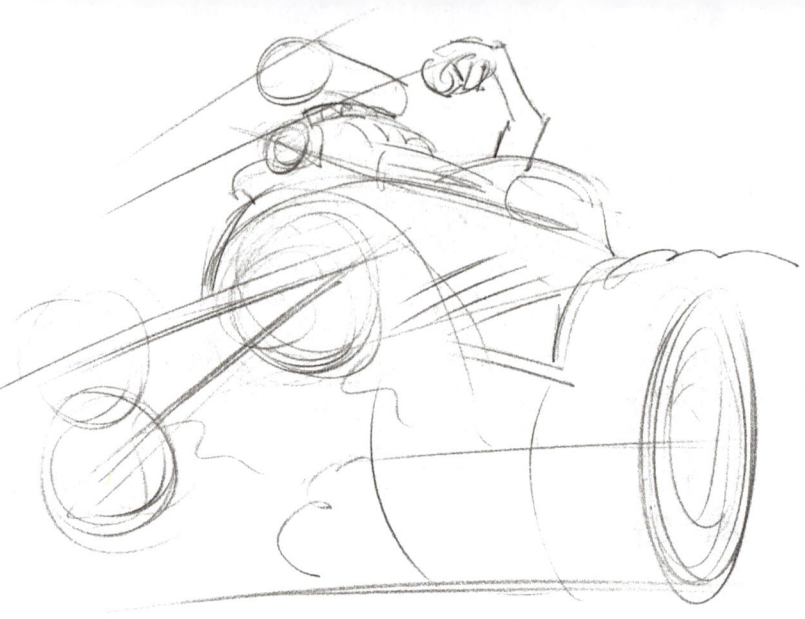

▲ Unlike Newt, I need to go through a series of preliminary sketches to get to where I'm going. This one hones in the lines and details, but as you can see I'm still playing around with the placement of the rear slick. I wouldn't have to do this if were following perspective protocol, but because I'm trying to put some action and movement into the sketch, I toy with placing the tire on either side of the minor axis to give the effect of either rearing back to launch or spinning forward. I'm trying to force as much kinetic energy into the drawing as possible.

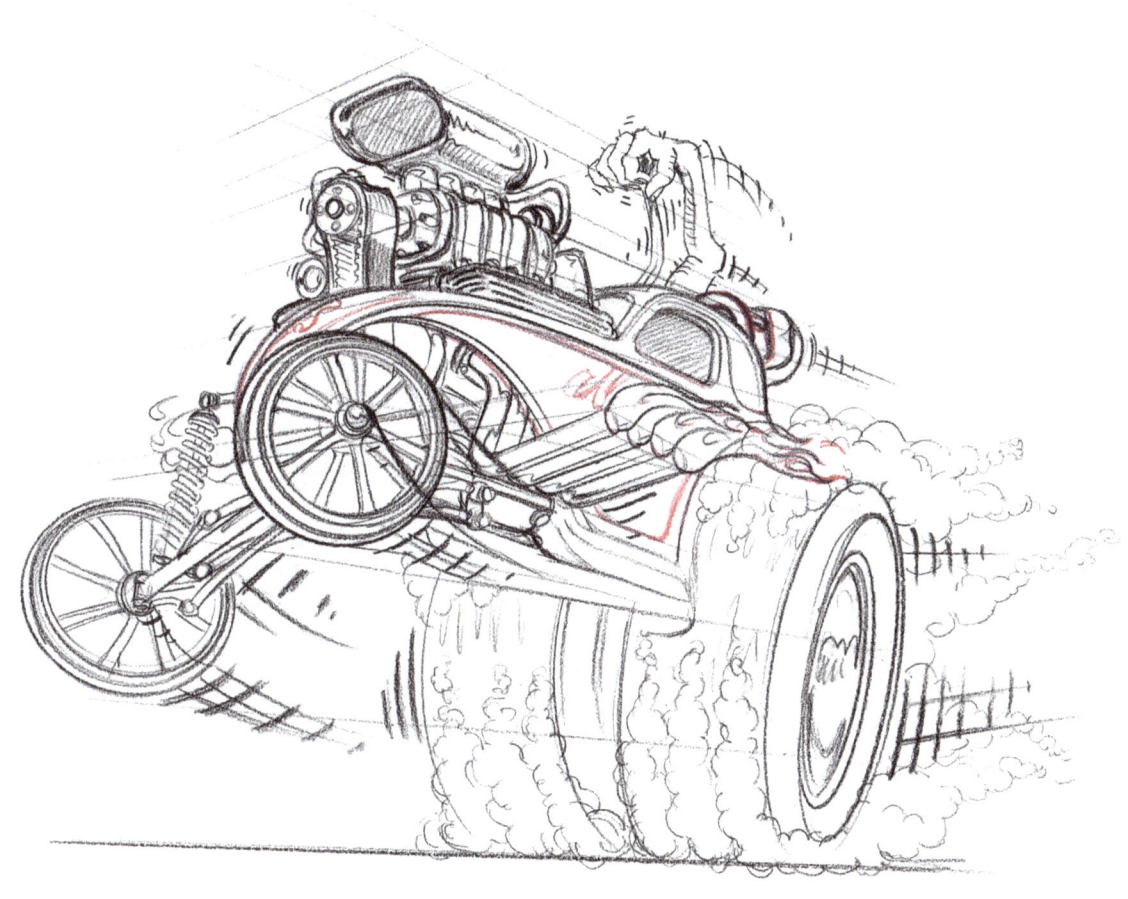

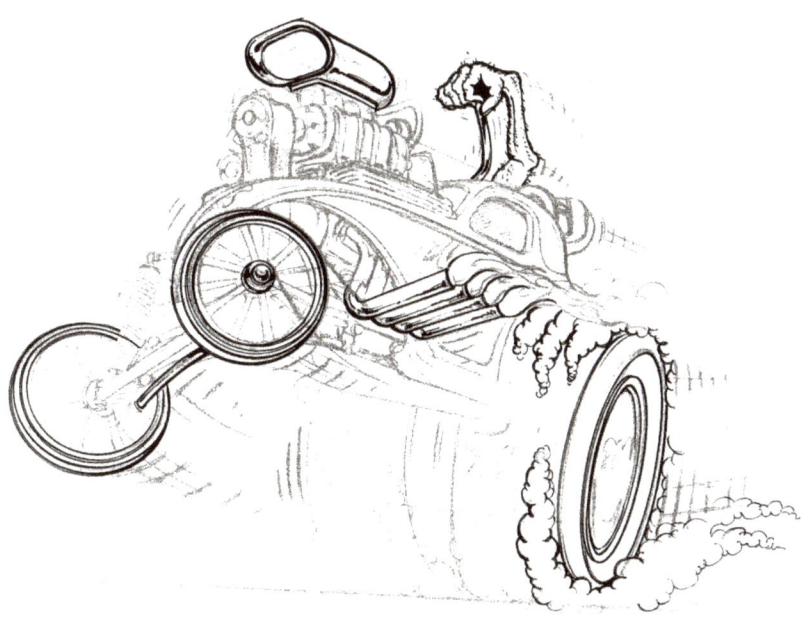

▲ Notice that I draw perspective guidelines to make sure I get the engine and blower in perspective. Because they hang so far away from the rest of the car, it's easy to place them in the wrong perspective. Also, I've decided to spin the slick back from the minor axis to give the impression that the car has just popped a wheelie and is ready to launch forward—sort of like a tiger ready to spring onto its prey. This will be my underlay for the final drawing.

◀ To start, I wanted to draw in the very most outside elements to frame the area I will work within. I'm getting a little ahead of myself by drawing some reflections and emphasized lines.

▶ Here, I want to establish other critical lines, including the outside edges of the body. Since things are placed all around this key component, it will help with placement of everything else. To this point, the drawing consists of lines and elements that will help me stay in perspective and help with component placement.

▼ I continue to fill in the spaces within the car. It's almost done, with just some finishing to the engine, putting in the other slick, and filling in some of the rest of the car.

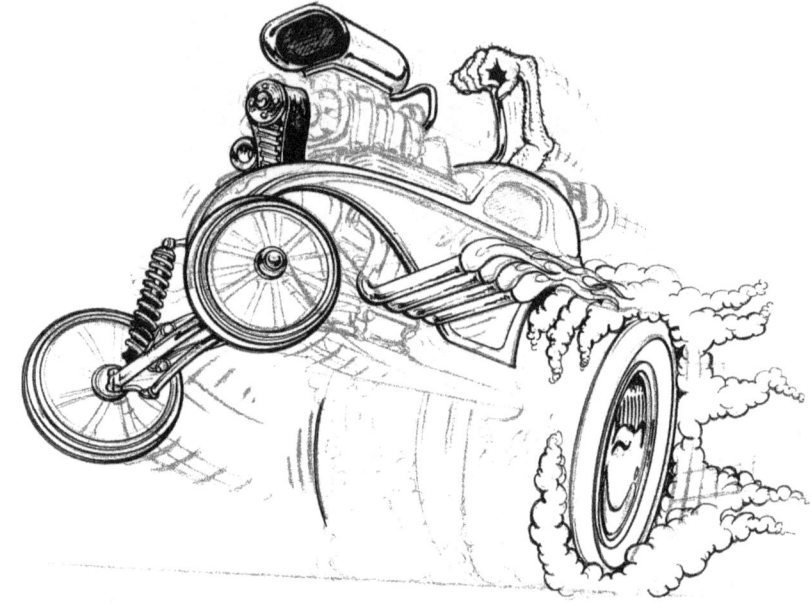

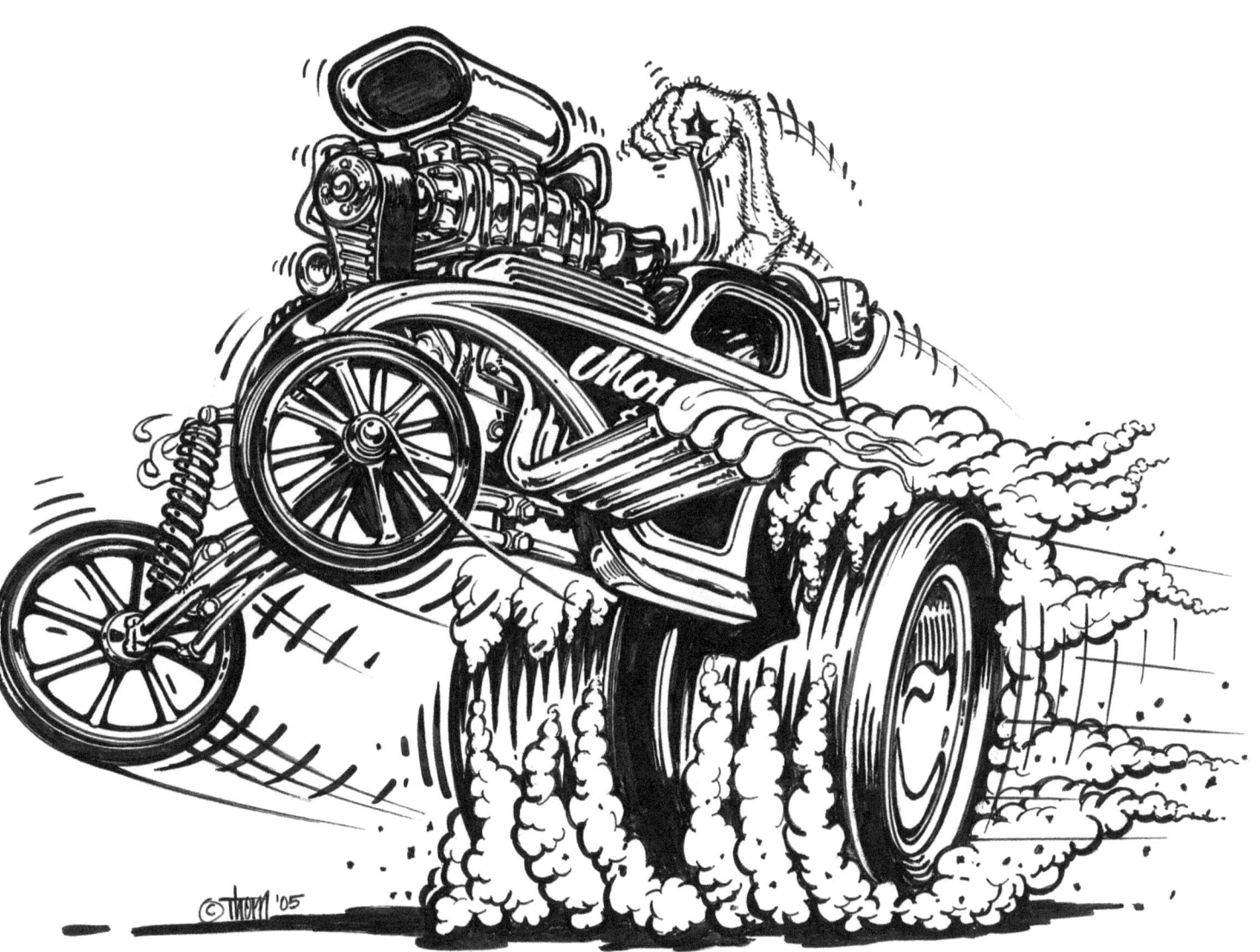

▲ Once your drawing is done you may want to stick it up on the wall and glance at it every so often to see if you can find areas that need to be cleaned up, emphasized, or added to. I had to come back in with white gouache to clean up the front spring, the M and O on the side of the body, and a couple of other places. With that completed, I'm done with this rather frenetic Mondello and Matsubara Fuel Altered from the late 1960s.

▶ This cool painting by Keith Weesner is a perfect example of one-point perspective. That one point is right in the middle of the horizon line, which is right at the water's edge behind the girl. These may not be mad monsters, but Keith does exaggerate (he tends to shorten up the cars) and the people depicted are a larger scale compared to the hot rods. And Keith tends to exaggerate his people—all of this cheating to great effect.

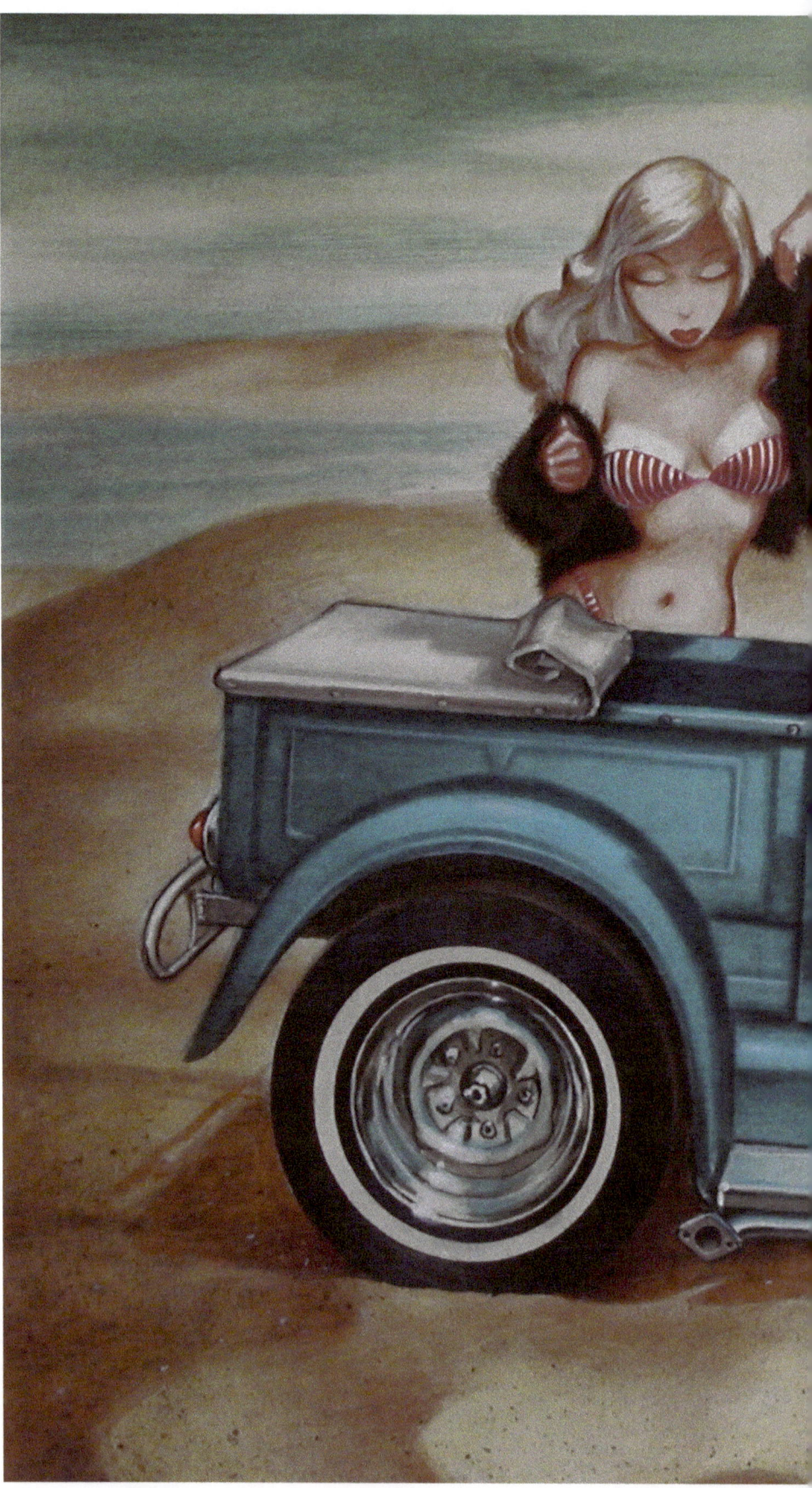

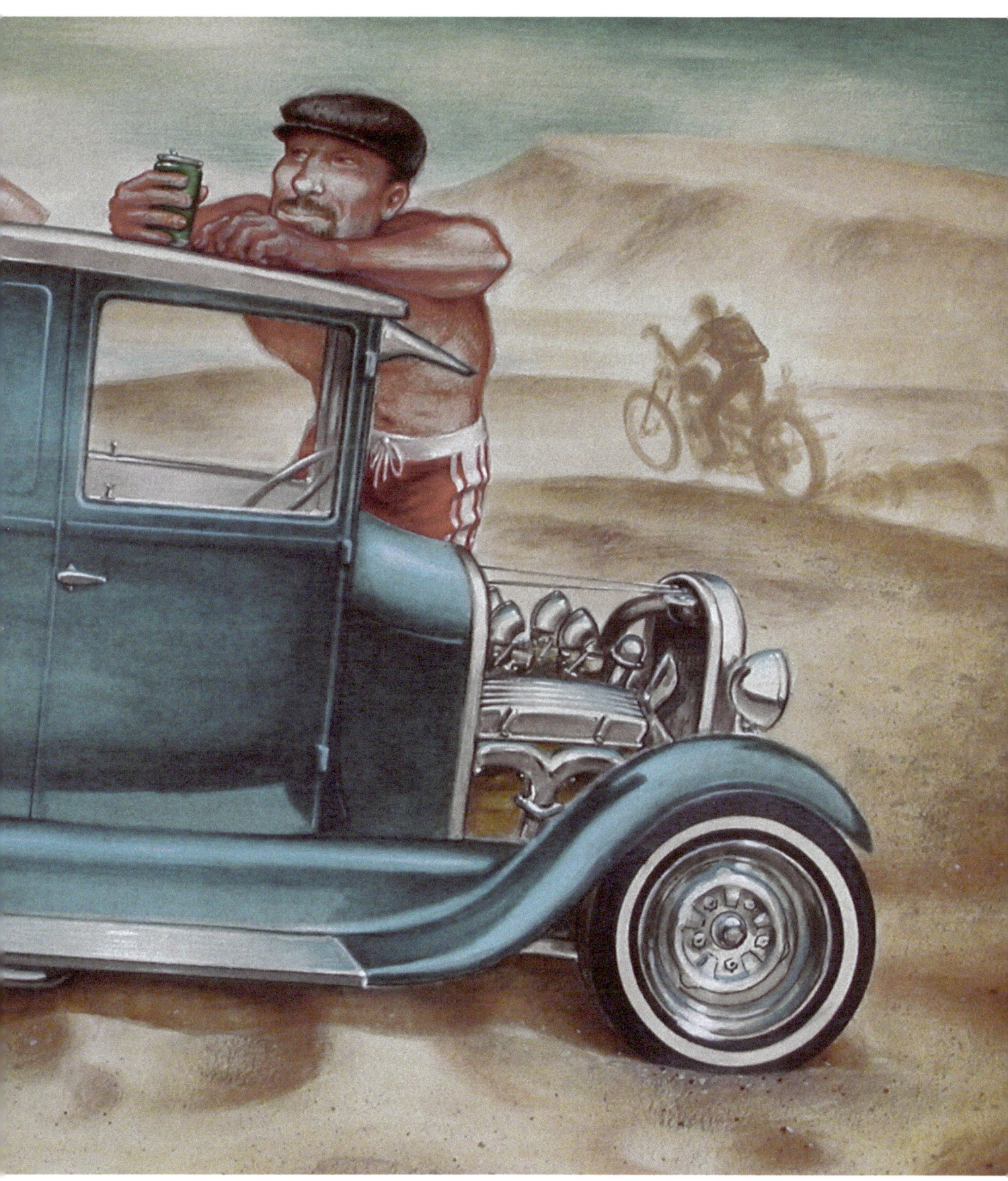

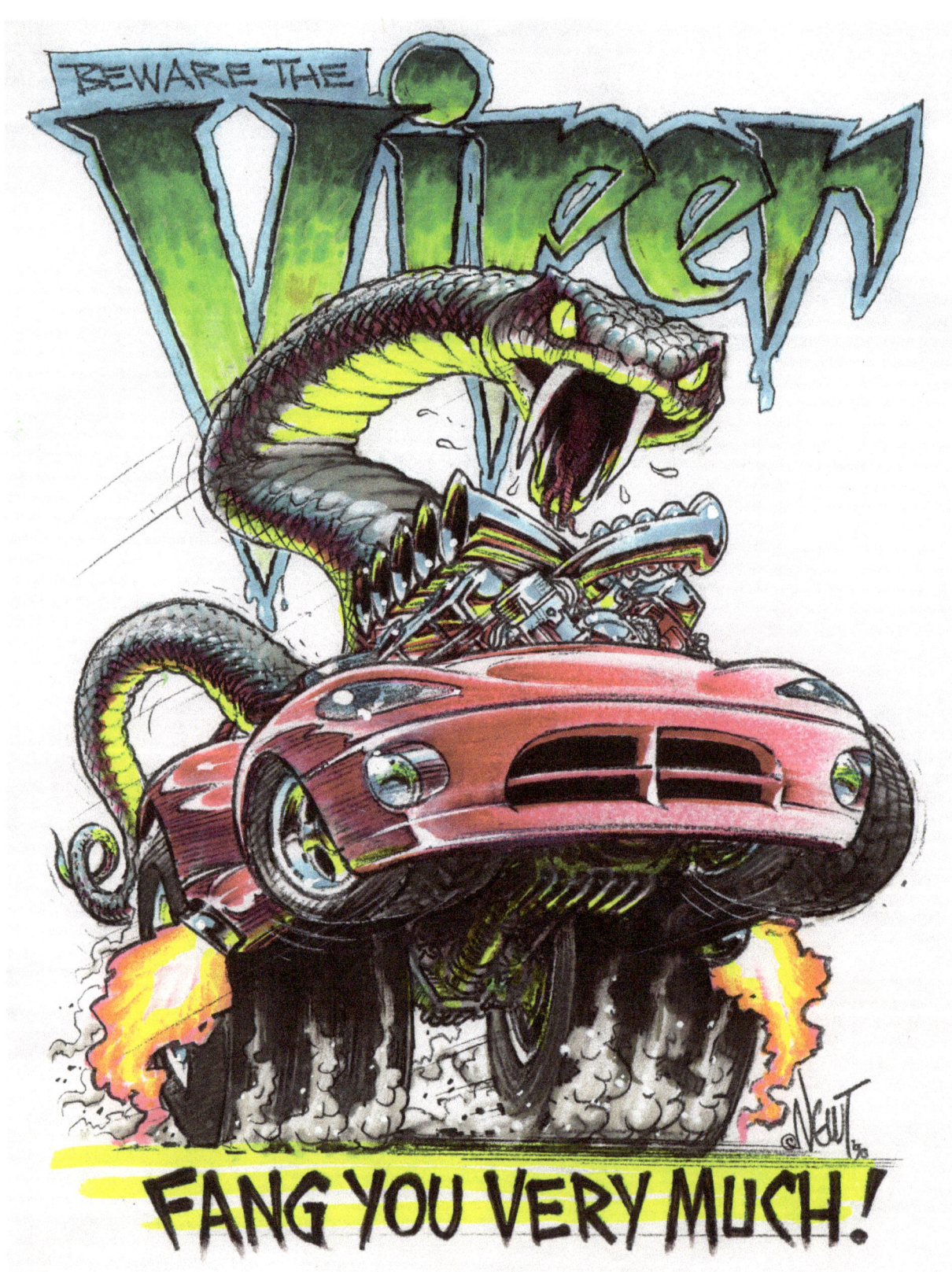

▲ With the horizon line going through the middle of the slicks, the body of the Viper is above it, directing all perspective lines that create the car, engine, and snake down to the horizon. This places the viewer low, which makes the car and snake seem more menacing. It is one of Newt's quick marker sketches.

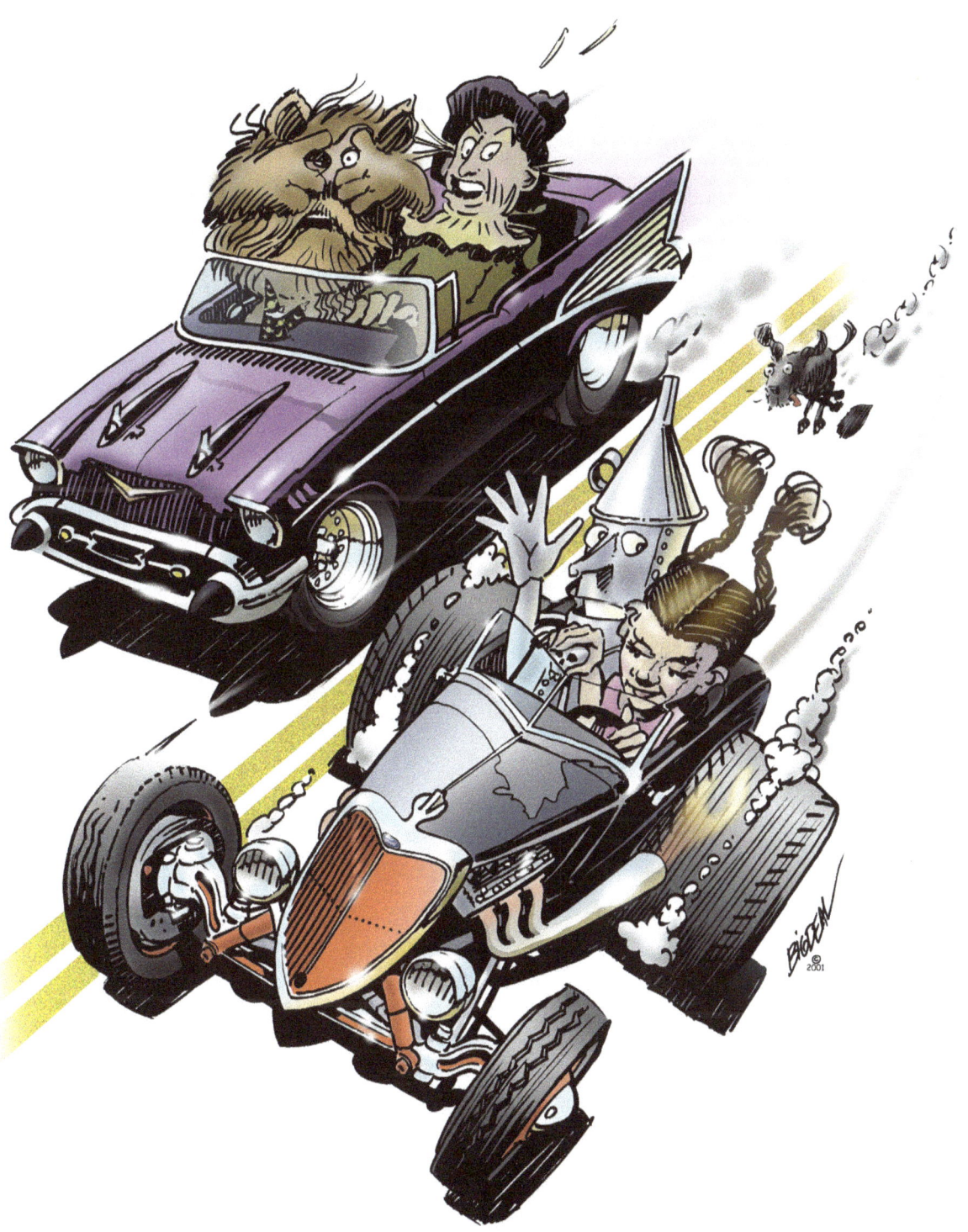

▲ This Dave Deal sketch offers a great perspective because it allows the viewer to look down on the action. It also gives you lots of leeway in forcing some action into your drawing. Notice that placement of the cars in slightly different perspectives defines the arch in the pavement. The perspective lines of Dorothy's roadster go to a higher vanishing point, which gives the crowned pavement illusion. Also notice that the passenger front wheel on the roadster is out of perspective relative to the rest of the drawing. Why? Well, to me it adds an ambling, bouncing action to the car, giving the eye an additional detail that tells your brain there is a lot of movement. And besides the speed lines and smoke trailing off of the tires, look at old Toto galloping to keep up. This is one more detail that tells you these Oz-bound characters are haulin'.

▶ The yellow and blue roadster's perspective lines in this C. Cruz illustration are going to different vanishing points than those of the purple roadster, yet all three appear on the same plane. Why? Because even though the perspective lines are going to different points on the horizon line, all three cars have a common horizon line. As the cars go progressively farther back toward the horizon line, more of the side of the car faces the viewer, and less of the top surfaces are in view.

▼ The dramatic perspective for this Newt design results from the low horizon line and the tricky use of vanishing points. One vanishing point is shared by all three cars, but the other vanishing point is unique to each. This happens because Ed wanted to force the perspective—almost like a fisheye lens—and also because the red car is farther back than the white car, which is farther back than the blue car in the perspective space. This makes for a very forced setup. You may want to put some tracing paper over this and draw the perspective lines yourself.

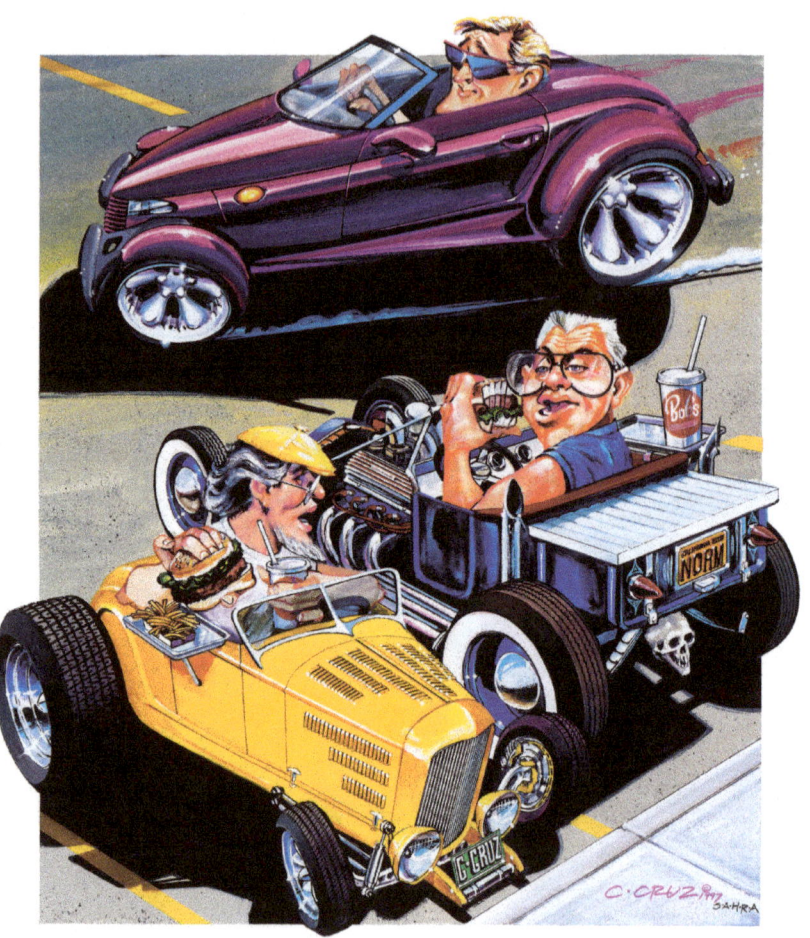

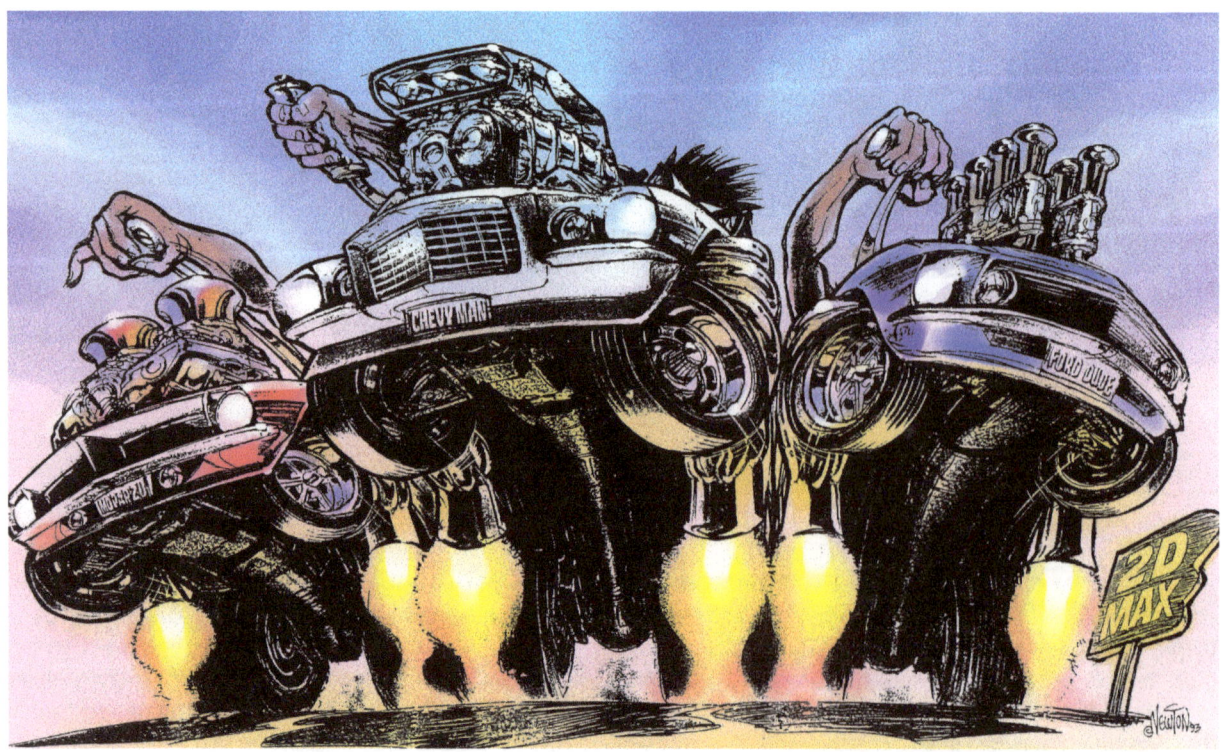

▲ This C. Cruz sketch uses one-point perspective. The vanishing point is approximately at the driver's left shoulder. Though the perspective is simple, the view shows you a lot of the car and figure. What more could the viewer want?

▶ Combining all of the elements to create this composition took C. Cruz some figuring. The coupe, trailer, and each package are all drawn in a different perspective—if you could see them, there would be vanishing points all over his drawing board! But when combined, the twisting effect of the coupe and trailer give the drawing a sense of floating through air. Drawing the packages in different perspective give them a randomness that would be the case in real life because there would be no sequence of movement like a link on a chain. All of this creates a lot of movement and lightness throughout the composition.

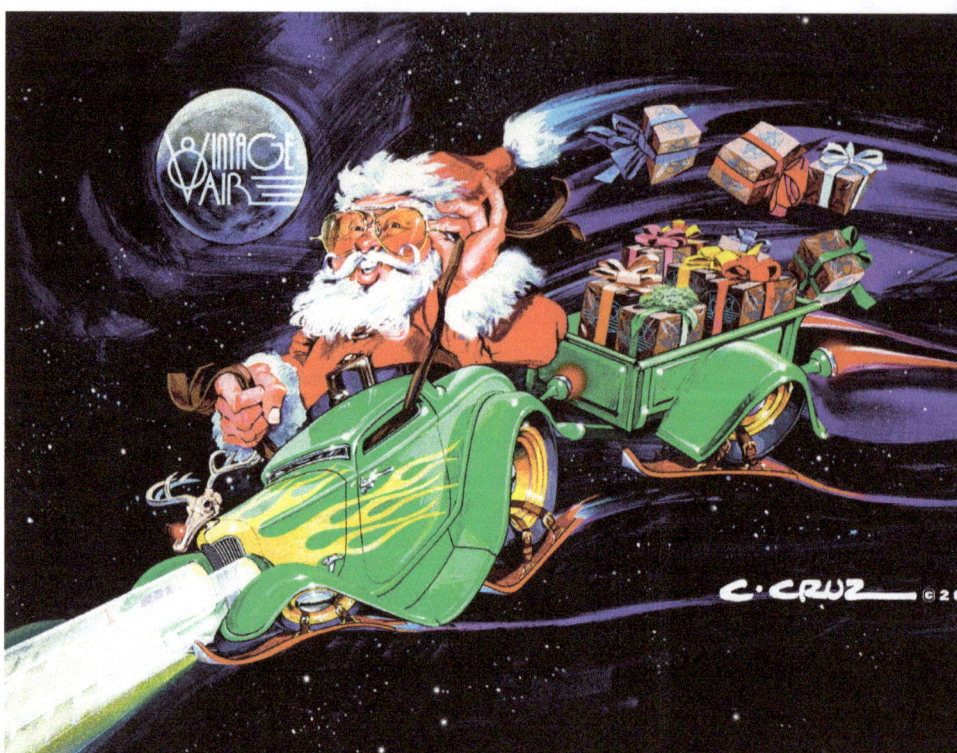

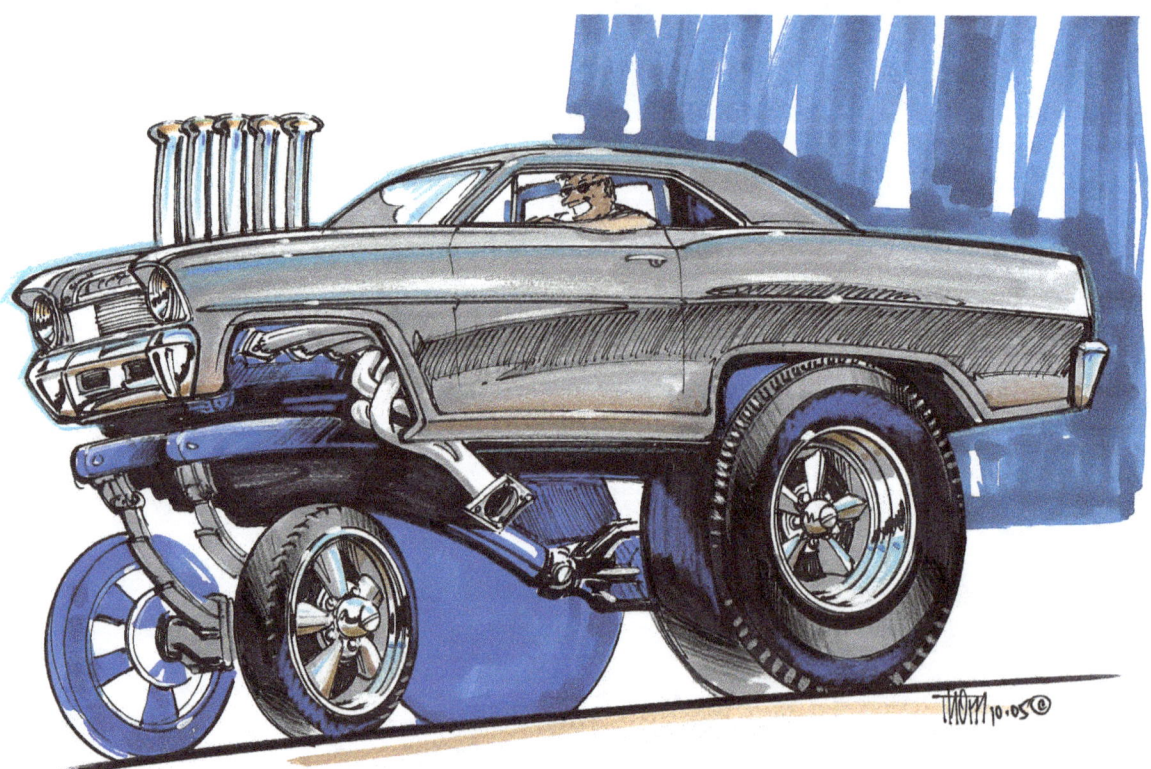

▲ An example of two-point perspective where the vanishing points are so far out from the paper that you almost don't need to have convergence. This can be the easiest way to start tackling perspective, but you'll still need to jump in with both hands at some point, so don't rely on this setup exclusively.

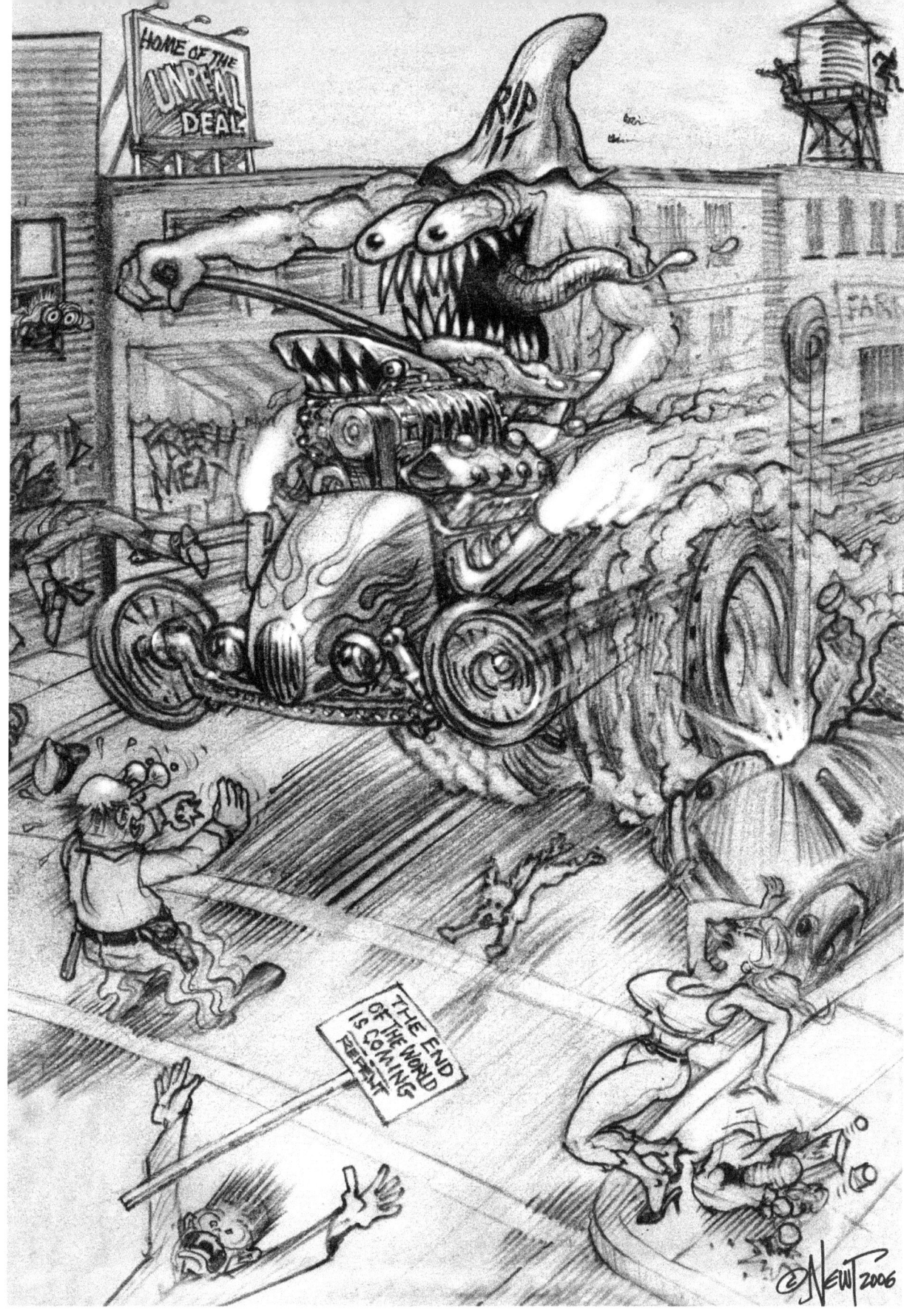

▲ Newt calls this work Invasion of the Killer Monster-Cars. It is included to illustrate that when you plan your perspective and layout, you should keep in mind that you want the viewer to see everything that is going on. Because there is more foreground, this view clearly shows the people and objects in front of the car and the monster. The depth of field is longer because Newt put his horizon line in the upper part of the page.

CHAPTER FOUR

Proportion

Maybe you have heard the word "proportion" bandied about when people discuss cars and have wondered just what it meant. Proportion refers to the relationship the car's visual elements have with one another. We're talking about the size of the windows and how they relate to the car's body, the size and height of the top compared to the body, the overhangs or length of the body relative to everything else, and so on. The result of these visual relationships can give the car a more realistic look, or more of a cartoonish proportion, depending on what you're after. These considerations can be very subjective, which is why you see so many different-looking cartoons depicting different types of cars or trucks. This is also the reason why we see so many variations in design.

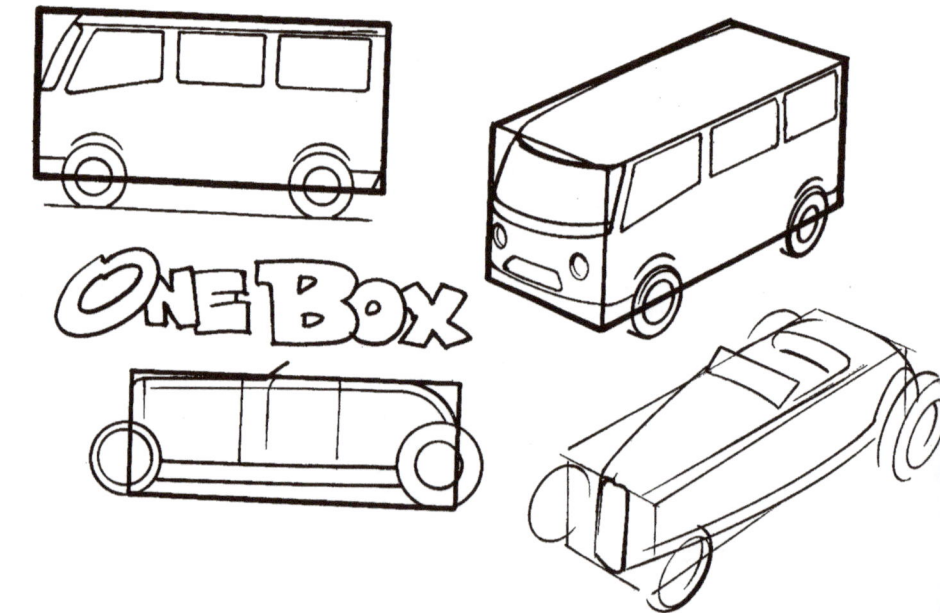

▶ The building blocks of proportion are simple one-, two-, and three-box groups. Keeping these in mind should aid you in visualizing a car's proportions and serve as loose guidelines on paper. Included in one-box proportions are vans and even 1930s roadsters and tourings.

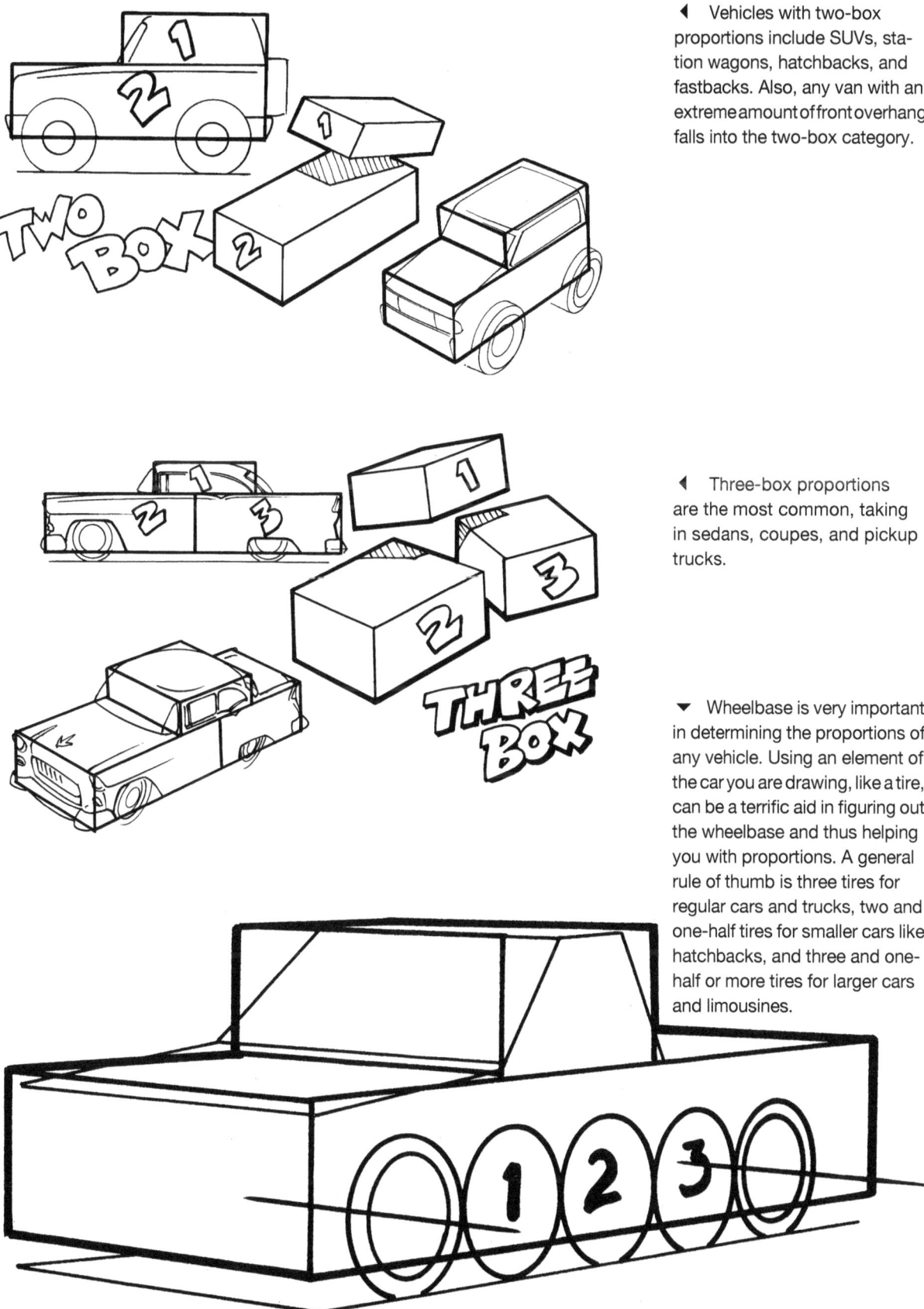

◀ Vehicles with two-box proportions include SUVs, station wagons, hatchbacks, and fastbacks. Also, any van with an extreme amount of front overhang falls into the two-box category.

◀ Three-box proportions are the most common, taking in sedans, coupes, and pickup trucks.

▼ Wheelbase is very important in determining the proportions of any vehicle. Using an element of the car you are drawing, like a tire, can be a terrific aid in figuring out the wheelbase and thus helping you with proportions. A general rule of thumb is three tires for regular cars and trucks, two and one-half tires for smaller cars like hatchbacks, and three and one-half or more tires for larger cars and limousines.

▶ To better show the difference proportion has on a drawing, I've sketched three Scion "breadboxes" with very different proportions. This first sketch is very vertical, implying the car is high and boxy, a suggestion further exaggerated by the size and location of the tires. Fun, goofy, and very different from the others, but still a cool drawing.

▶ Again, very narrow and boxy, but this time with an exaggerated ride height and tire/wheel combo. There are a lot of these running around my area, fairly stock-looking but slammed, and this represents an amplification of that look.

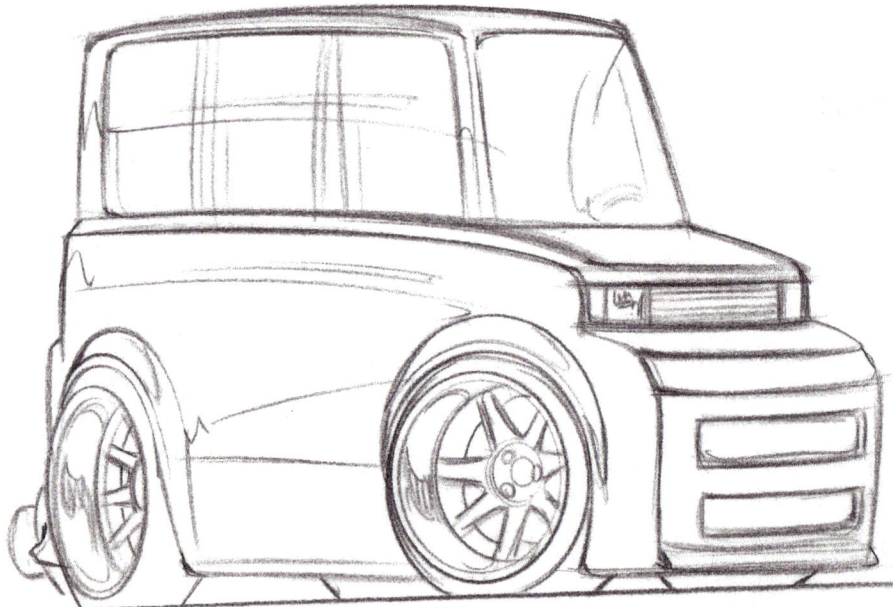

▲ Taking still another approach to proportion, this sketch represents a wide, low, ground-hugging Scion box. The short upper combined with the tall body and low stance with very wide fender flairs magnify the low-and-wide look I was trying to convey. These were all just quick, fun sketches—exactly the kind of drawings I like to do!

The accompanying illustrations show you variations on car proportions and how they relate. There is an infinite number of ways to treat an object like a cartoon car or a monster driver. If it looks like what you have in your brain and how you wanted it conveyed, then it is correct. In other words, nothing is really incorrect in the cartoon world. Tires can be too large or too small, the person driving can be miniature or so big they stick out of the top of the car—anything is fair game. Experiment and try different combinations to see what works best for you.

Sometimes it is good to use an element of the car to figure out its proportion. I recently had a job where the client wanted some toy cars drawn with different wheelbases (the distance between the centerlines of the front and rear wheels) to see different cartoon proportions. They asked me to base the wheelbases on tire diameter—in other words they requested a one-, two-, and three-tire distance. They were using an element of the car to determine each variation they wanted to see. You can use the same strategy to get your cartoon into perspective. You can change the proportions of the car based on tire dimensions in a side view, then spin the car into perspective and use those tire distances to determine the length of the car in that perspective space. Don't forget that those tires will get progressively smaller as they go farther back into the space you have created in your drawing. In the following chapter we'll look at ellipses, which are what we use to create round objects in perspective. Then we'll combine your knowledge of proportion together with the information on ellipses to start drawing in perspective.

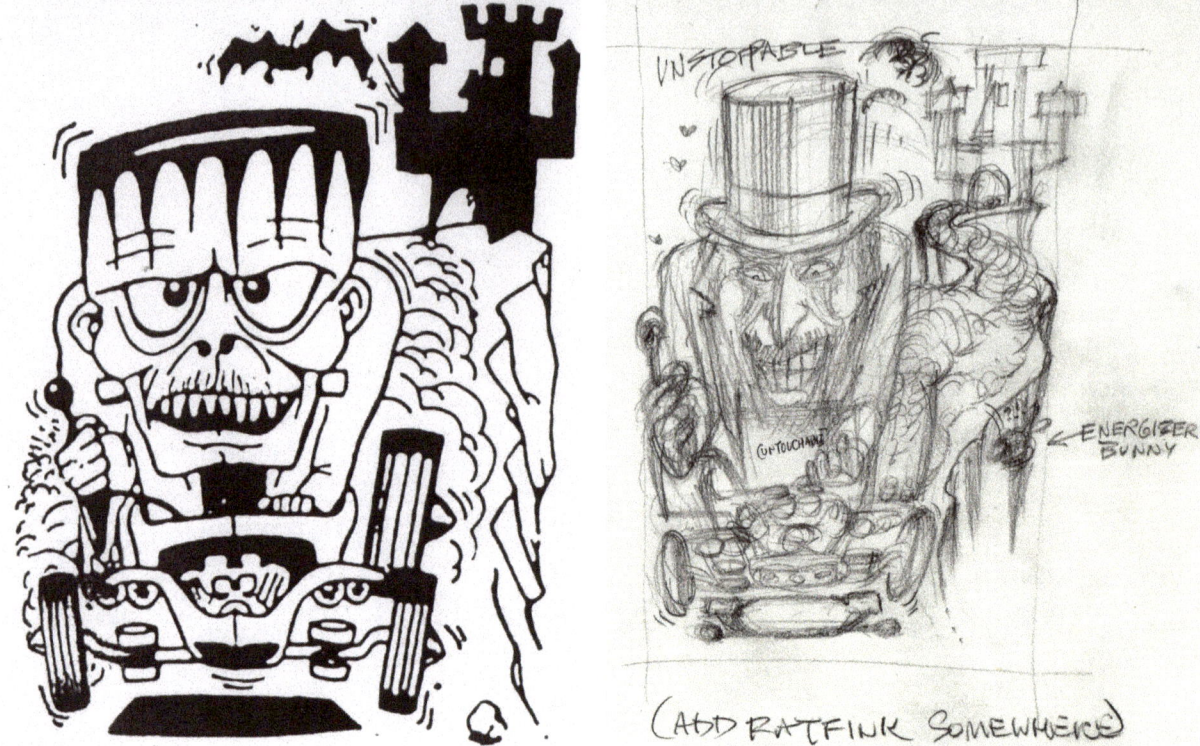

▶ Newt wanted to do a tribute to Big Daddy by replacing Roth for Frankenstein in Roth's favorite shirt design (top left). The proportions of the car are greatly reduced and stretched out horizontally, while the proportion of Big Daddy is tall and oversize. Together, these two subjects dominate the picture, with the road, castle, and rat/bat secondary—as they should be.

Newt speculates that the reason the "Frankie Outlaw" shirt was Roth's favorite was because Roth actually drew the design. Versions of this design can be seen in the earliest "Roth Weirdo Pad" advertisements.

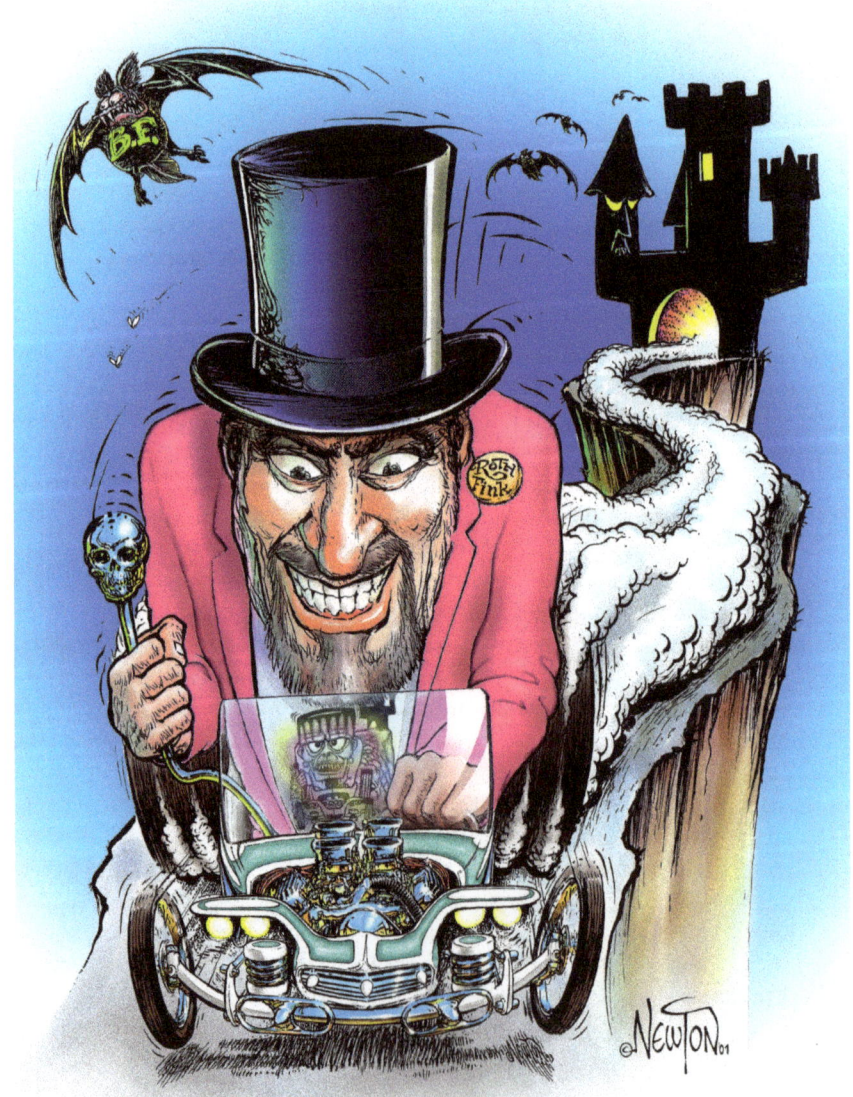

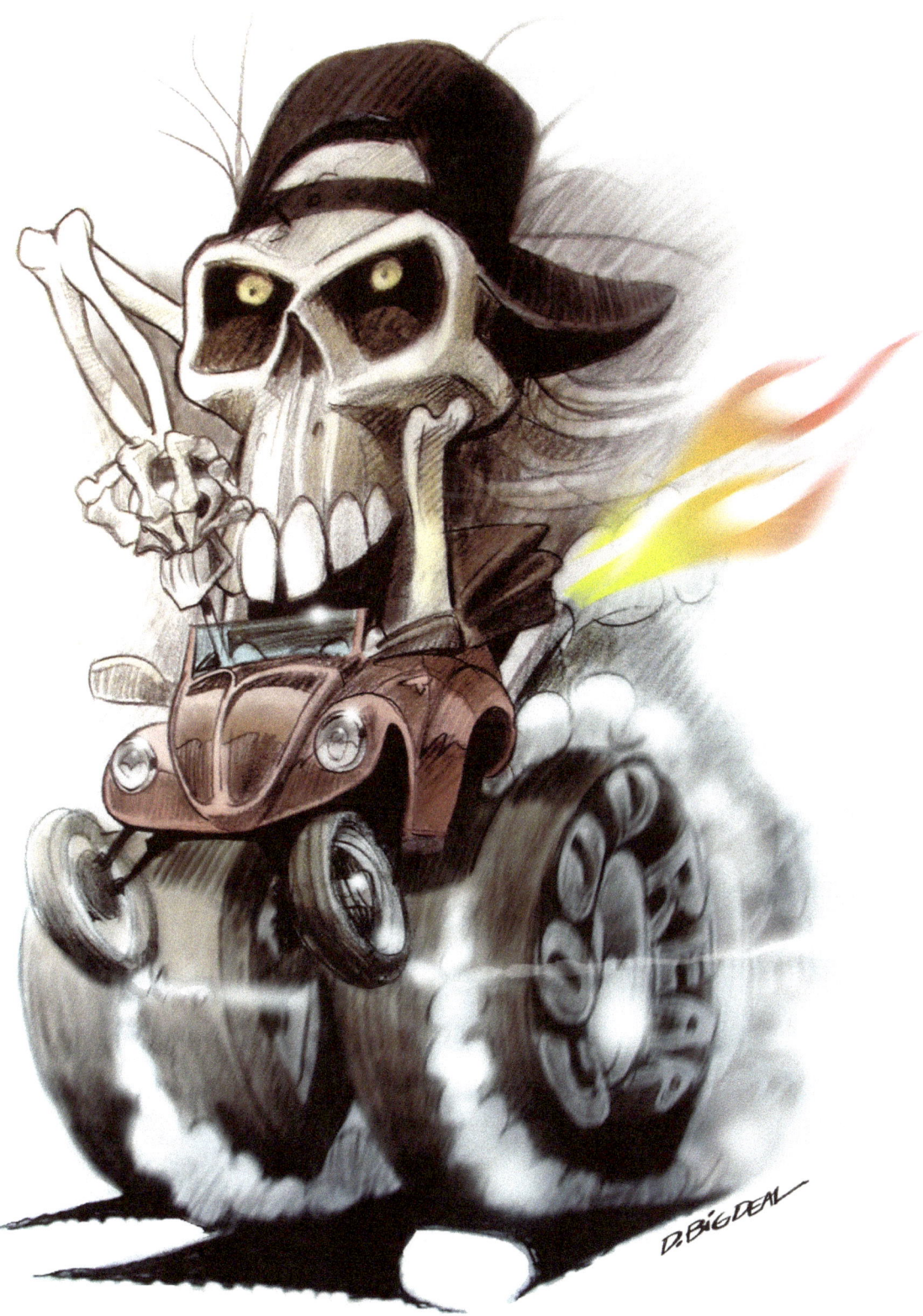

▲ Note that almost every element of this Dave Deal sketch is exaggerated in some way—either too large or too small relative to the other elements in the sketch. The vertical composition gives you an idea of how a very vertical drawing is set up with an almost dead front view, tall skull driver, and very tall rear tires. This started out as a pencil sketch that Dave scanned into his Mac and colored in. Both the smoke and highlights are white blown into the compressed layers as the final step.

▶ To me, this has the classic C. Cruz proportion for the truck (and perspective for the high view looking down). Cruz is also known for drawing extremely small front tires that are sometimes turned or twisted out of perspective—which he does for effect. This image was done entirely on his Mac.

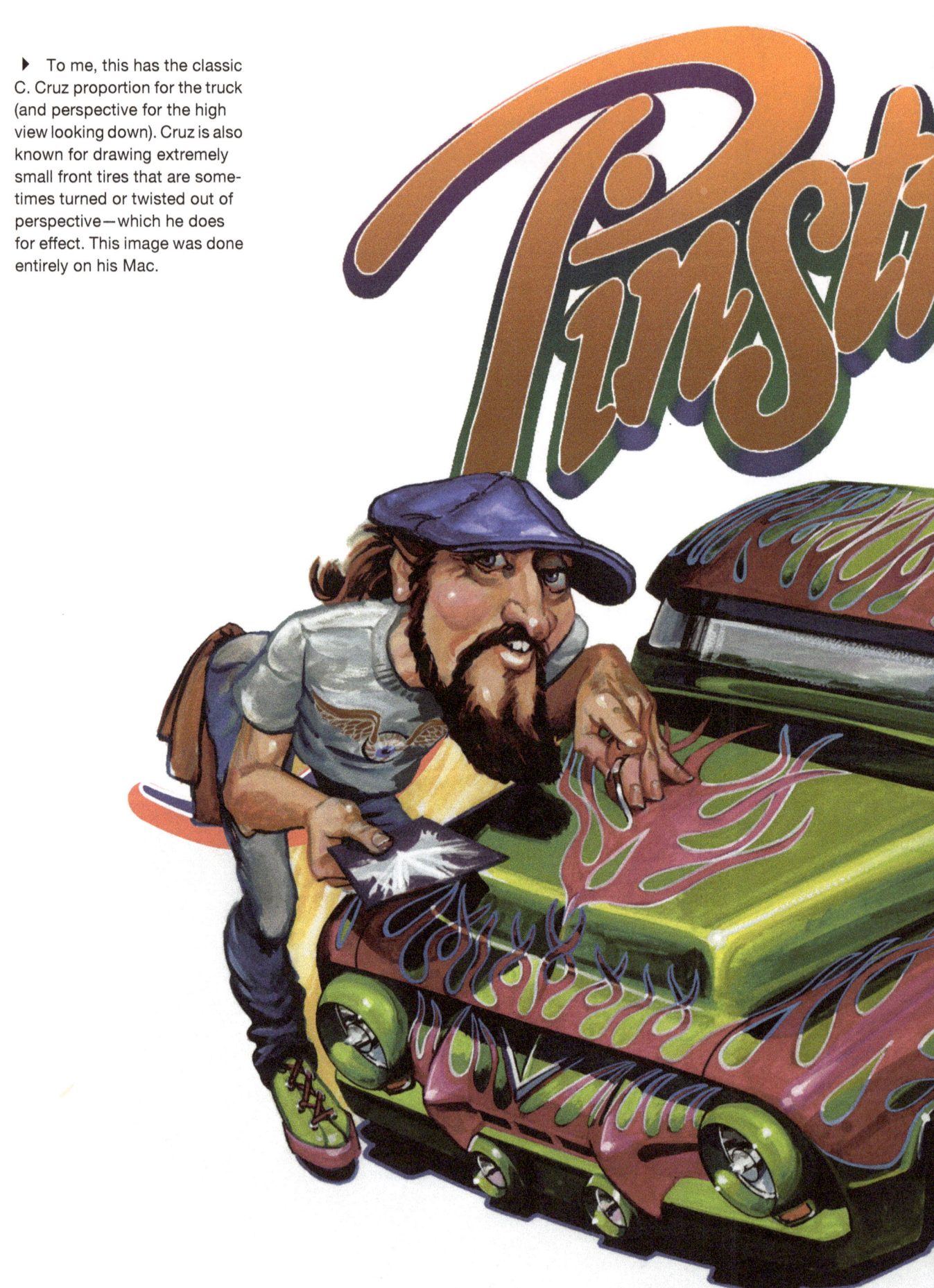

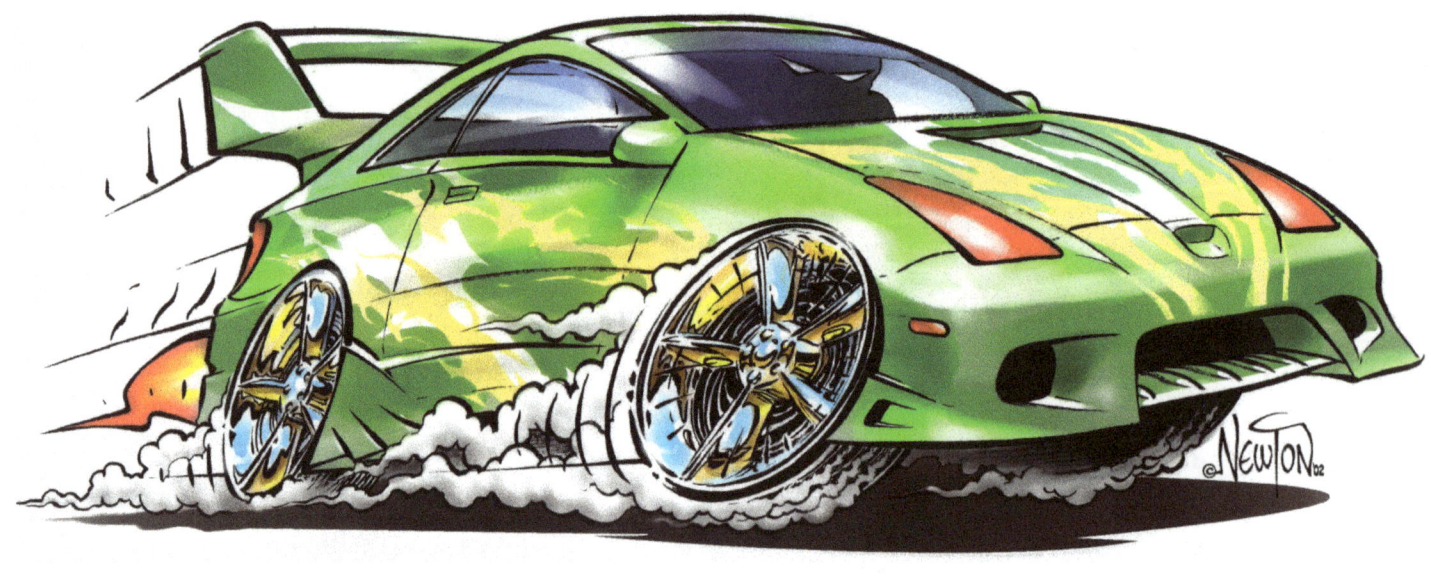

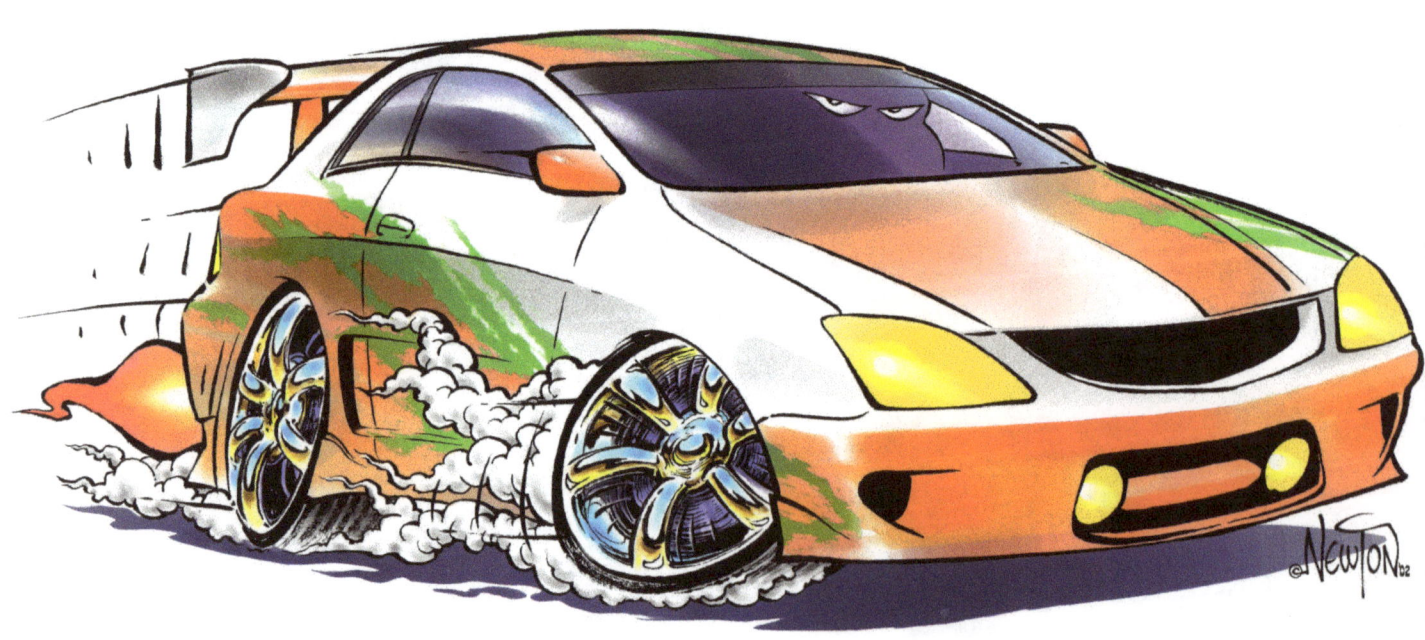

▲ Here, Ed applied that "old school" style of his earlier work to modern tuner cars. They can't do wheel stands because they're front-wheel drive, so Newt changed the proportions of each car to make them seem under extreme torque steer and cornering pressures. Says Newt: "They must show velocity, power, and motion by utilizing other artistic tricks and graphic suggestions."

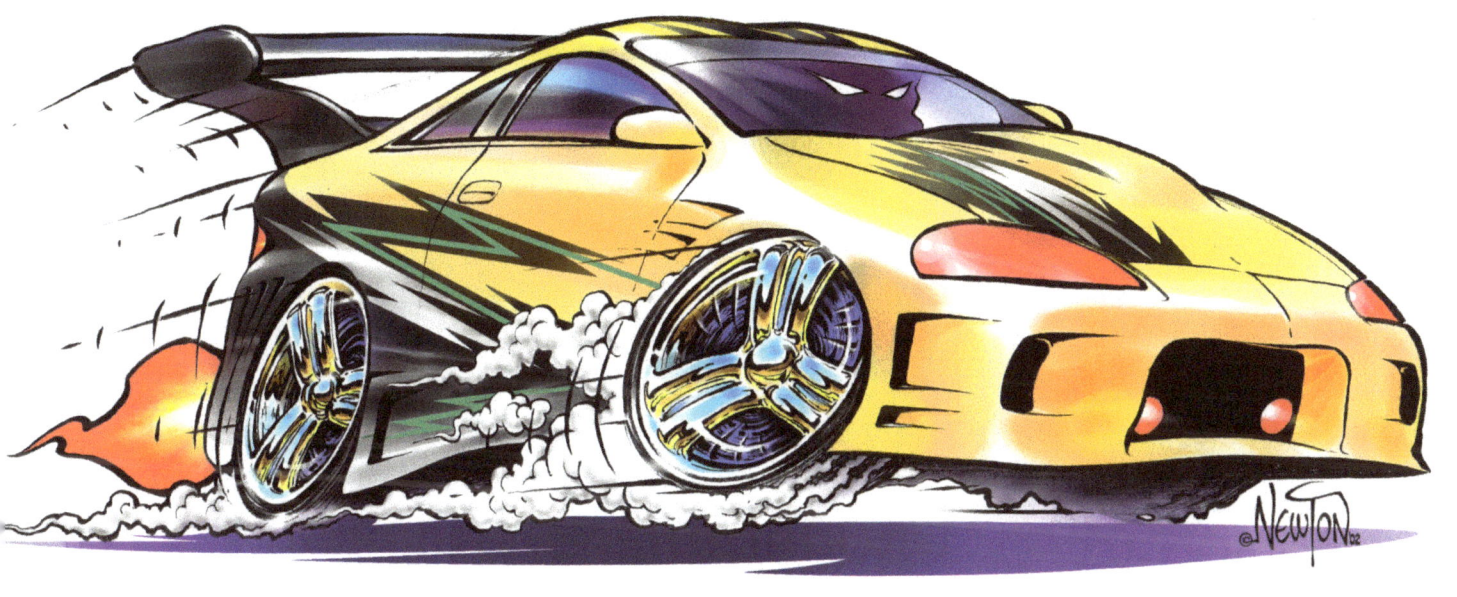
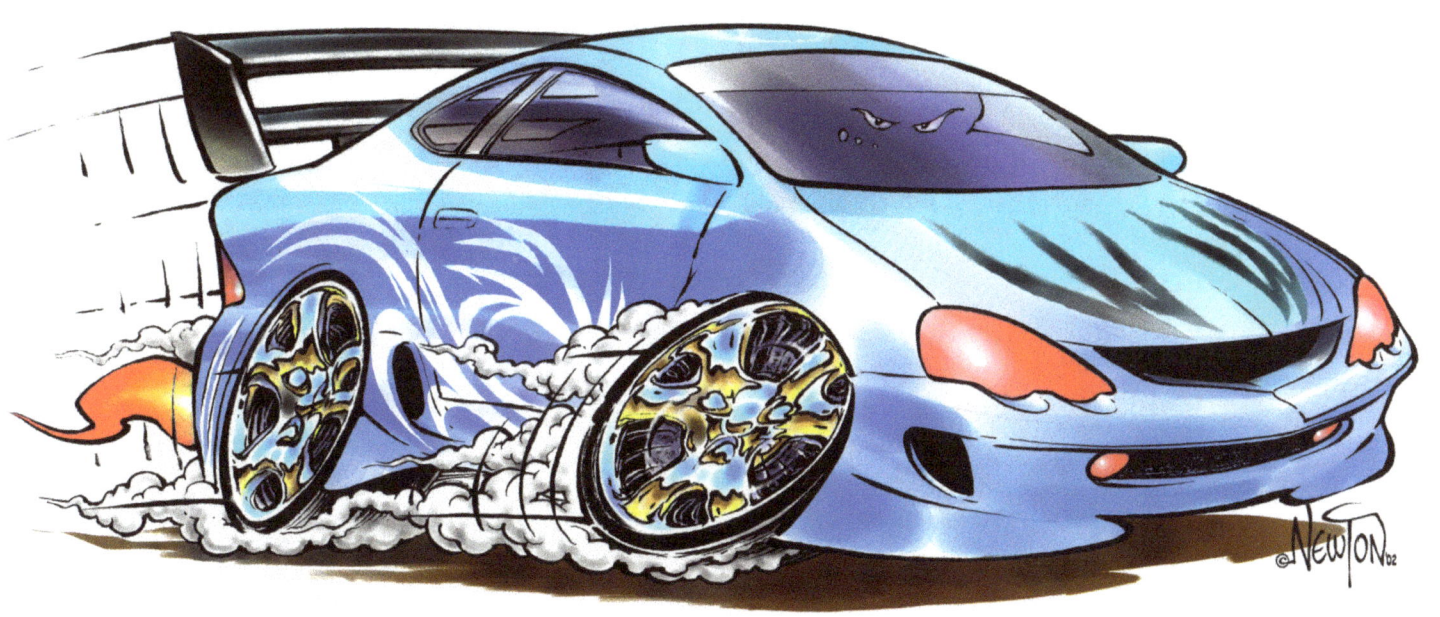

▼ This is in many ways like the third Scion sketch (page 47) where the lowness and width are played up. Look at the relationship of the side window to the body—its very squat top sits on a very tall body. Combine this with the lowness of the car and you have a very flattened-out proportion. How many other ways could this Eclipse have been handled? How about millions!

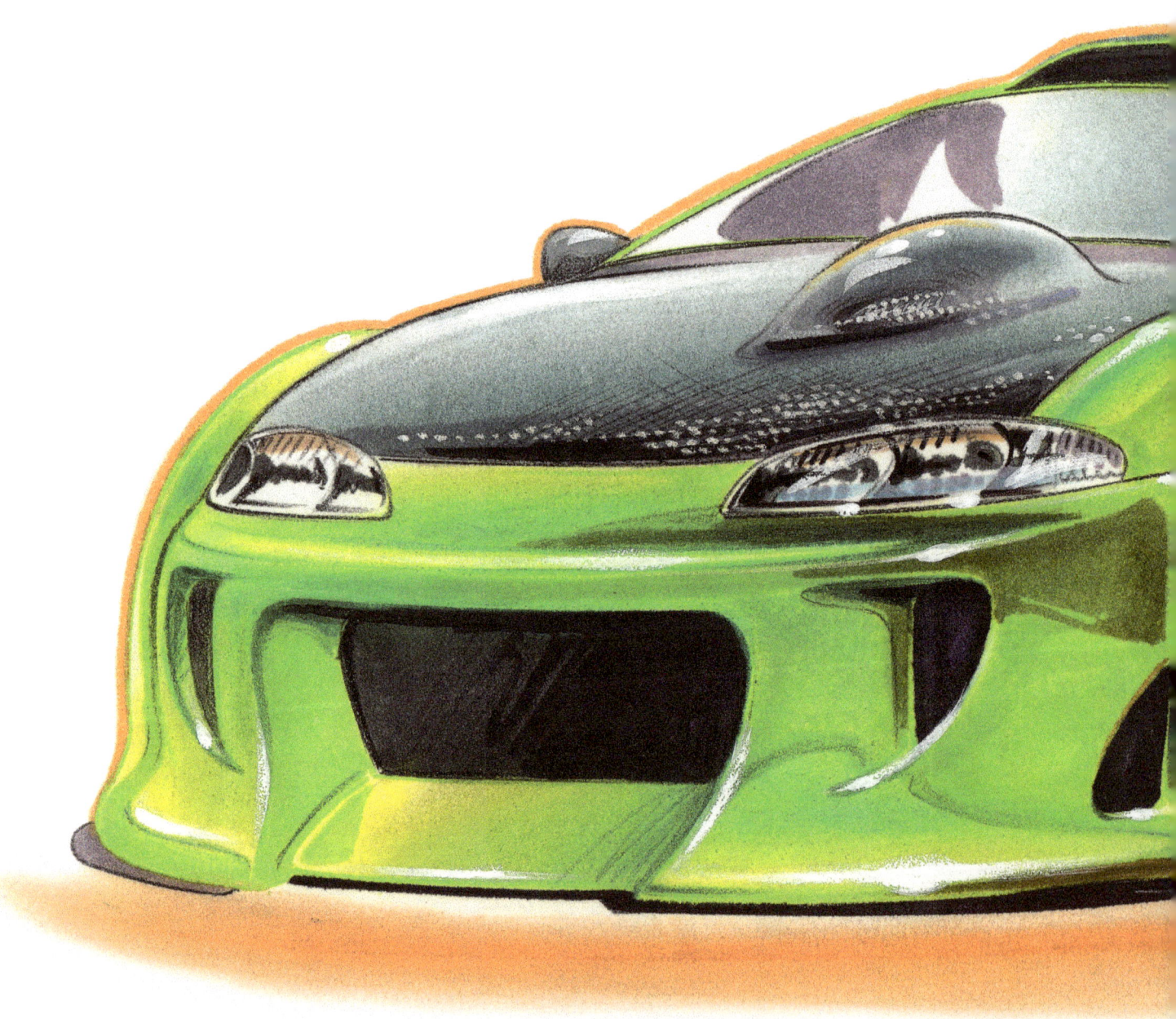

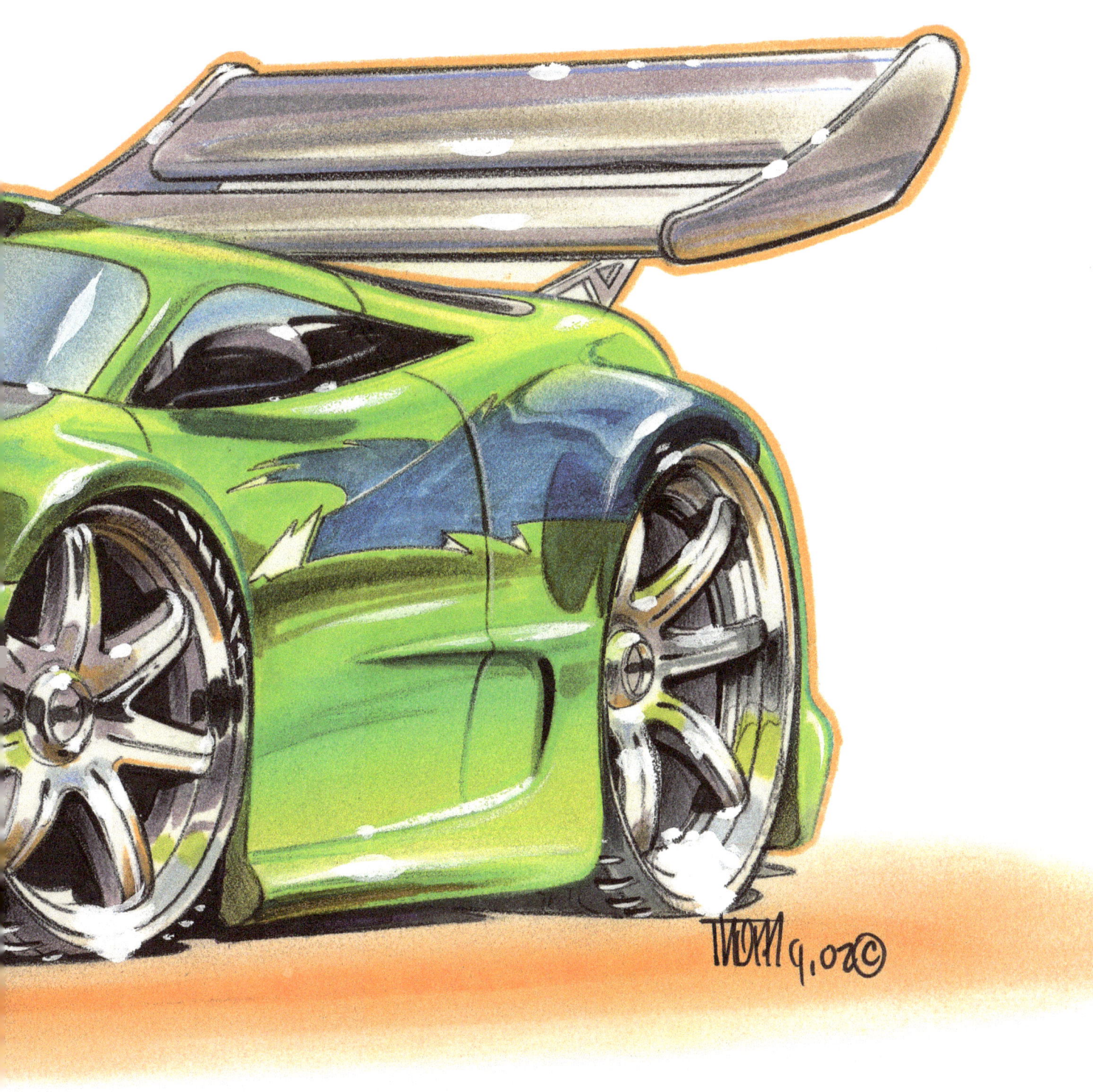

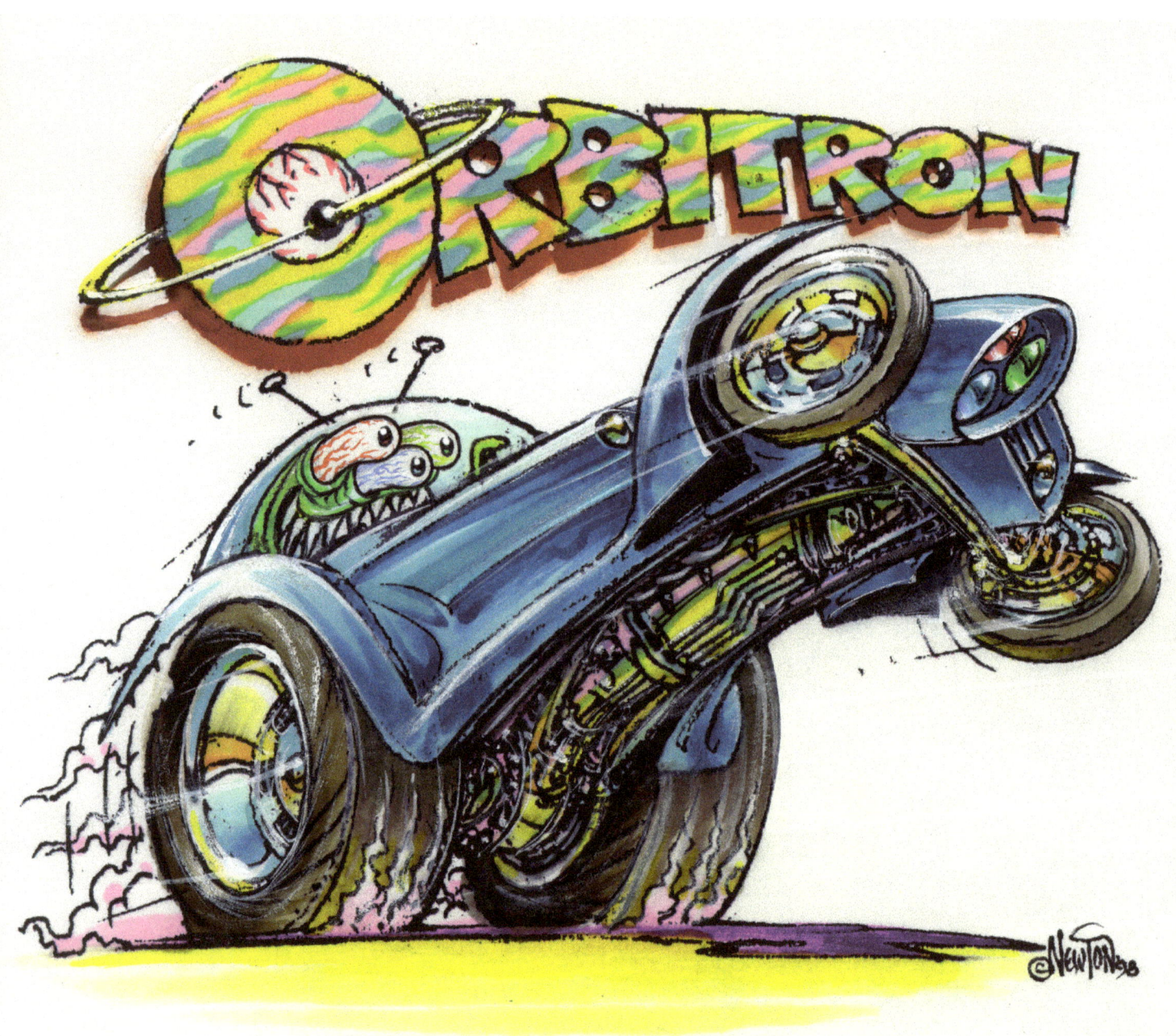

▲ Here, a combination of proportion and perspective work to create the twisting of Orbitron's body. The general proportions of this cartoon are actually better than those of the real car (no offense to either of the Eds). The media are ink, marker, and gouache on paper.

Ellipses & Axes

CHAPTER FIVE

Here are two more concepts you need to know so that you can violate them to create drawings that look like they are screaming at a thousand miles an hour. Actually, you need to know them for a whole gang of things you may wish to draw—speeding or not. To know the mysteries of the ellipse is to know what is drawn correctly and what is not.

Placing a round or cylindrical object in perspective is the most common mistake I see in drawings and illustrations—even when the objects drawn are supposed to be distorted. You can tell those who draw for fun from those who draw for fun *and* know the technical aspects of drawing—there is a difference! You want to be in the latter group.

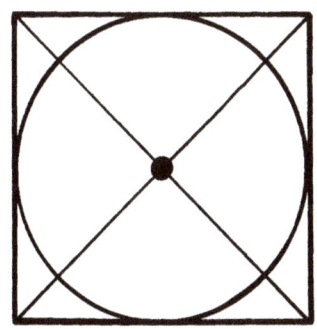
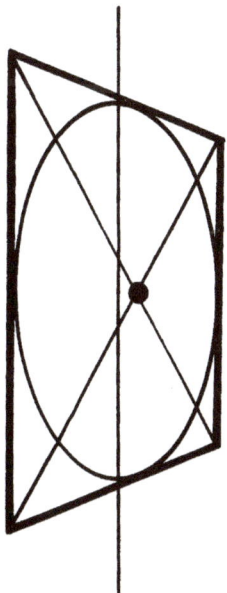

◀ Since it is easy to put a box into perspective, this is how we will begin in order to help us place circular objects like tires, wheels, and headlights into our 3-D imaginary space. The dot represents the center of the box in the first example, and the perspective center of the box in the second example. When the circle is placed into perspective, it becomes an ellipse. Notice that the ellipse is a continuous curve and that there are no points at the tight ends of the ellipse.

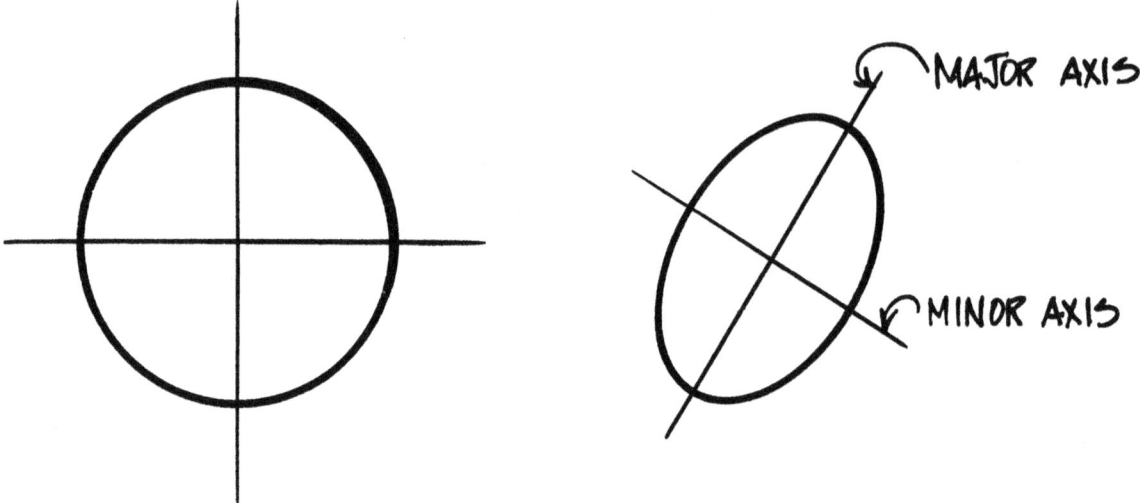

▲ Eliminating the box, we have a circle with its center represented by the cross lines. Flipping the circle into perspective gives us a better relationship of the cross lines, known as the major and minor axes. For car illustrations, we will be concerned mostly with the minor axis, as this represents the axle or centerline, which is always used as a guide to determine whether our wheels are in perspective or not.

▼ Creating a cylinder or a cone relies on the minor axis. In the cone's case, its point rests somewhere on the minor axis, depending on how tall you would like to make it. For our cylinder, the minor axis determines its far end, or end cut. Since the cylinder is going back into perspective, we have to converge our sides slightly, which means our far-end ellipse will be slightly smaller than our front one. Got it?

An ellipse is just a circle in perspective. As you will see in the following examples and throughout the book, the keys to putting a tire or steering wheel or any round object into perspective are the major and minor axes of the ellipse. Knowing this and using an intelligent eye should work for you every time. The one point you must remember is that, except for a football, no cylindrical object has points in perspective! A tin can, a bowl, or a tire lying on its side—all of these and more are devoid of pointy ends. Got it?

Refer to the drawings in this chapter for simple methods and aids to help you nail down this next technical portion of drawing. You say you didn't think drawing cars and monsters could be so technical? Just hang in there! If you master these methods you should be able to draw anything with a high degree of confidence. Honest!

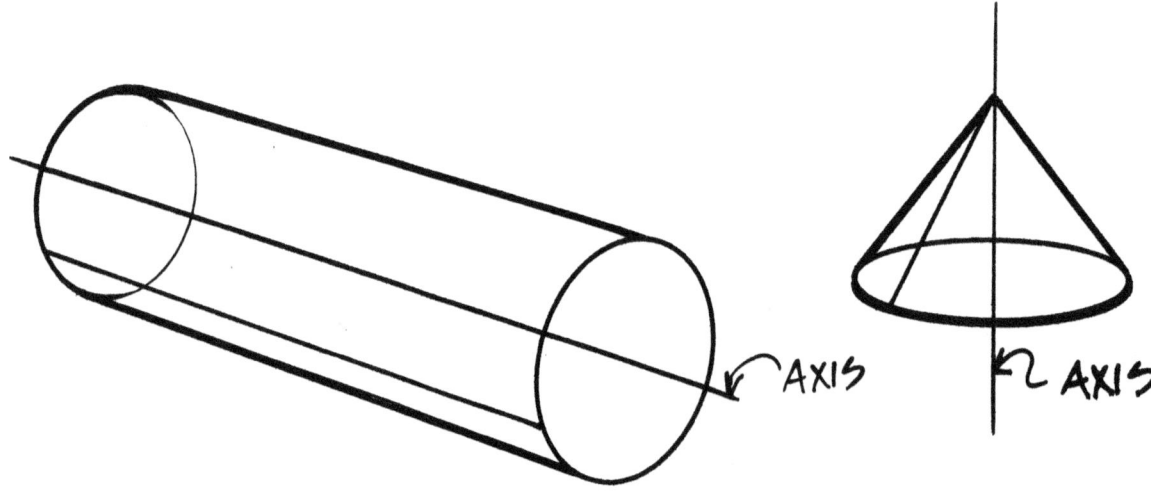

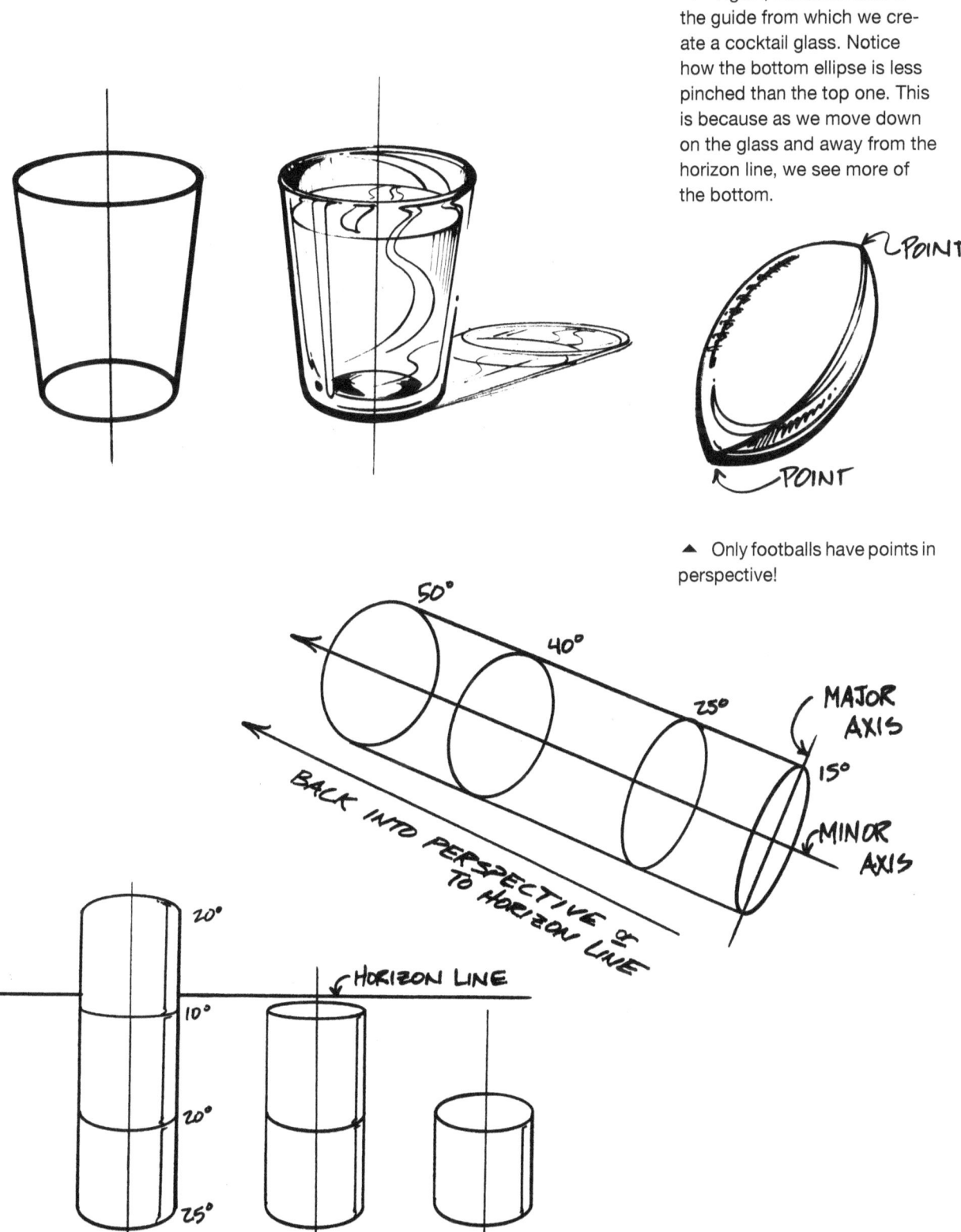

Again, the minor axis is the guide from which we create a cocktail glass. Notice how the bottom ellipse is less pinched than the top one. This is because as we move down on the glass and away from the horizon line, we see more of the bottom.

▲ Only footballs have points in perspective!

▲ Ellipses are identified by degrees, with the tightest being almost 0, which would be represented by a line and not an ellipse. A full circle is 100 degrees, represented by a true circle. As mentioned with the cocktail glass drawing, as circular objects move away from the horizon line, their degree of roundness becomes larger. A circle sitting on the horizon line becomes a line, or 0 degrees, while moving above or below the horizon line yields a larger-degree ellipse, increasing in size the farther you go.

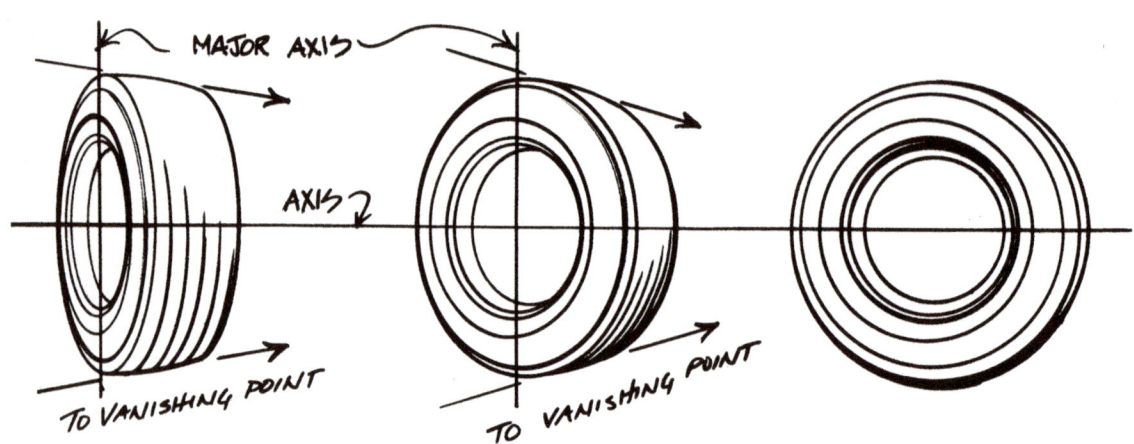

▲ A combination tire/wheel assembly is just a series of built-up ellipses. The vanishing points will dictate the angle that the face of the tire tread takes. Because the axis represents the center of the car's axle, it becomes the predominate concern when constructing a tire/wheel combination for your car drawing.

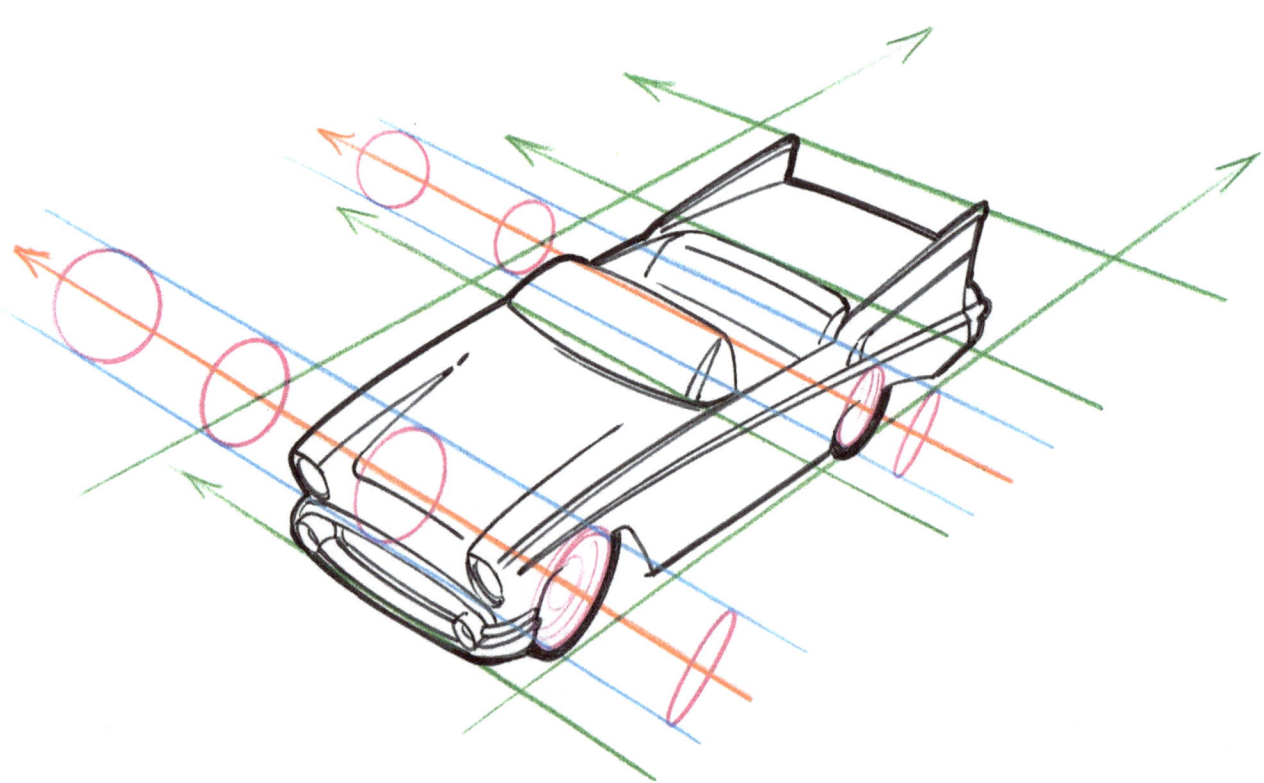

▲ We're going to show how the minor axes relate to Mr. Gasser's '57 and how that determines the ellipses you would use. The green lines represent our vanishing points, of which there are two, making this a two-point perspective. The minor axes are shown in orange, with our red wheel/tire ellipses lined up with those axes. Notice that as we go farther out into the perspective space we have created, the ellipses become fuller. Even though they become fuller, because they are moving away from us, they also get smaller. The outside edges of our ellipses are indicated with blue lines; notice that they point to the same place as the green lines because all of this is going to either one or the other vanishing point. Get it? The problem with this "correct" ellipse application is that it is fairly static—it isn't very dynamic and doesn't show movement. We'll fix that in a moment.

◀ This is the same car as that at the bottom of page 60 at more of a ground-level view. I have represented the '57 in its most basic perspective as blue or red lines. In the blue sketch, the ellipses are lined up the proper way—just like they teach in Perspective 101. Notice that the tire/wheel combo in the red car shows more movement or thrust. That's because I shifted the ellipses forward and off of their perspective axes. It is incorrect as a perspective sketch goes, but it sure gives our car a lot more action, direction, and movement.

◀ The same car, as a side view and shown in a perspective like the basic block examples above. Again, these ellipses are in proper relation to the minor axes. Now let's compare it to the next sketch.

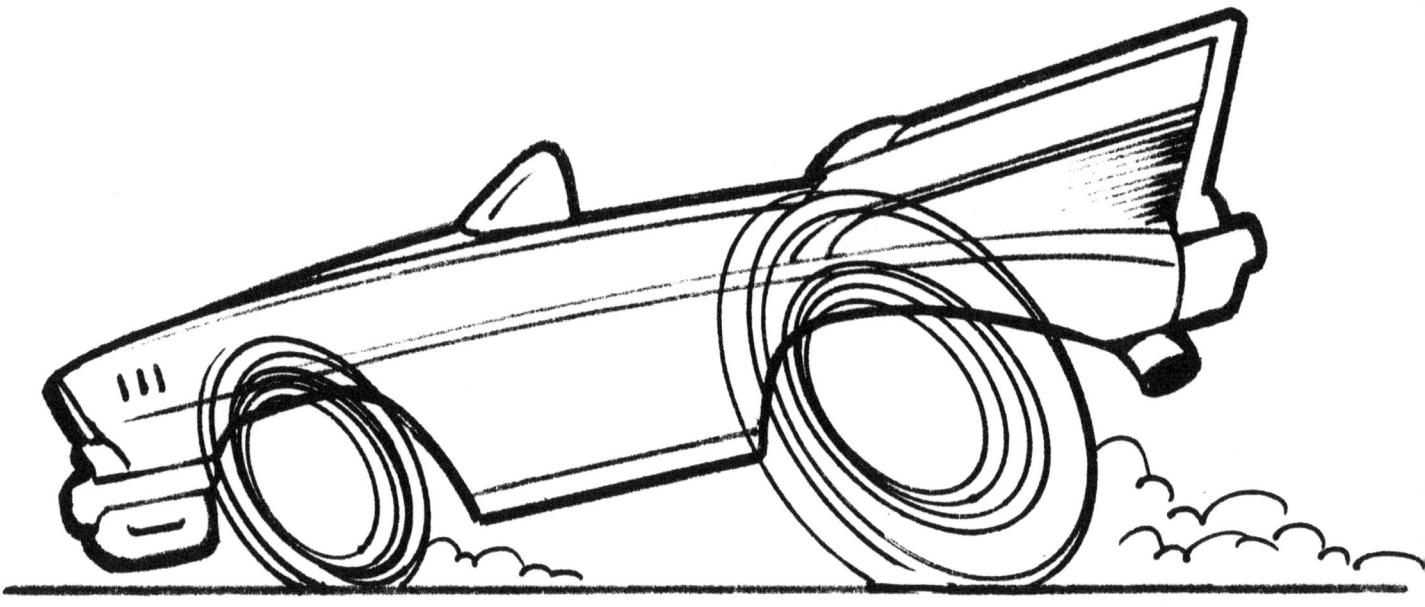

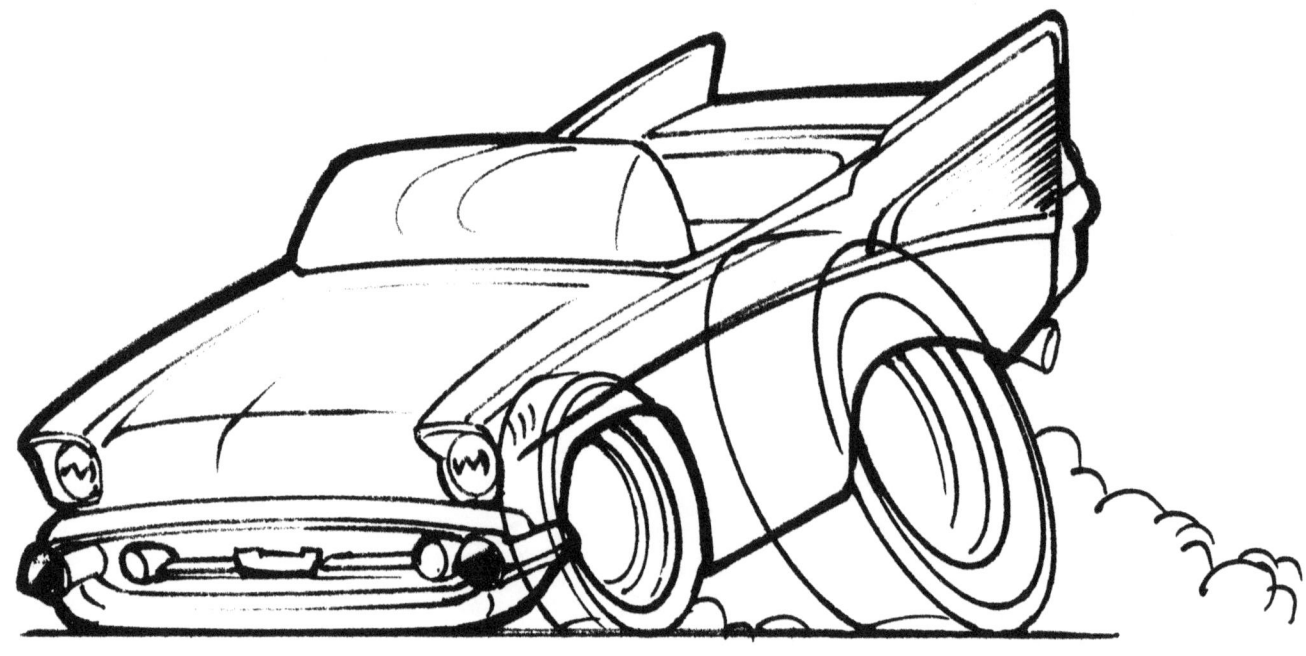

▲ Still the same car, perspective, and side view as page 61, but notice our "off-center" ellipse location. More thrust, more movement, more action. How would this look if the ellipses were cocked in the opposite location on their axes?

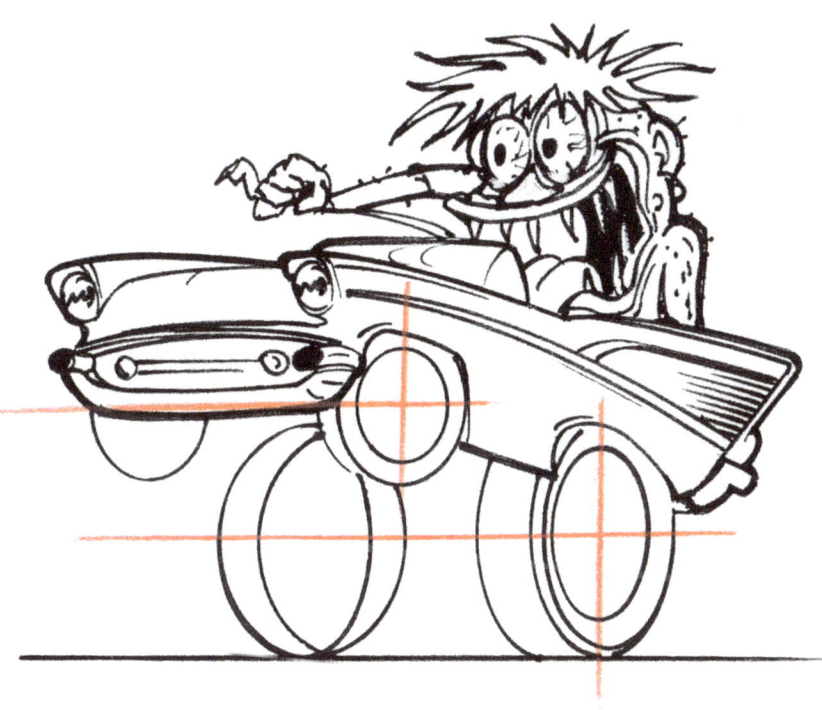

◀ To take this one step further, we're taking Mr. Gasser's '57 and doing a wheelie. This is how the ellipses would properly be placed.

▼ The same sketch as above but with those ellipses shifted on their minor axes. Wrong but right.

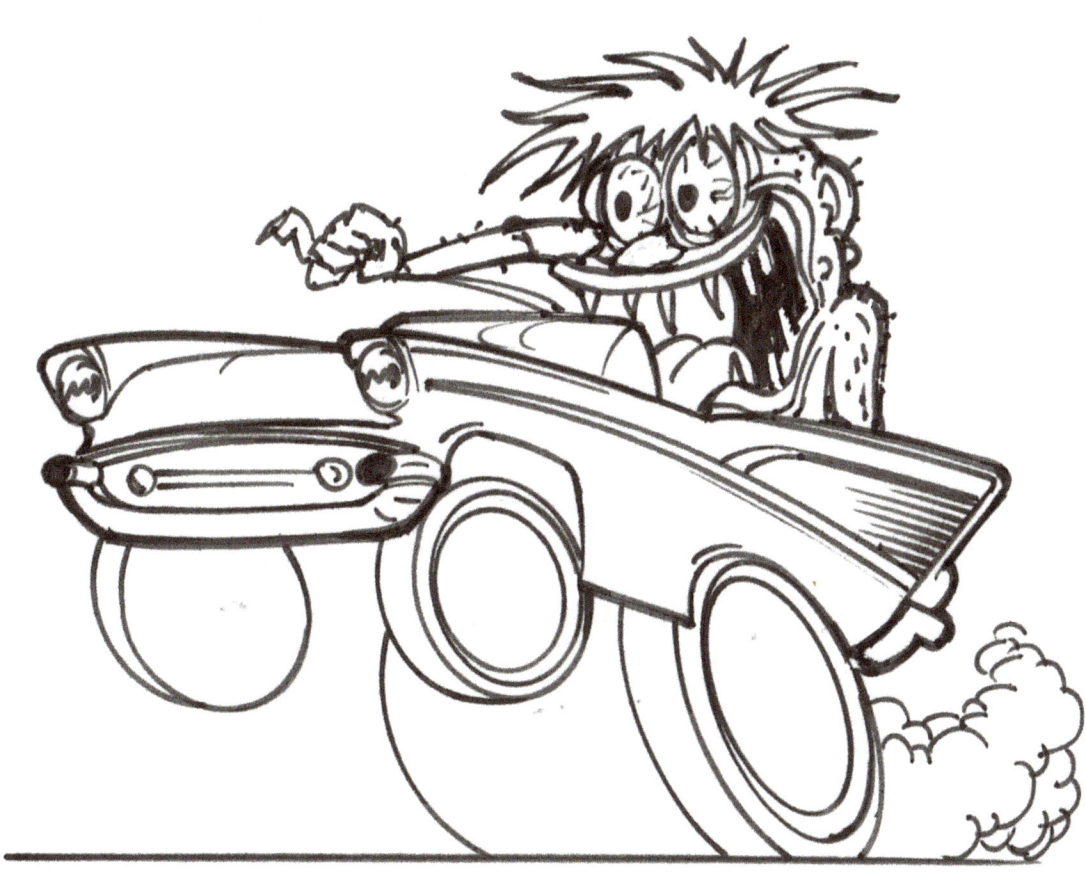

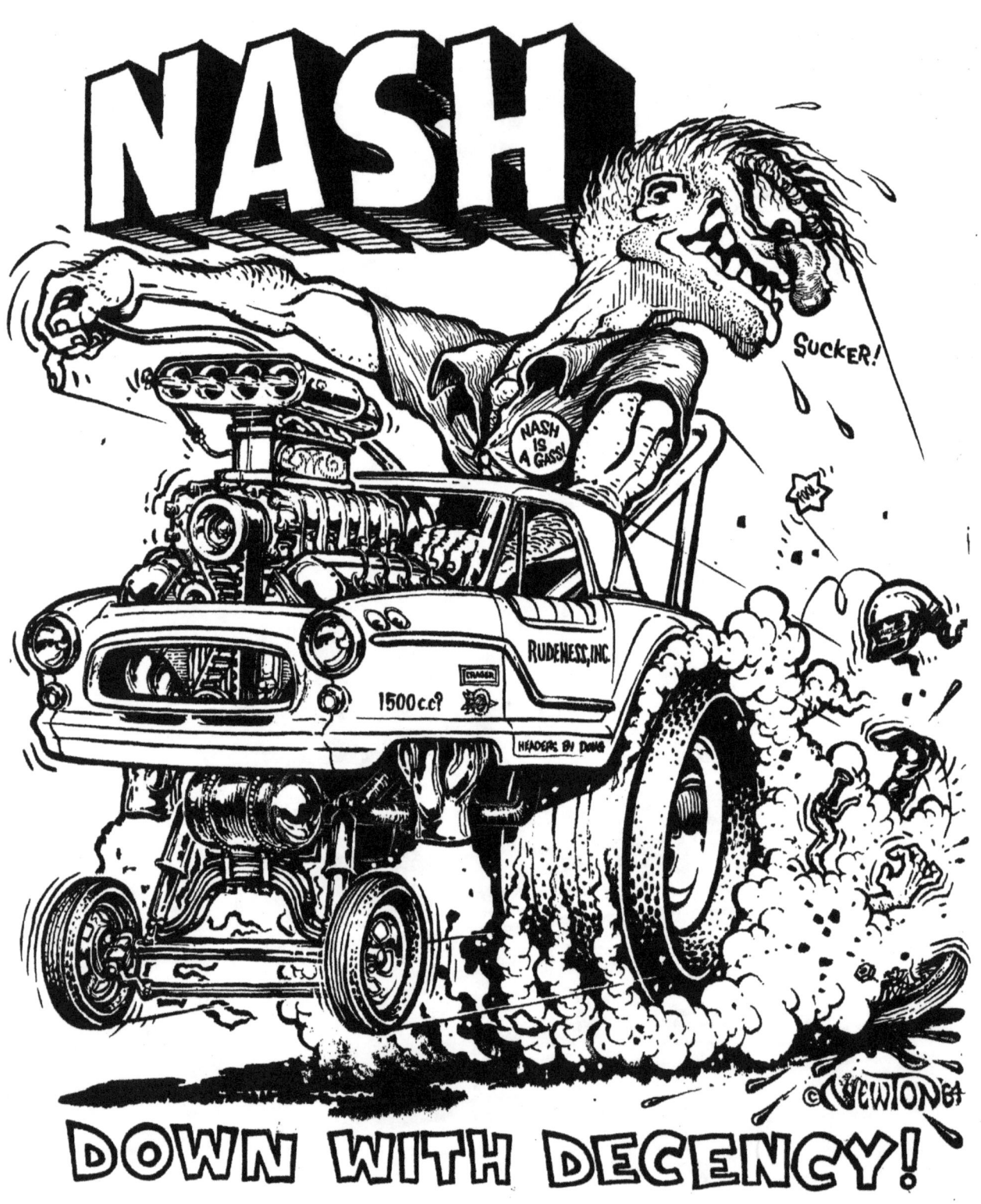

▲ Here's a rare Newt design with straightforward wheels. This shows what one of his drawings would look like without the ellipses and axes purposely drawn out of perspective. This is the only design ever commissioned by Ed Roth that he never paid for or used. Roth Studios residents Dirty Doug and Ed Fuller convinced him that no one would buy a shirt with a Nash on it. What do you think?

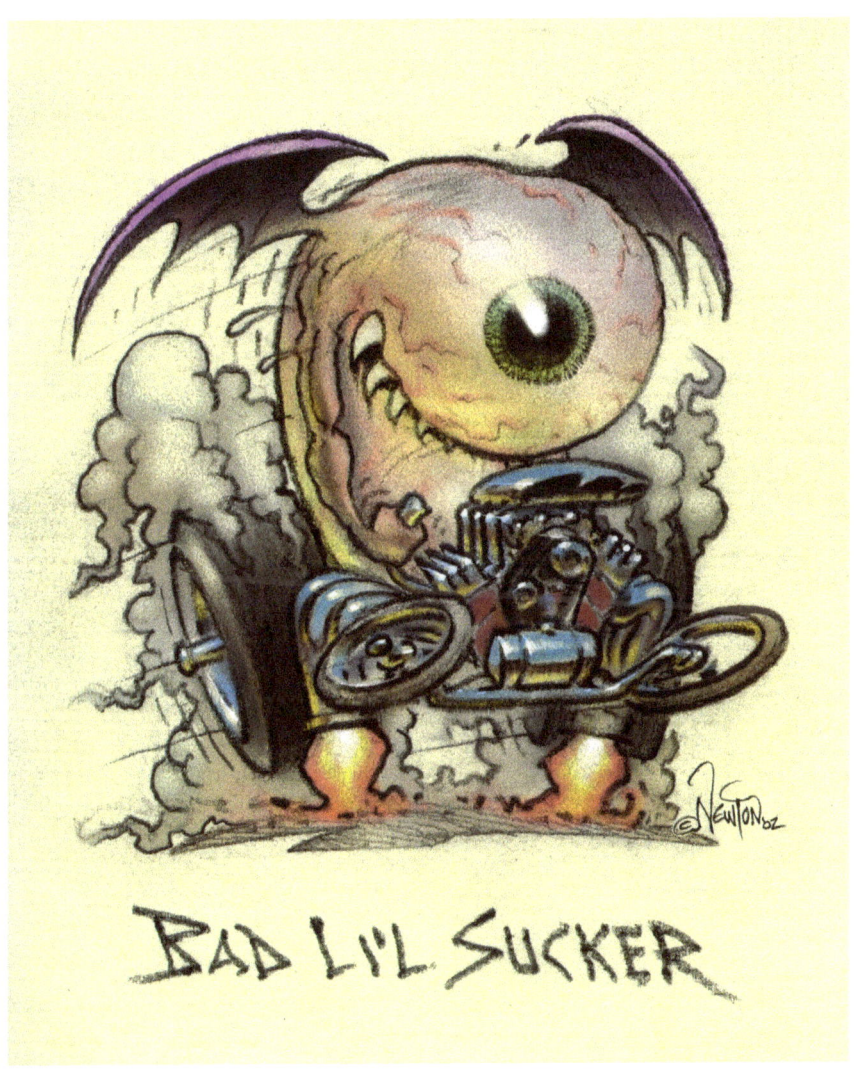

BAD LI'L SUCKER

◀ At the other end of the spectrum, Newt drew this monster eye with all of the tires out of perspective to give the impression that the car is dancing out of control. The minor axes are positioned to give a very random feel. Do you see the minor axes in this drawing?

◀ On this logo created way back in 1964, Newt incorporated the wheel and tire as the O. The word is in perspective, so the O needed to be in that same perspective. The heavy black outline around the letters helps them stand out.

CHAPTER SIX

Technique, Sketching & Line Quality

Your style of sketching, and the line quality you exhibit within your sketches and renderings, is all a function of your drawing technique. You're going to see a lot of cool techniques shown within the pages of this book. Hopefully you'll pick up on some of the juicy sketching so you can adapt it to your own crazy creations. Go ahead, copy at first. Soon you'll develop a style and subtleties of your own as you get comfortable with sketching.

▶ "I keep a clipboard handy and when I get an idea I do the quickest, dirtiest scrawl I can, just so I can remember what I had envisioned," Newt explains. "Then, step two is to create a slightly more detailed version while still trying to maintain the immediacy and movement generated by the original sketch notation. Step three is, of course, doing the detailed version. For some reason, I drew Rat Fink going in the opposite direction than is most comfortable for me. Since I'm right-handed, drawing a vehicle moving from right to left is the easiest and most natural for my hand and arm action. Also, I don't use the 'box and circle' method of roughing these things out because I'm concentrating on the surging and rhythmic composition — and also because I have been doing this for so darn long."

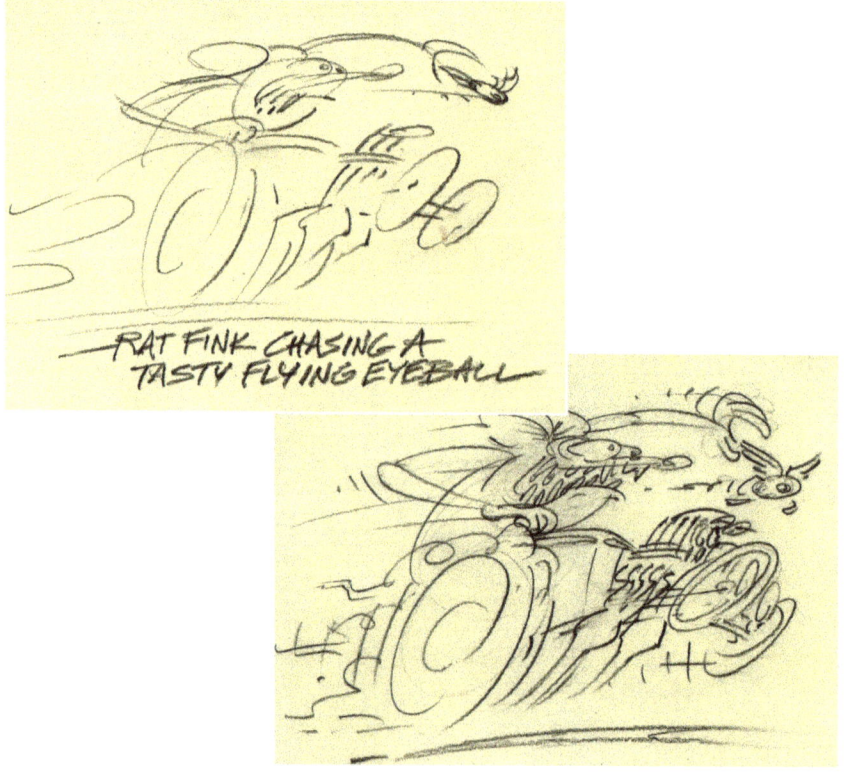

▲ This preliminary sketch by Newt is an example of his pencil technique. It's lively and contains a lot of light and dark areas that make for a lot of contrast. The car is generic and not meant to be any specific model.

Sketching techniques are as varied as mad monsters. Each artist in this book has his own style, and it is pretty easy to pick out. How did this happen? I don't know—I'm an artist, not a psychologist! It's just a function of abilities, likes, and dislikes, what you see and how your brain interprets it, and a lot more.

The main objective is to have fun—stay loose when you draw. A relaxed and free hand, drawing from your whole arm—even your whole body—instead of quick rips from the wrist, helps to maintain a nice flow and more controlled lines. You've seen the chicken-scratch style of drawing with short, quick strokes and jabs. For the most part this becomes distracting and not very professional-looking. Plus, it makes it difficult to establish clean lines and line weights.

Line weights are the thick and thin lines you see throughout a sketch. Variations in line weight hold your attention longer and are a lot more interesting to

continued on page 72

▲ **These pages and following spread:** Here's a rare opportunity to explore both the initial Newton sketches and the final art for Roth silk-screened shirts of the 1960s. Newt has the unique ability to do quick sketches that capture all of the detail, action, and lettering on his first shot because he has so much experience with "off the top" drawing and airbrushing. I would need to do a series of overlays to achieve this level of sketch, so don't get discouraged—I told you this guy's the king of monster cartoons!

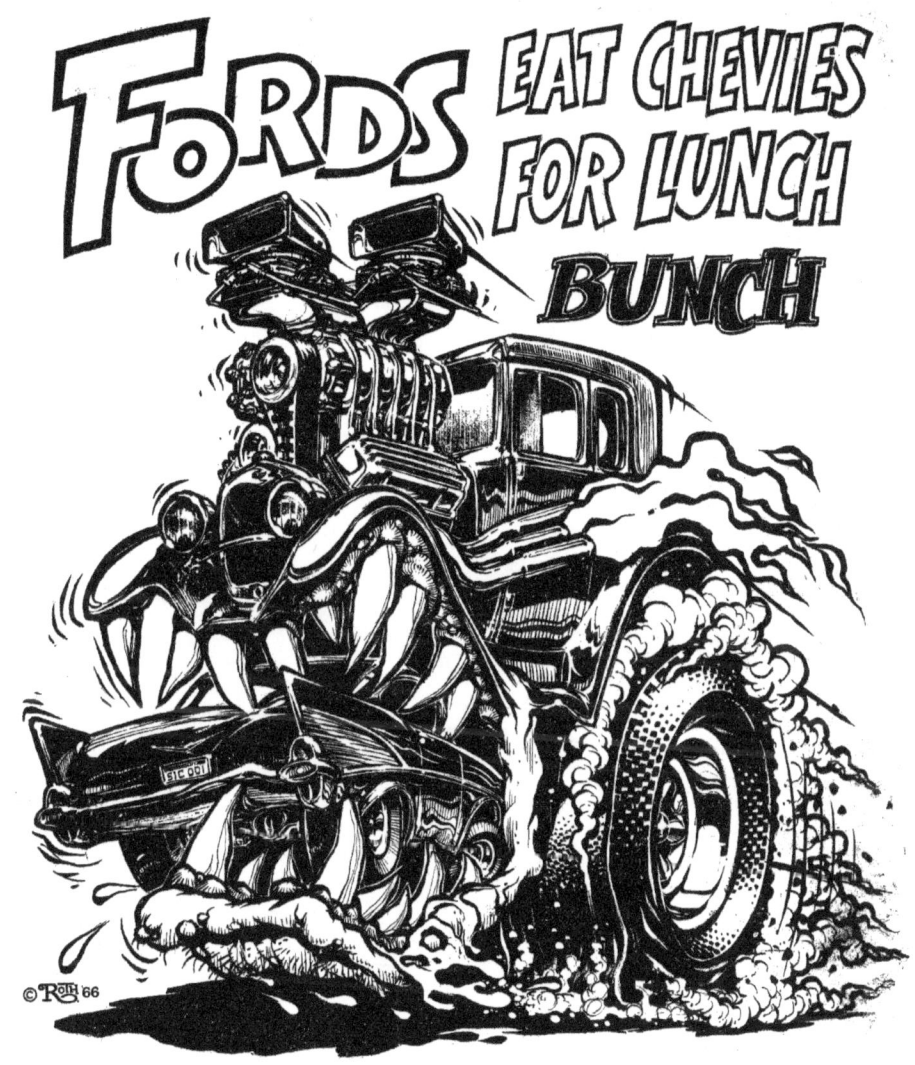

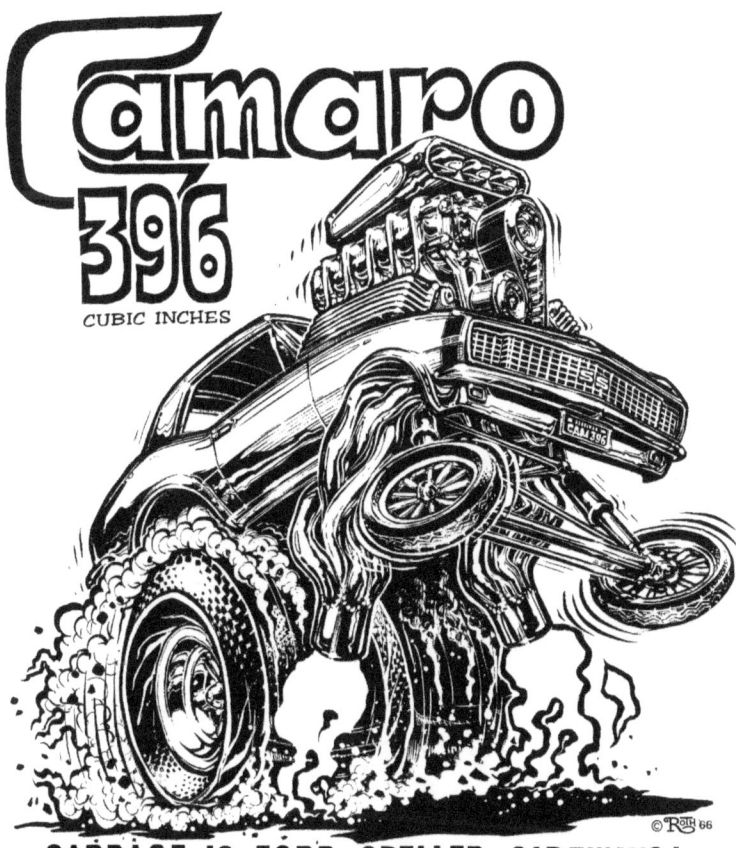

◀ From the pencil sketch Newt would enlarge the image and then trace it in pen and ink for the final art. Silk screens would be made, and shirts would start rolling out of Roth Studios. There is a lot of thick and thin line quality, and Newt even puts in different gray values in some cases.

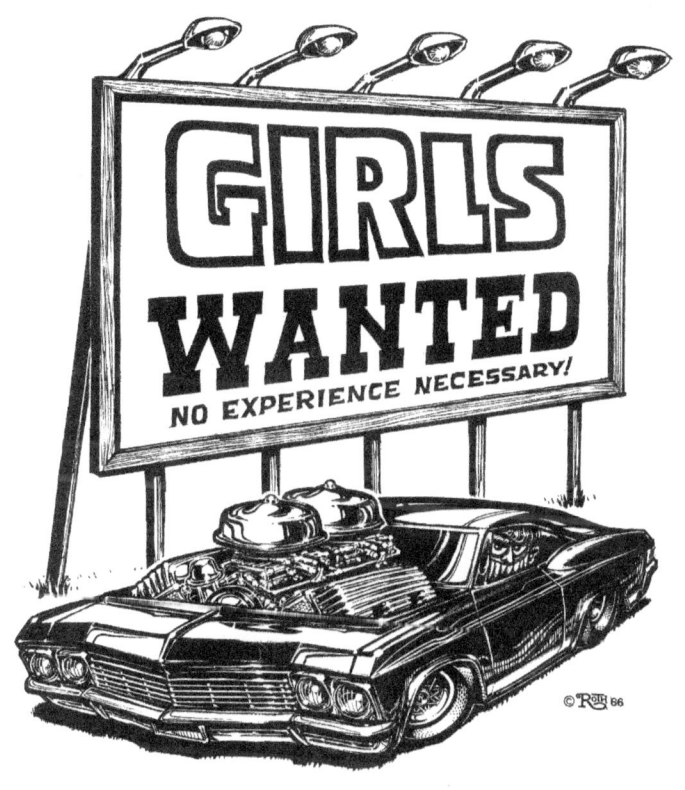
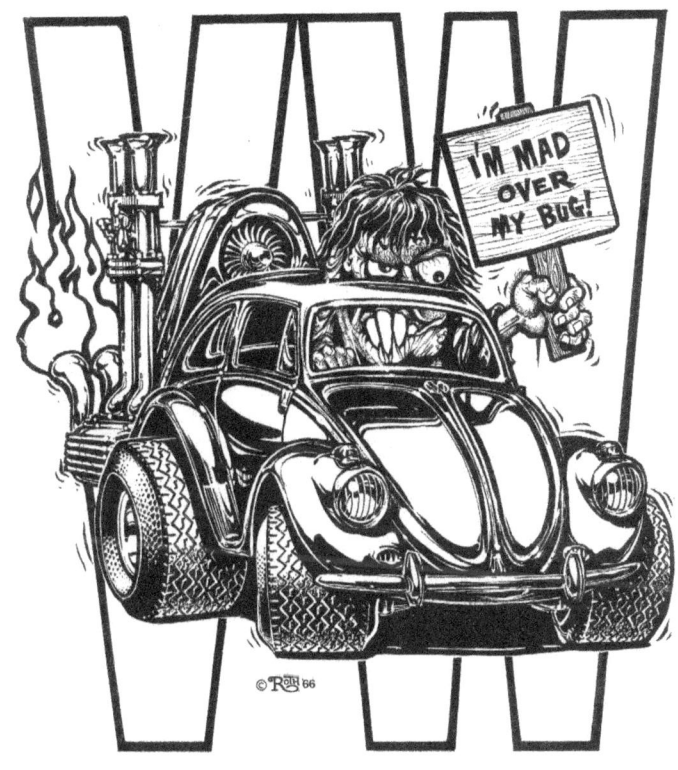
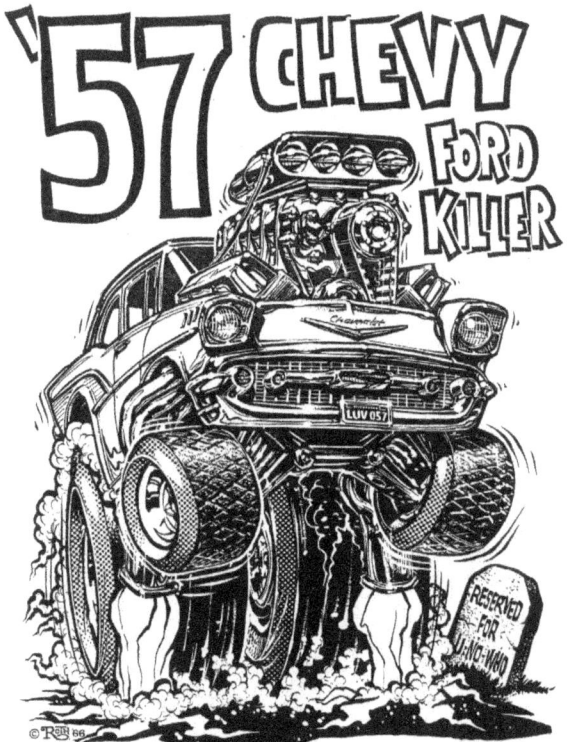
OLD CHEVYS NEVER DIE...THEY JUST GO FASTER!
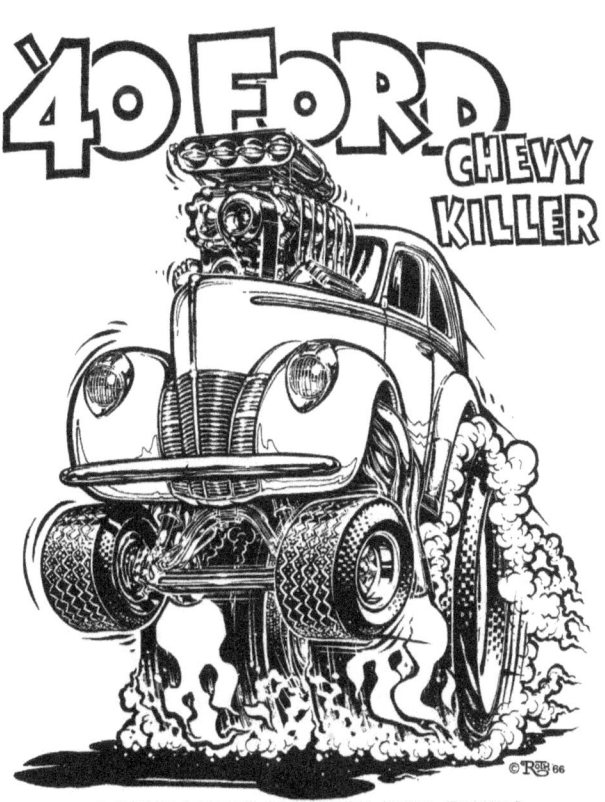
I HATE EVERY CHEVY IN THIS TOWN!

Continued from page 67

look at than consistent lines throughout a drawing. In fact, consistent lines for an entire drawing are fairly hard to achieve. Typically you give more weight to a line that is closer to the viewer, a line that represents an undercut edge or bend, an edge defining something round, or a particular part of a drawing that calls for some extra pressure. After all, drawing is a tactile experience as much as it is a visual one. It feels good to press a little harder at certain points in your sketch. So, different line weights equal better line quality, as does having fun with your drawing. Give your monsters some spark and interest by varying those weights—you'll feel the difference!

Technique means the way you actually draw, as well as the medium or utensil used to achieve the drawing. Everyone has a technique lurking inside of them. Your technique is your unique combination of how you see things, whether you have a heavy or a light touch, your dexterity, ability, and experience, and even how you feel on a particular day. These, blended with more mechanical aspects such as what type of pencil, marker, or brush you're using, the type of paper or board you have, and whether you choose to draw in color or black and white, make for the characteristics that define your technique.

Just because you cannot do a drawing exactly like some of the examples in this book doesn't mean you aren't drawing properly. It just may be your style or technique starting to come through. That's great! The difference is what makes your own efforts prized and marketable instead of just copies of someone else's work.

I've tried to assemble some varied styles from different artists to illustrate the great diversity in techniques that are possible. That is why there is not a gang of different artists here; although there are a lot more I would have liked to feature. Even when similar materials are used, scrutinize how the differences come through. This is one reason why someone would prefer art from one artist instead of another. It's technique—the unique way one draws—that attracts a following or creates interest in that person's work.

This book also includes examples of different techniques applied to an identical subject. This can be a lot of fun to try for yourself, so experiment with different media, techniques, and paper. You may find that the same sketch is easier or more rewarding when done one way rather than another. And while you may discover that you prefer the work of a particular artist, strive for your own technique. Hopefully, along the way, you'll achieve a style that is uniquely yours.

▶ To start off I usually do a quick thumbnail sketch to get the overall shapes, placement of elements, and a rough guide for the perspective. With the horizon line going through the middle of the car, you have to worry less about vanishing points, but you still need to know perspective. I wanted the car's body to be very tall and spindly, and to force the rear slick's perspective so that you hardly see the side of it, yet get a front 3/4 view.

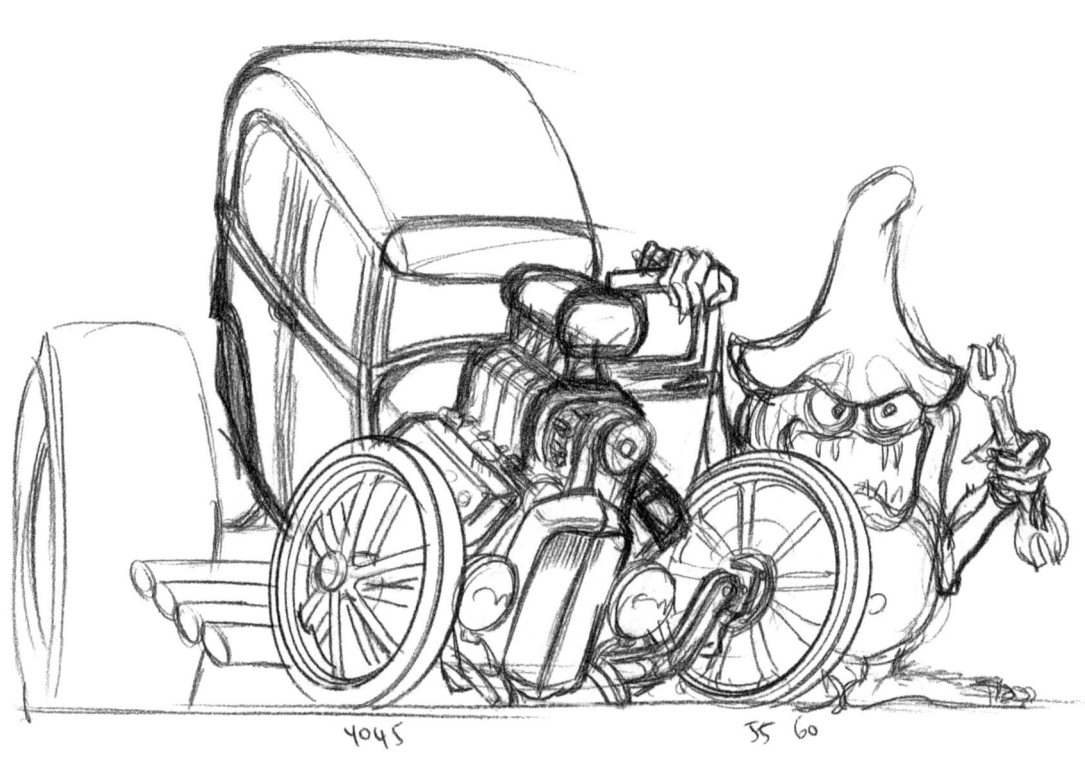

▲ Here's a very rough drawing of the little thumbnail. The lines are a little horsy, especially around the body of the sedan. This is rough stuff and not meant to be seen, but it's a part of the process that I need in order to figure out the drawing.

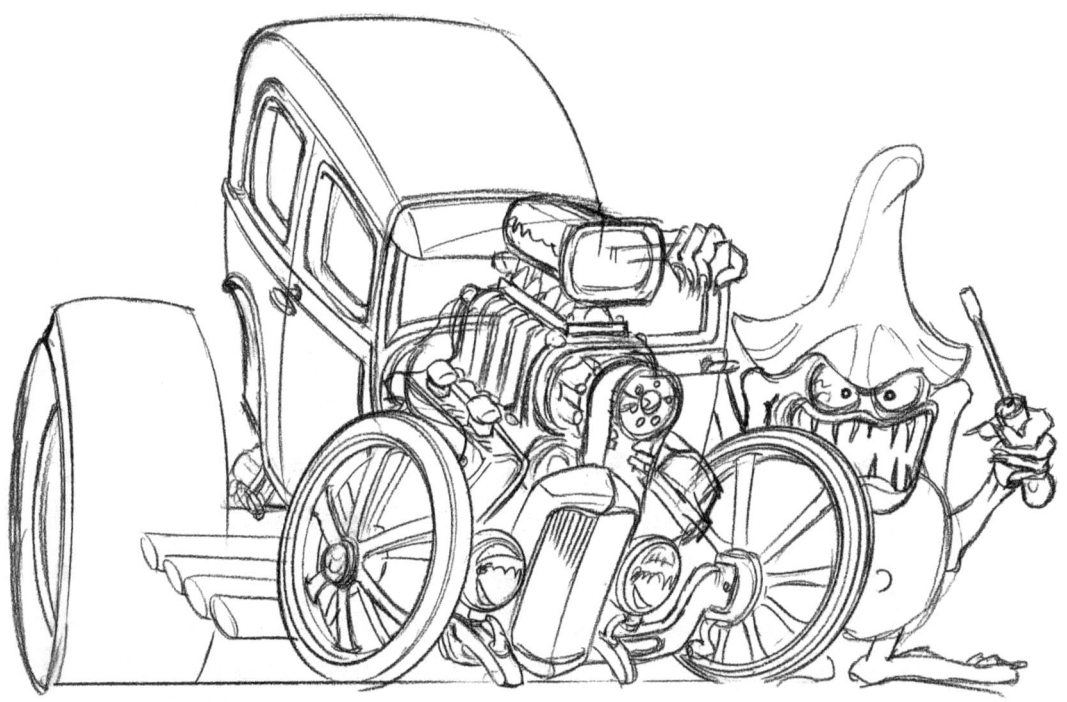

▲ This is an overlay of the previous sketch that hammers in the details, perspective, and location of everything, such as Finky, the scoop, tire placement, and more. This is what I'll trace to do the final ink drawing. All three of these sketches have been done rather quickly, but it's all fun for me because I'm creating and drawing.

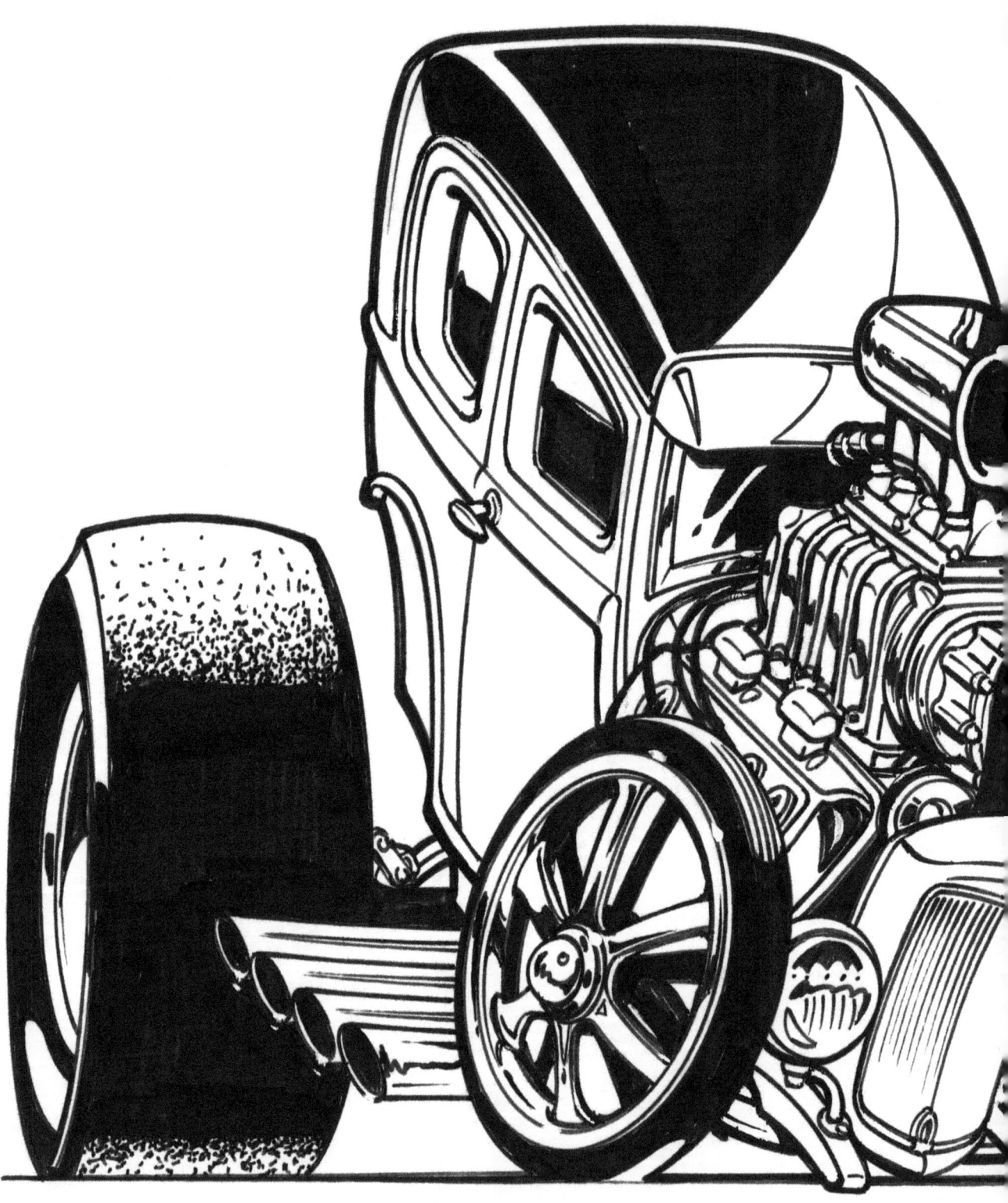

◄ The finished drawing has those thick and thin lines and beefed-up undercuts. That's Darryl Roth's Finky adjusting the injectors on this blown Hemi Model A highboy. Finky wouldn't be able to fit into the sedan let alone see through the windshield and around the engine—but that's the fun of drawing mad monsters and crazy cars—nothing needs to be true as long as it looks real.

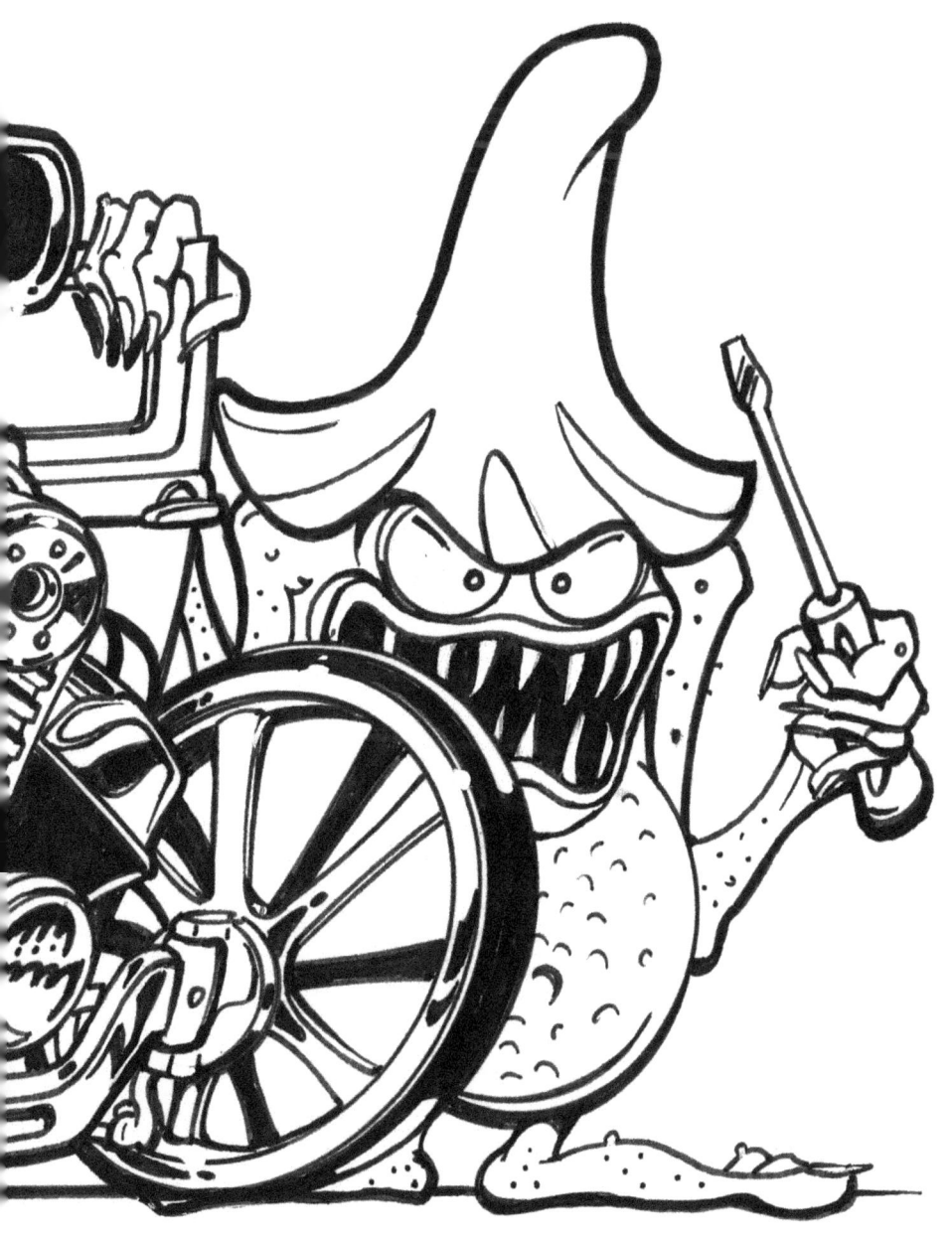

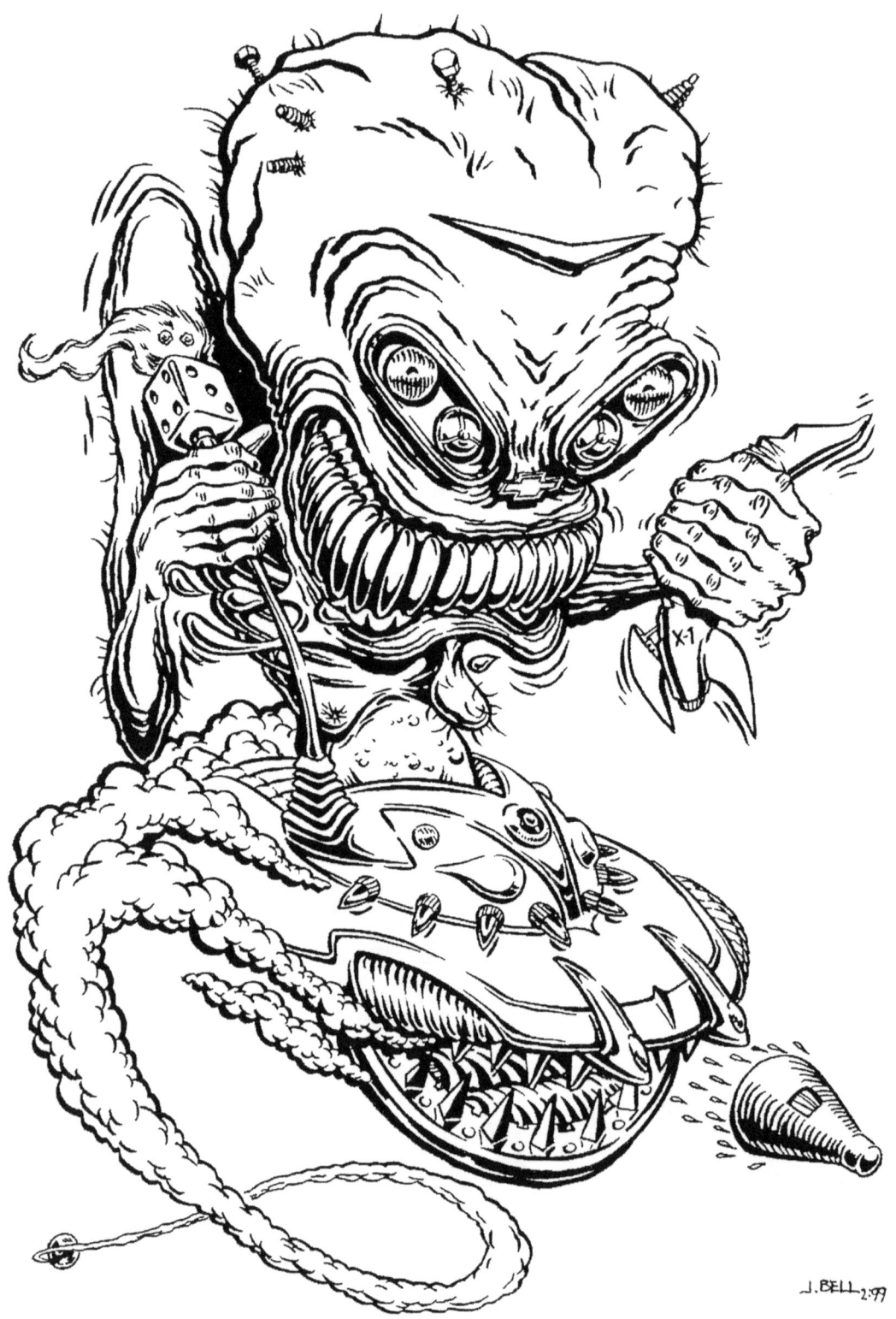

▲ Sweatin' Bullets is the name of this John Bell drawing, incorporating a lot of iconic hot rod touches. The sketch quality exhibited is great. Notice all of those thick and thin lines. A lot of the surfaces turning under feature thicker lines that help give some visual support and a bit of extra shadow because they turn away from the light source.

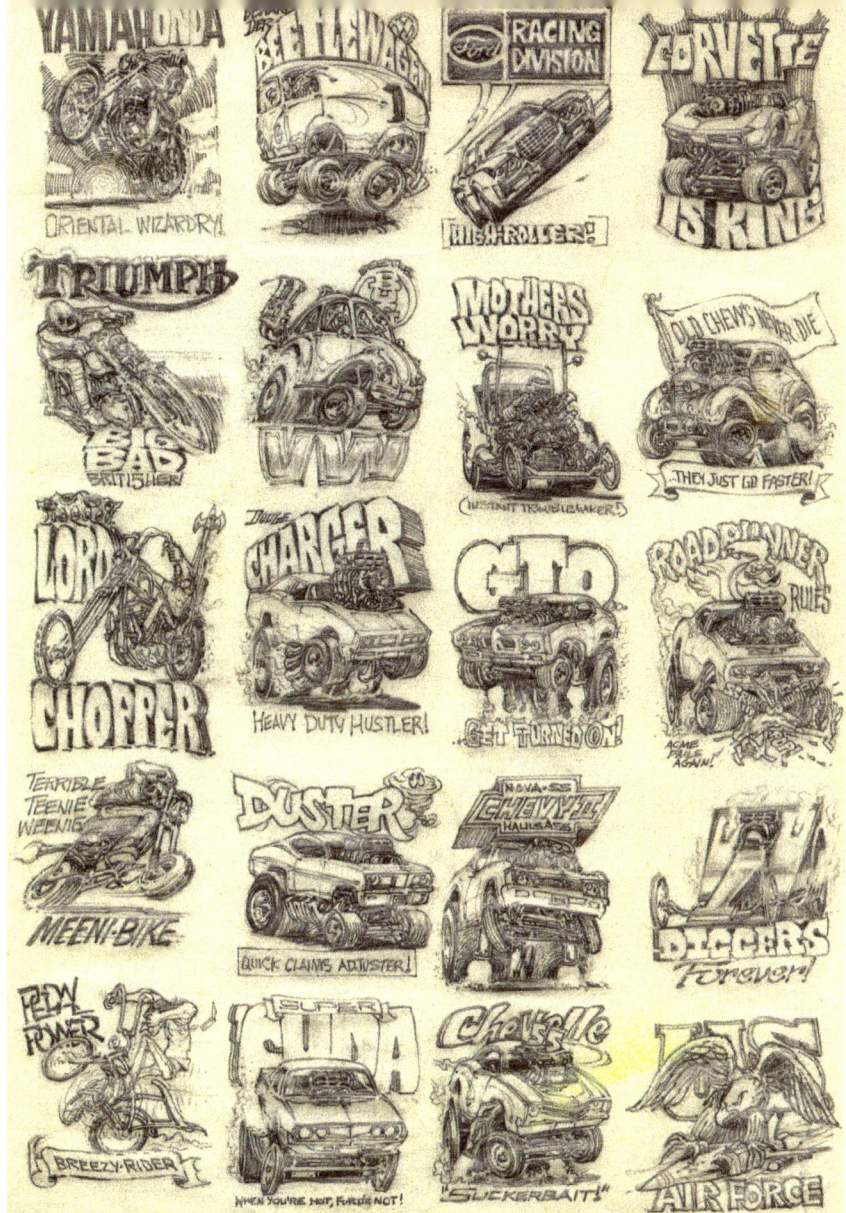

◀ Some very tight thumbnails that Newt sketched for Roach Studios in the early 1970s. This is one of those things that Newt does best: super-tight thumbnails with clearly defined and correct values, lettering, proportions, and more. Unbelievable! A photo of the sketches is included below with Newt's hands shown for scale.

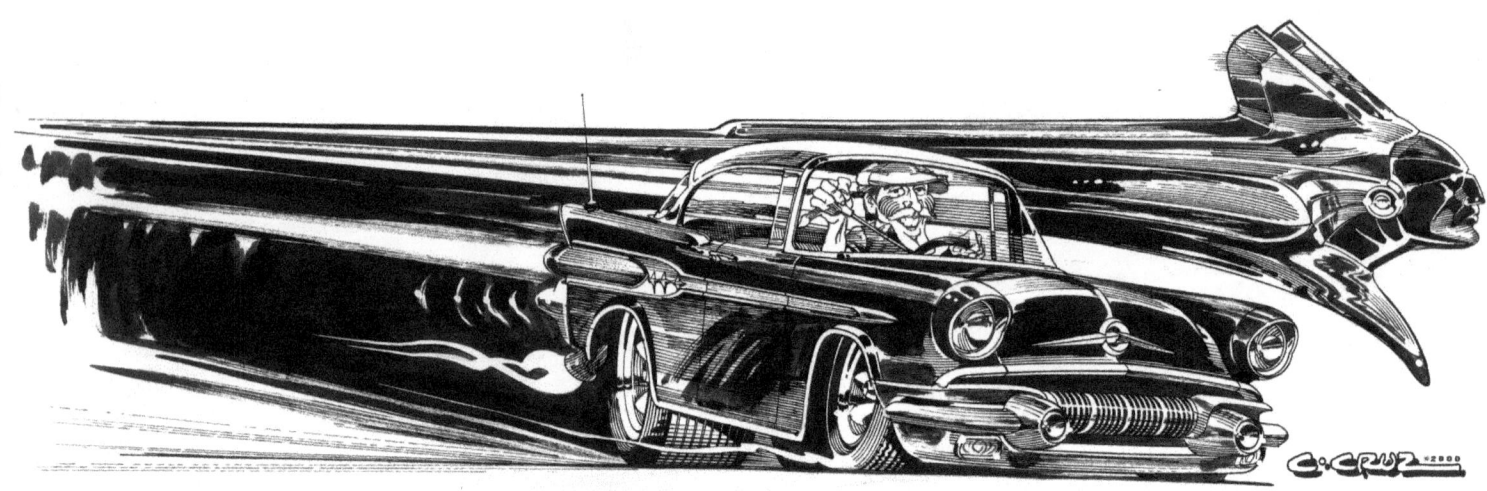

▲ If you're dealing in pen and ink, you only have black and white to play with—so the thinking artist must figure out how to come up with middle values to make for a complete depiction. C. Cruz does it with a very distinctive sketch quality that is largely defined by his use of thick and thin lines and how they are spaced.

▲ Other than the bit of crosshatching in the wheels, this whacked and smashed Chrysler 300 has no tonal variation—just lines, lines, and more lines.

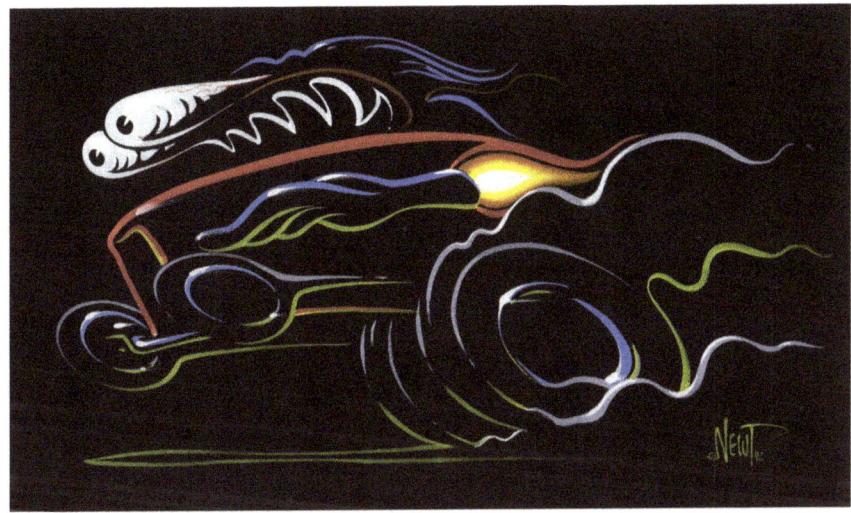

◀ "This was the first of a series of efforts to capture the bare essence of a monster in car," Newt explains. "By using black canvas, the viewer mentally fills in the blanks to create volume when only the highlights of certain surfaces are delineated." Newt created very rhythmic shapes and forms here, which lend an abstract appeal to the composition.

▲ Dave Deal has a very distinctive look, which is a function of the technique he uses. This is a pre-computer drawing that he did in pencil before coming back in with a few markers to add color and tone. In some cases he's taken these older drawings, scanned them into the computer, and burned in some highlights or saturated the color.

▼ Although he has different sketch techniques, John Bell is represented here with a pen sketch that he scans into the computer and colors in Photoshop. Straight lines are done with a straight edge but the rest is freehand—even the wheels and tires. With some well-placed highlights, even the slab sides of this hearse show some section to them.

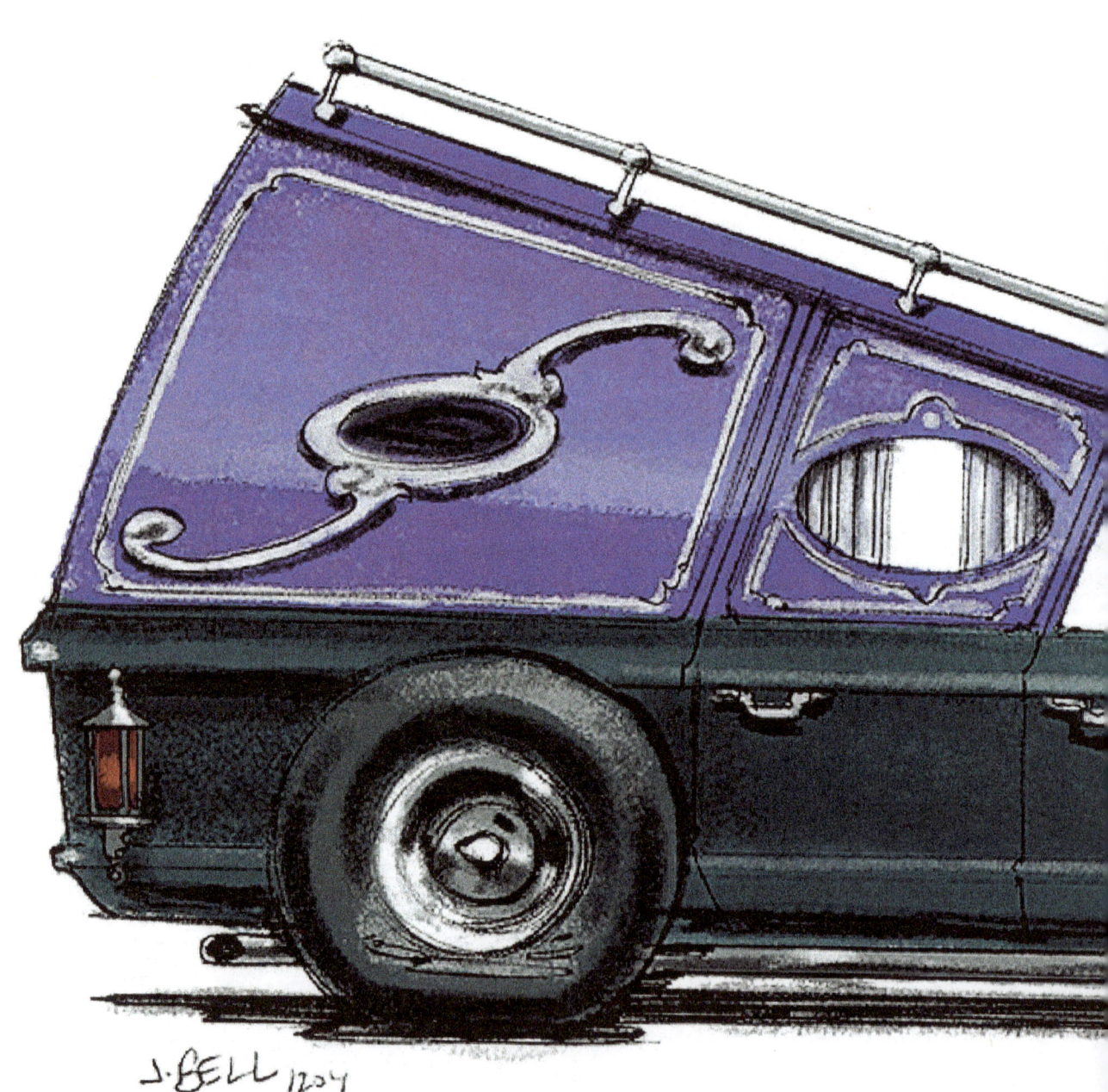

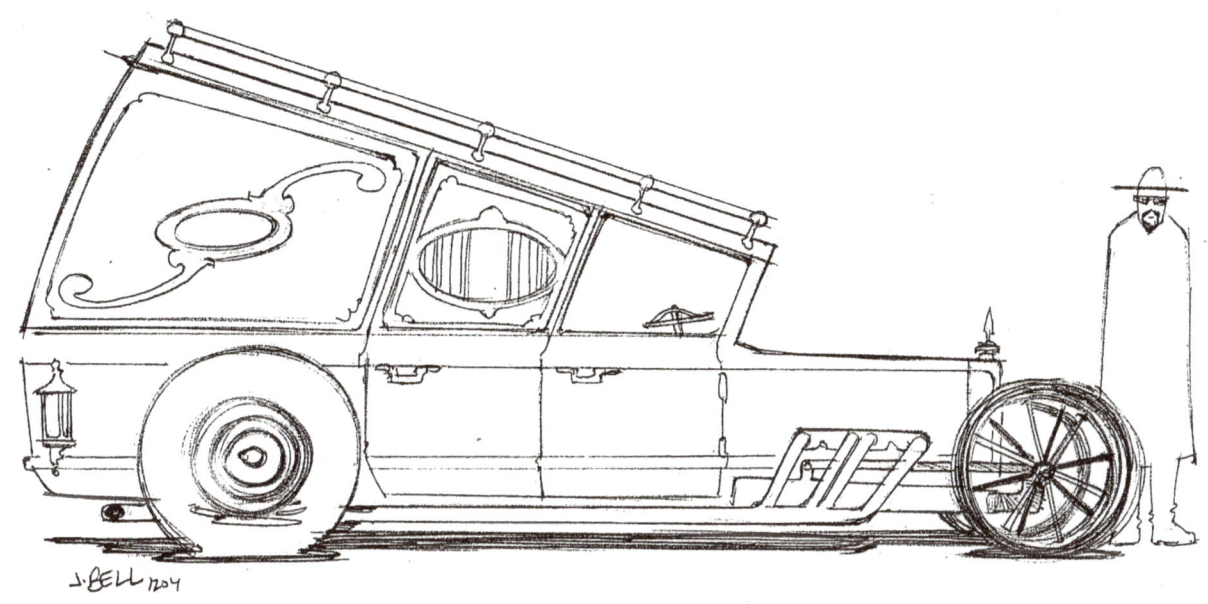

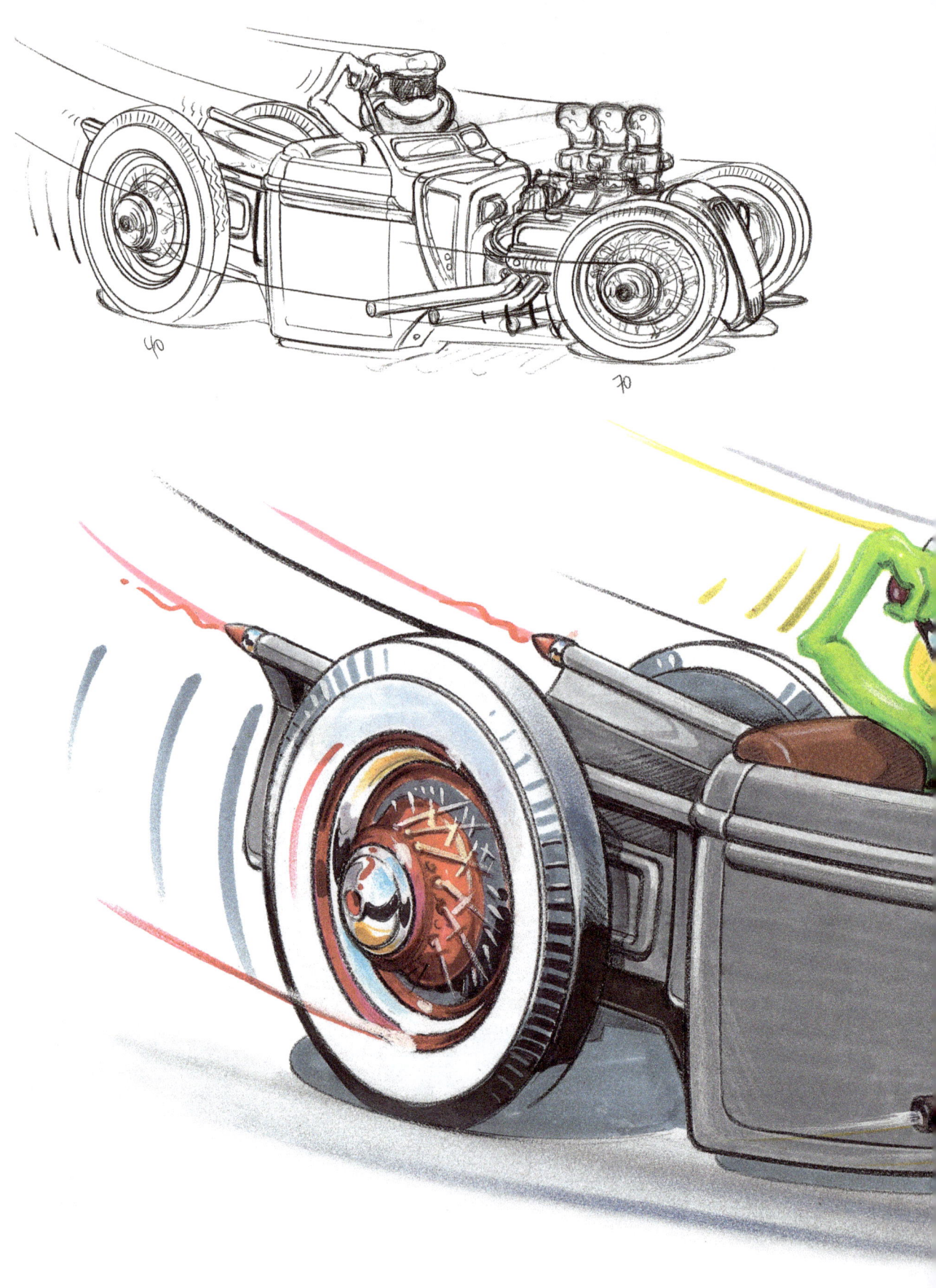

◀ I like using markers to color my sketches. I can get them to blend and flow, and I feel like I have good control. I'm slowly feeling my way through computer applications, but for now this is my bread-and-butter technique. This pencil sketch is how I start off; then I trace over it for my final sketch. In some of the areas that seem a little rough, I stab around for the right shape or line. No one normally sees this version, so I don't care how crude it gets.

▼ This is the final version. Note the marker strokes in the body. Normally I'm able to hide these better within my reflections, but since this car is supposed to be gray primer, there are no reflections. Some of the highlights are white Prisma pencil; the really hot spots are white gouache.

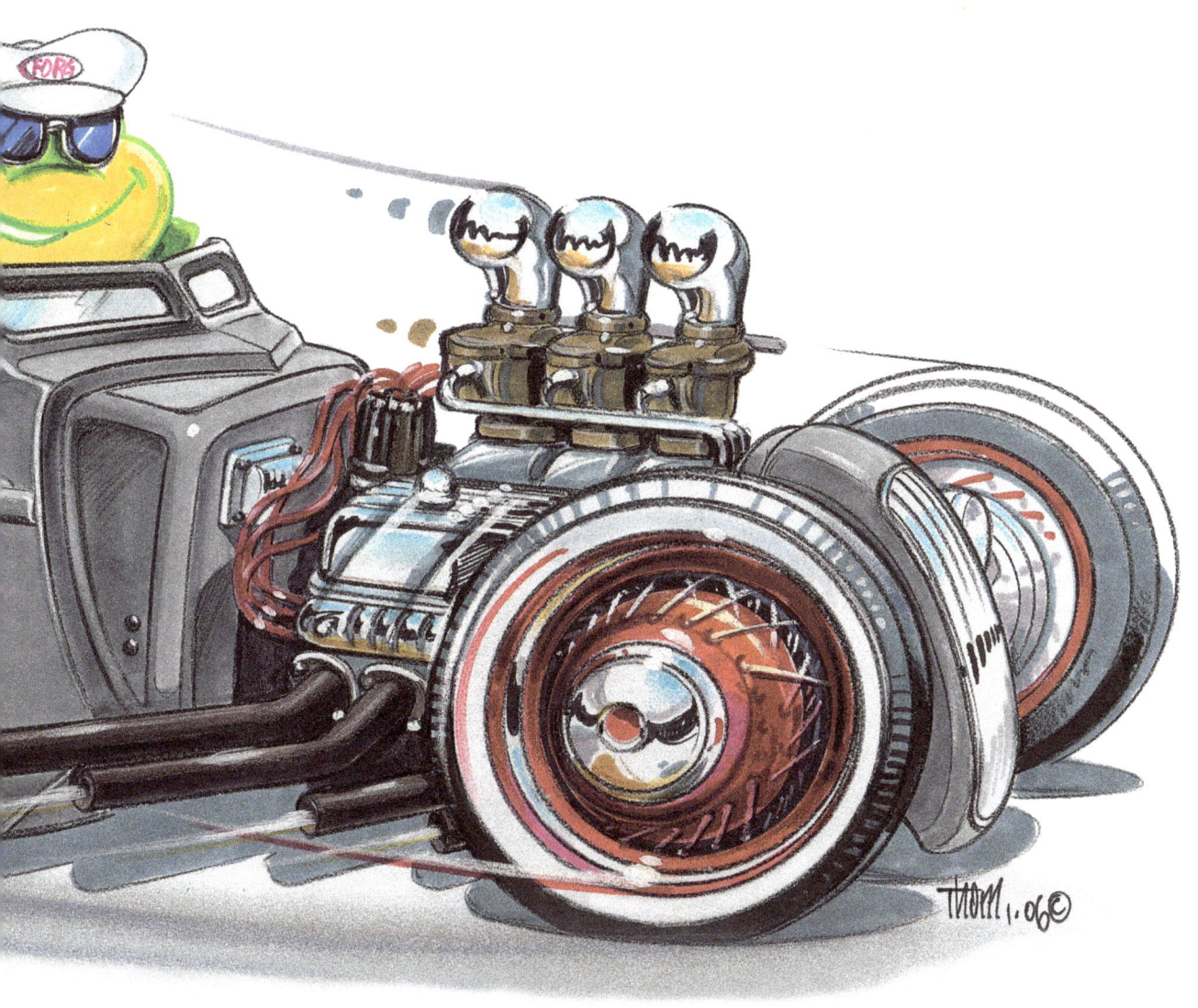

▶ The funny thing about an artist's technique is that no matter what medium, if he's good, it comes through. C. Cruz was doing art for years and establishing a look before he first plunked the keys of a Macintosh. Today he does 100 percent of his art on the Mac, yet the look he established decades ago is the same whether done with pixels or by hand.

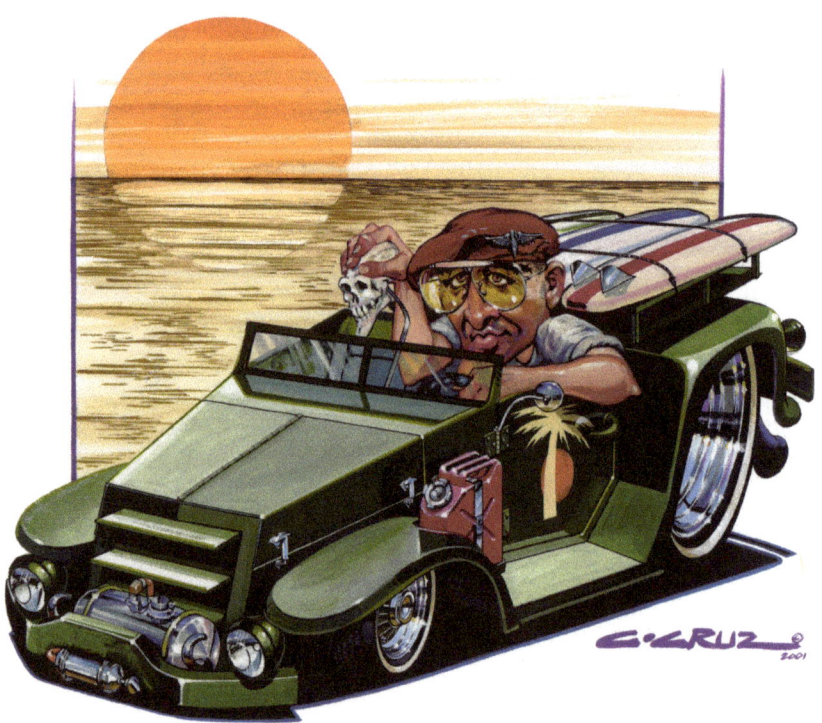

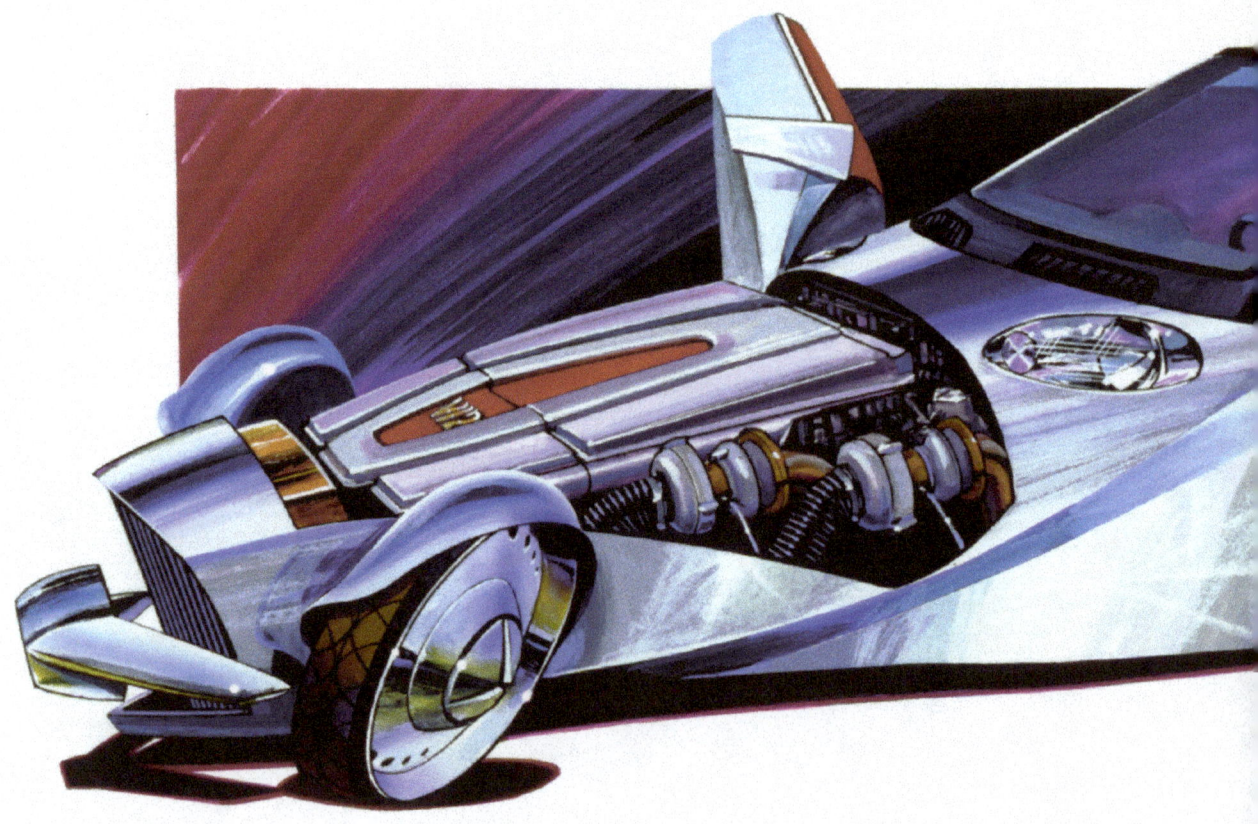

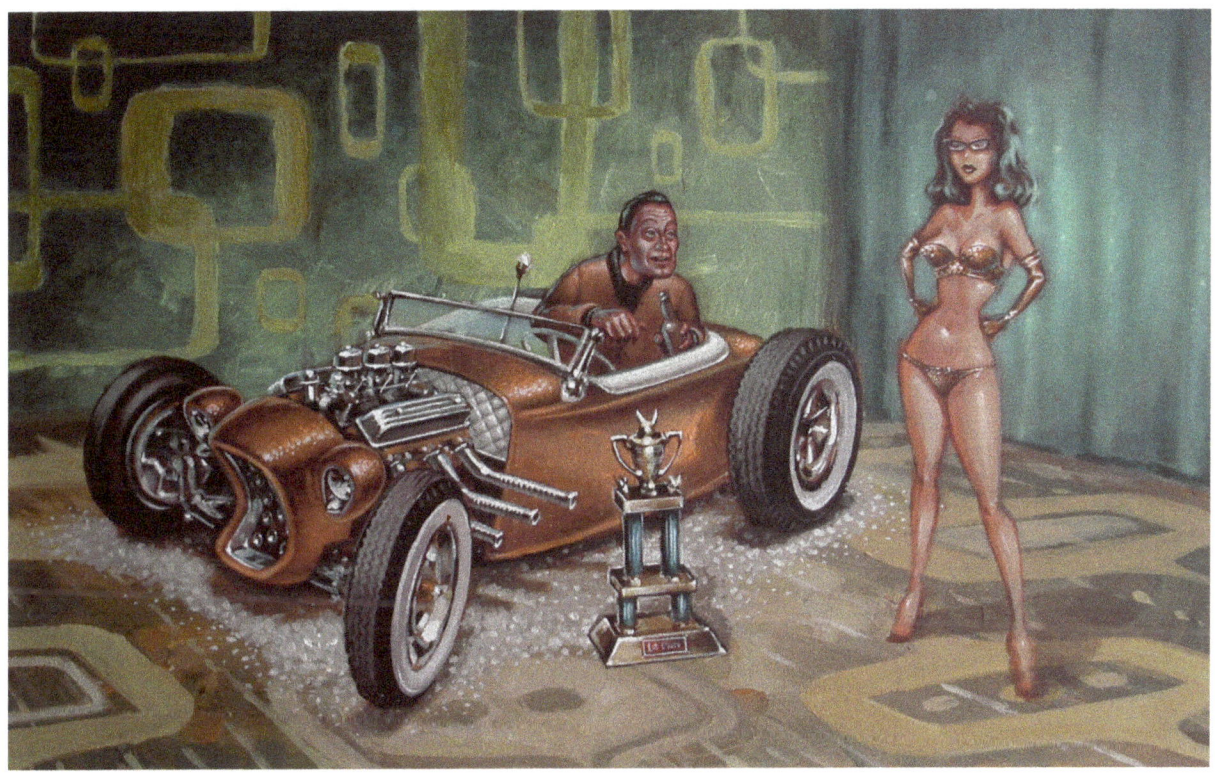

▲ A lot of the finished art you see from Keith Weesner is painted with acrylics. He does a light pencil sketch and then lets the paint fly. There are no lines around his subjects—the way he defines their edges is by gradating darker or lighter as he gets to the subject's edge. Also, notice how Keith uses a contrasting color behind the roadster to help pop it off of the page (see Chapter Eight).

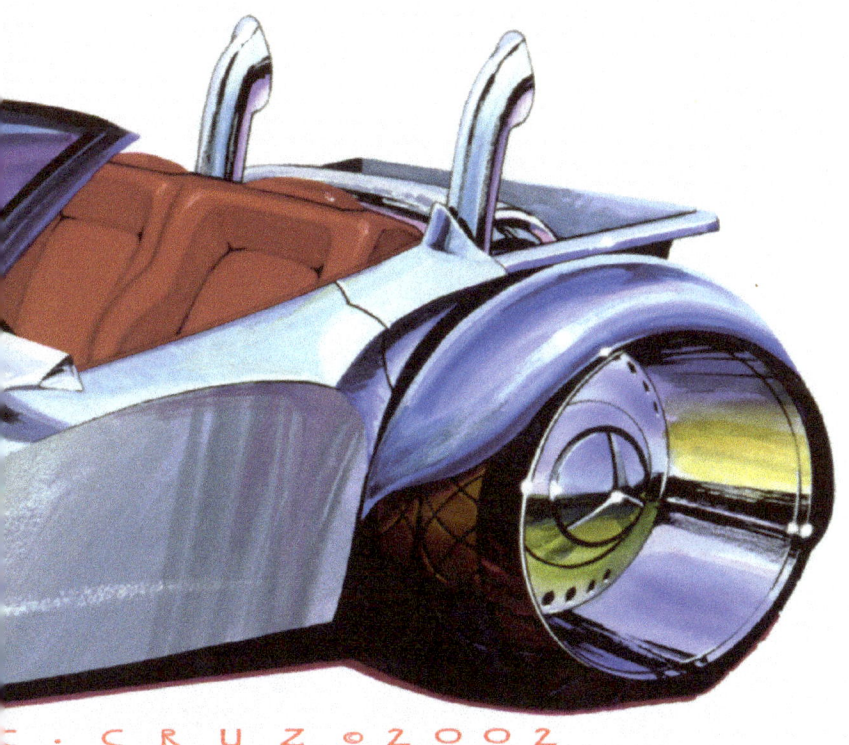

◀ With a series of broad strokes of color, C. Cruz obtained the look of brushed stainless for the body of this roadster. I'm sure he tried a few different approaches before coming up with this technique. It's a combination of the colors he chose to use and the pattern of the strokes that effectively conveys the look he was after.

TECHNIQUE

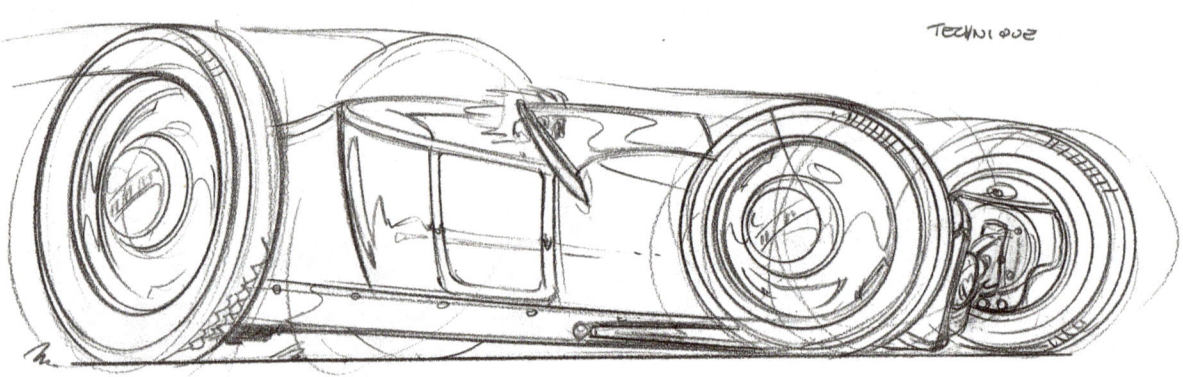

◀ One of my simple pencil sketches. Sometimes, after it's roughed in, I'll come back and tune it up with an ellipse guide and sweep, which is what I did here.

▼ Another example of my chalk-and-marker technique, done on bond paper from a tracing underneath. I worked blue into the shadows and tires, which I hope not only adds a little color but translates into interest.

Mad Monsters in 3D

Everybody needs to express themselves in different ways, right? Some can do it with an airbrush, pen, or pencil. But what if you have a mad monster pent up inside of you but not the chops to draw it? Or, what if you can draw your monster but you want to get it out in a different form other than the two-dimensional— say *three-dimensionally*? In this regard, at least two wacky projects based on the Brother Rat Fink T-shirt that Ed Newton designed for Roth Studios back in 1964 bear mentioning. (In 2006, the original ink drawing sold at auction for $25,000! Yes, that's three zeros. BRF was also a popular plastic model kit in the 1960s.)

The "Finkocel" is the warped brainchild of carousel-horse carver Chuck Kaparich. With the help of many, including John Detrich, who supplied the initial sketches to help Chuck visualize each station, Chuck is well on his way to finishing this long-running project. He's a big fan of Ed "Big Daddy" Roth and of Newt's art who wanted to pay unique tribute to the two Eds. We'd say he's a mad monster and crazy carver himself!

Andrew Miller is another mad monster aficionado who needed to get the Fink out. To express the art in a way uniquely his own, he created the life-size BRF sculpture seen here. The bike components are real, not scaled down, and the BRF was created first from foam, then from fiberglass. As Newt says, "It's both grotesque and startling when you see what I drew life-size." No kidding, Ed. You mean you didn't realize this when you first drew them?

Besides wood, foam, and fiberglass, there are also clays, papier-mâché, and even Big Daddy's method of creating his car bodies: plaster of Paris mixed with a little vermiculite. The point to all of this madness is that even if you don't have that thing inside that allows you to get your art down on paper, consider some other options to help you create monsters as incredible as Chuck's and Andrew's.

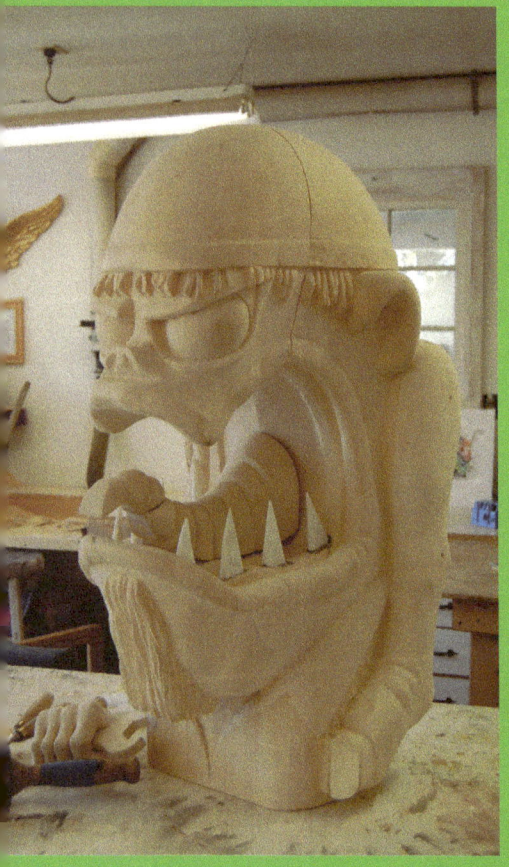

▲ Here's carousel-horse carver Chuck Kaparich's Finkocel version of Drag Nut before painting.

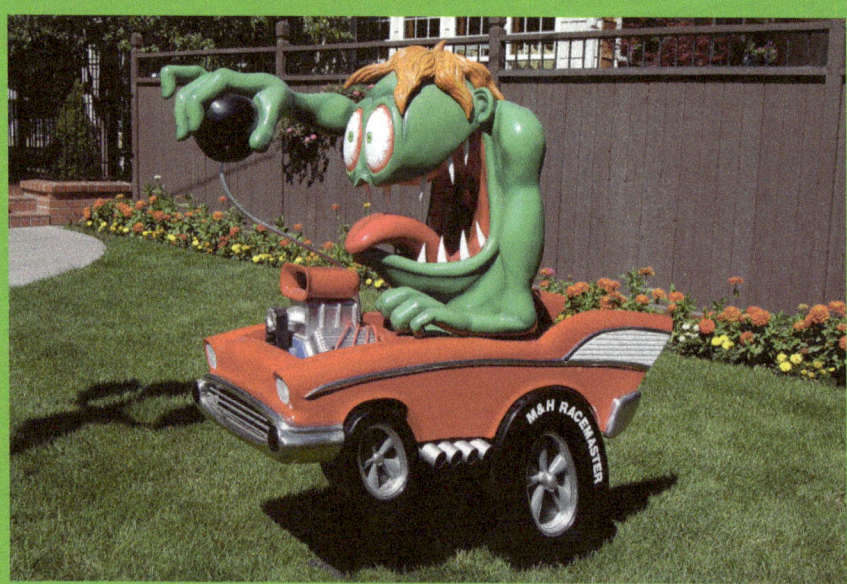

▶ Kaparich's Mr. Gasser eagerly waits to be attached to the Finkocel.

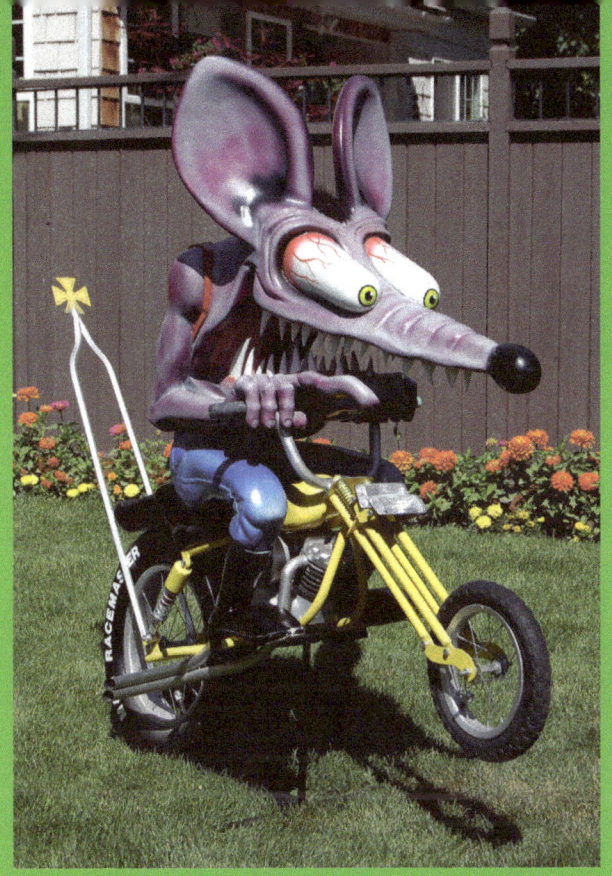

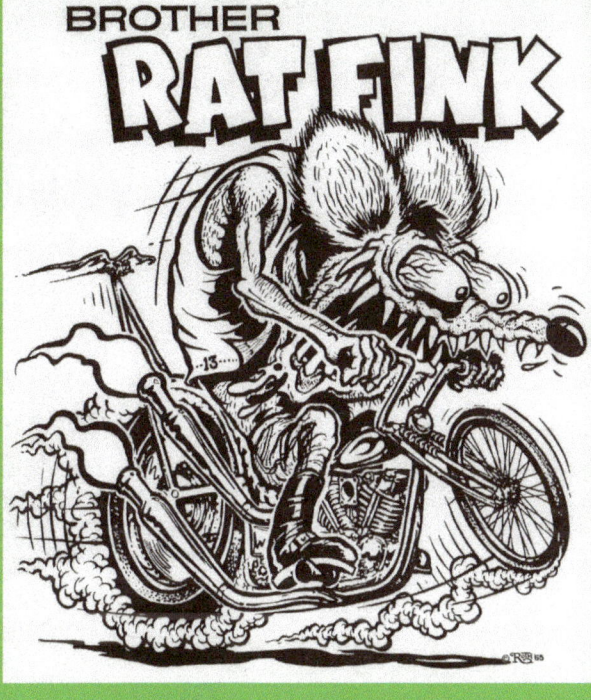

▲ Kaparich's 3D rendition of Brother Rat Fink owes a lot to the John Detrich sketch shown here.

▲ The original Newt art that inspired it all — and sold for $25,000 in 2005!

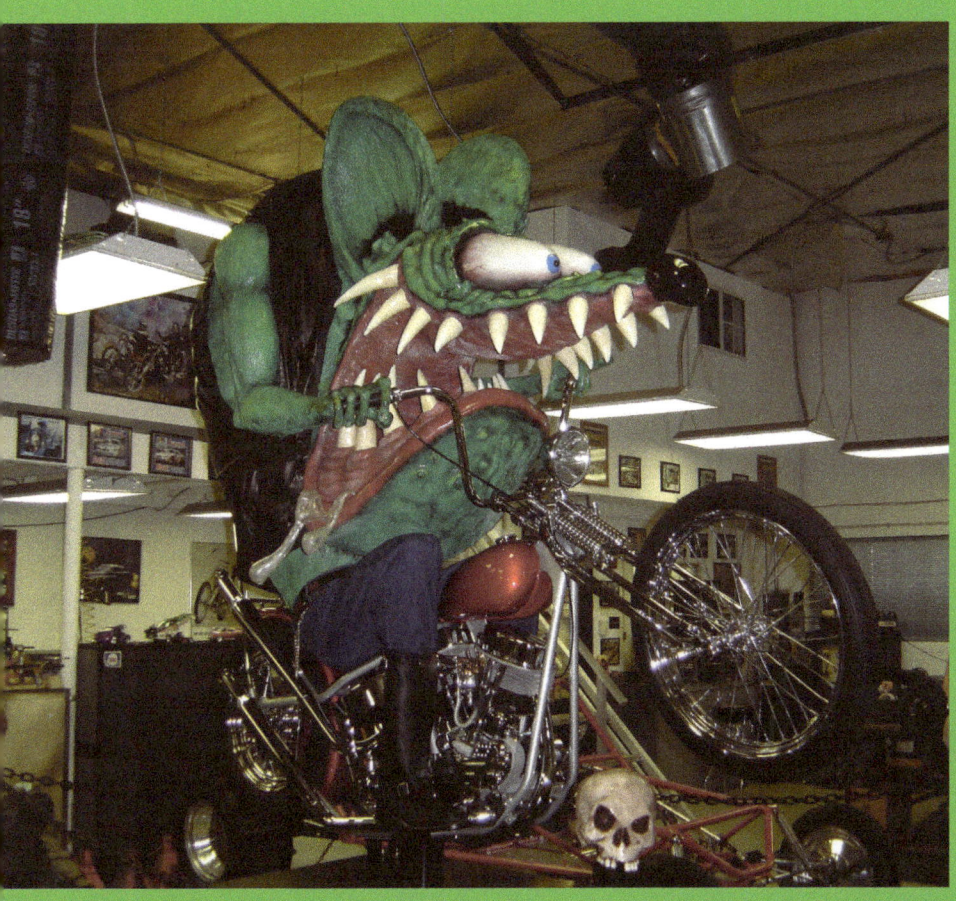

◀ Andrew Miller's life-size Brother Rat Fink homage features a fiberglass BRF and real bike components.

C
H
A
P
T
E
R

S
E
V
E
N

Light Source, Shadows & Reflections

You want that lizard-like skin to look wet and slimy, right? And how about that candy-green hot rod? You don't want it to look like it was painted dull army green, do you? Well, follow along while we wind our way through the world of light and shadow, reflections, and shiny images. Learn these tricks and your monster blood will look bloodier and that slobbering drool really will look wet and sticky.

The light source creates shadows, and both light and shadows have an effect on what is reflected on the car or on the monster's skin. Light helps to define the shape of your car and creature, as well as where they are in perspective; the color of the light source can provide a whole new way to dramatically show the objects in your drawings. So let's figure out where it is and how we get it.

▶ For automotive drawing purposes, your light source—whether artificial or the sun—will create a one-, two-, and three-box condition. Remember it! It is one of the most basic rules by which to render, and another part of that imaginary space that you create on your paper. Here's a trick to help you separate the surfaces of your car. The top surface—in this case, the one closest to the light source—is the lightest, or No. 1 value. The next-closest surface to the light source is the No. 2 surface, which contains a medium value. Finally, the No. 3 surface, the one farthest from the light source, contains the darkest value. The shadow cast from the object can be considered a fourth value, as it can be an almost black.

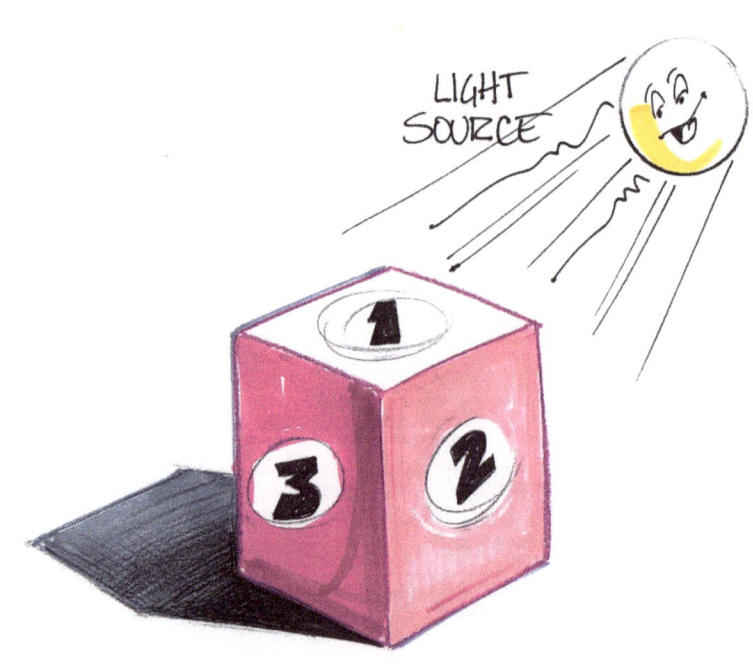

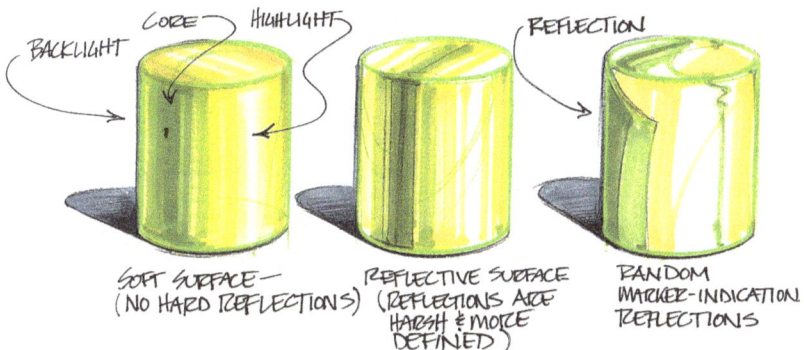

◀ To see the effects of light on a simple object, look at what happens to these cylinders. The first cylinder contains soft surface indication by the use of a core and the lack of reflections. A small amount of backlighting helps to separate the back of the cylinder from the shadow. The second cylinder is the same, but with a reflective finish that creates harsher highlights and a few reflections. But, it follows the same general rule as the first cylinder. With the third cylinder, I added some random reflections to indicate objects reflected onto the cylinder.

Generally the lightest portion of the drawing is where the greatest amount of light is cast on the subject. The light values grow progressively darker as the surfaces move away from the source of the light. Areas in shade are reserved for darker values. The easiest way to help you with this is for you to remember the one-, two-, three-box theory. If you imagine your car or monster as a simple box, the top of the box is your lightest or No. 1 value because it is facing up to the light source. The side closest to the light source is the No. 2 side, while the side receiving the least amount of light is the No. 3 or darkest side. This is another rule you must not forget.

Nature has given you a dark base from which to visually support your drawing by means of the shadow cast below it. A warning: Keep your light source in the general area of your head. It can cast from the right or left side of your skull, but don't try lighting your drawing from behind. Because the light normally defines the surfaces, lighting from the rear eliminates the ability to define the surfaces of your monster or your car. So you're left with only dark and darker surfaces to define, and you also get a big, ugly shadow of your car and monster right in front of it, which the viewer's eye can be drawn to rather than the subject. You don't want the shadow to become the big, bad hole into which the car is poised to fall—not good!

▼ This painting by Keith Weesner shows you what a light source directly above your car will look like. It's easier to figure out. Also notice that he uses a darker value of the background color to represent the shadow, which plants the car without being distracting or too contrasting.

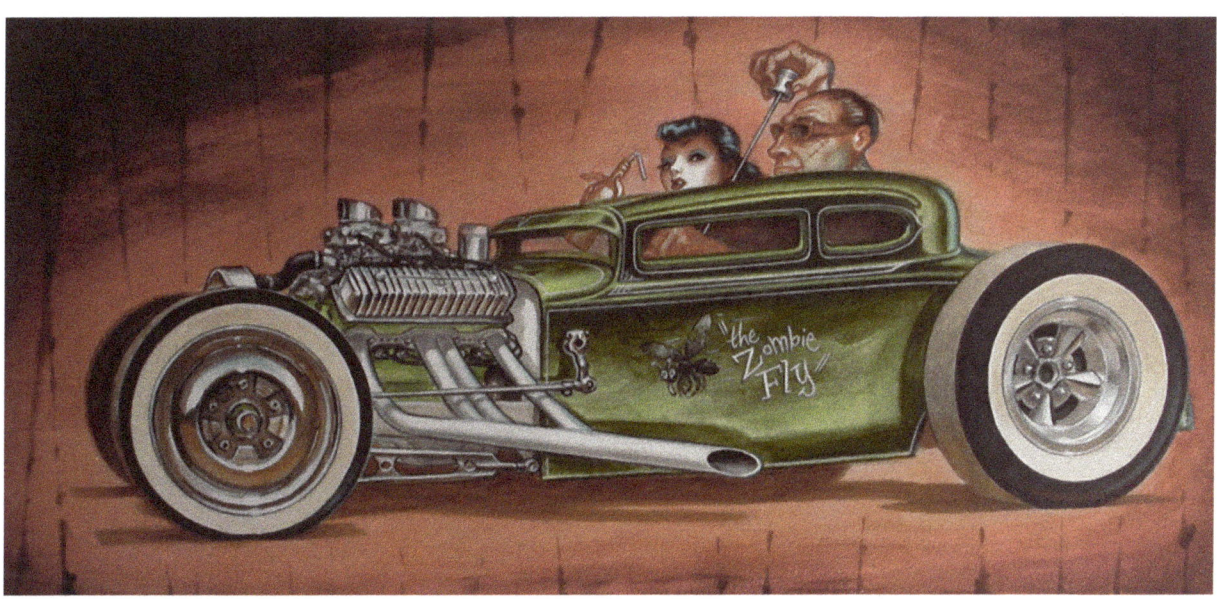

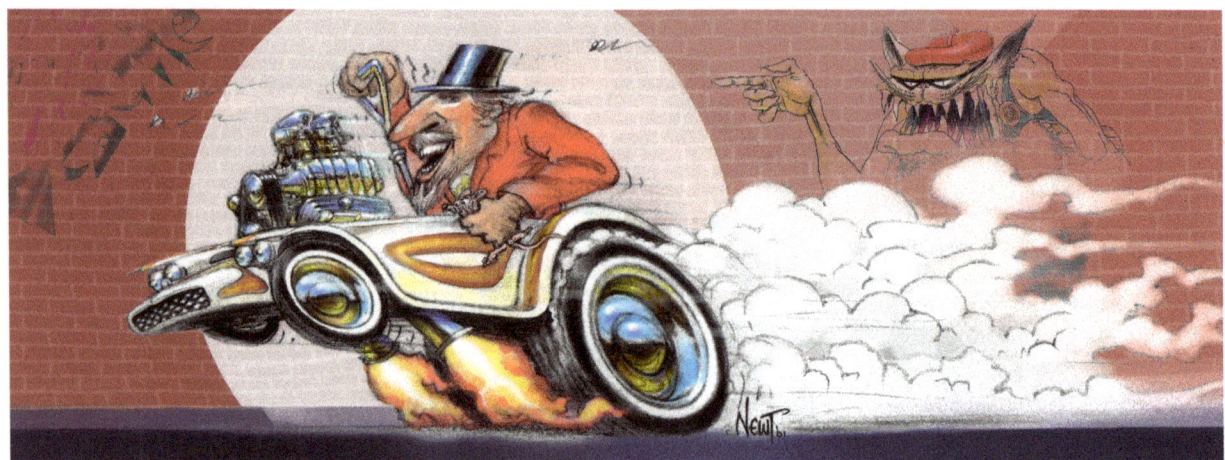

▲ This is the interior box art done for the Hot Wheels Outlaw diecast from a few years ago. The wall behind the main image creates a great place to feature some lighting drama. It also frames the main subject to give it a little more prominence or importance.

▶ There are some fairly standard rules to follow in order to give a proper shadow indication. These simple objects give a general idea of how shadows are created. Since cars exist outdoors, during the daytime, at least, the light source will always be the sun. Because it is so far out in the distance, the sun's rays are not radiating but rather are essentially parallel, which makes for easier plotting. A shadow is created when the outermost surfaces or edges that catch the sun's light are cast against another surface, usually the ground.

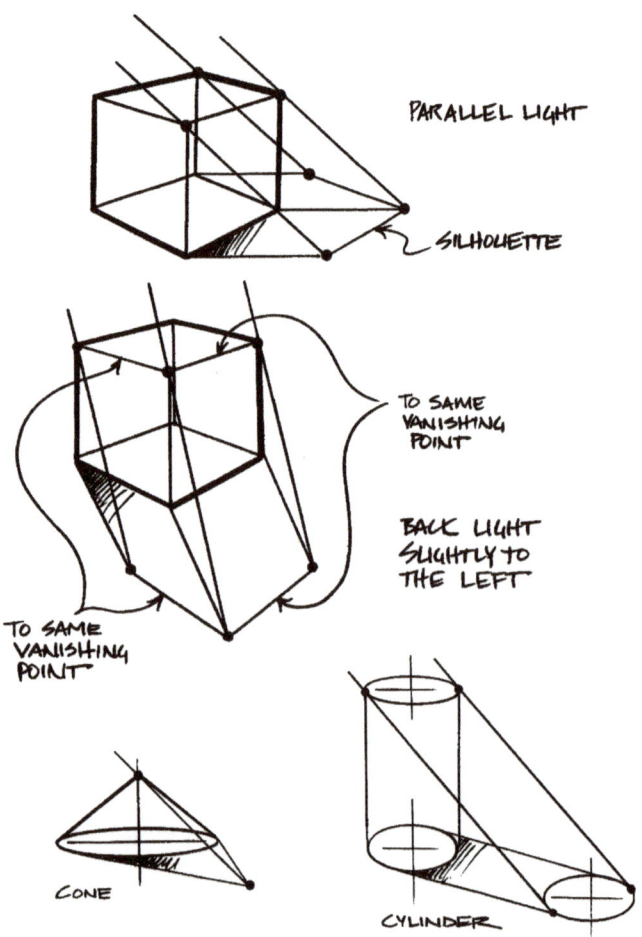

One final thought on lighting your drawing: Choose the side to light based on how much you need it to help you. In other words, if you need more light on the front of the monster and/or car to help define it, or to give the toothy grille some sparkle and interest, then that is the side you should light. If you need it on the side of the car to better define or highlight that part of the drawing, then light that side. You control everything in your drawing, so use your mind to determine what will work best to describe it in drawn form.

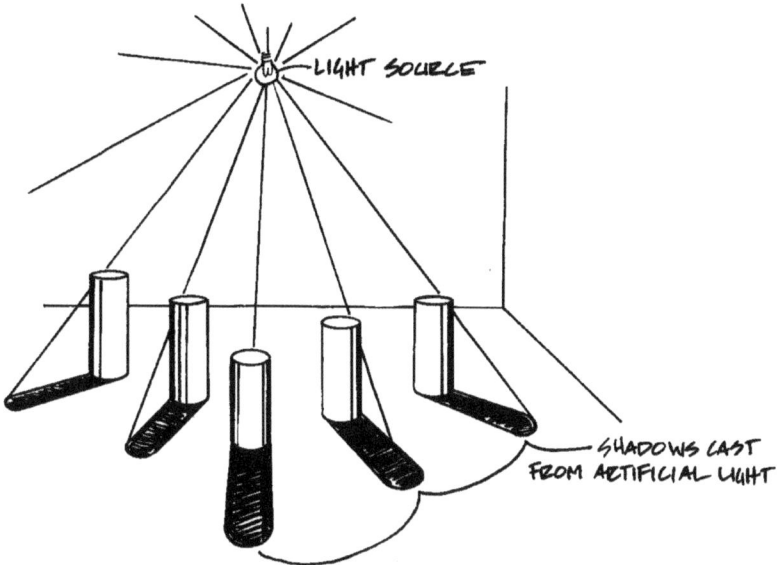

◀ This is the effect of artificial light on an object. Unlike the sun, the light rays are radial instead of parallel.

Rendering reflections on shiny surfaces of your car drawing or creature is probably one of the most enjoyable parts of doing the sketch. Constantly observe exactly what is going on in the surfaces of real-world cars and shiny objects to better help you define those same kinds of reflections in your drawings. Remember not to let reflections look like stripes running down the sides of your car—they should look like, well, reflections, not zebra stripes. The surfaces of anything shiny are just huge mirrors that reflect back what is around them. Carefully visualize the surface and what it would reflect, and you have a basis for your reflection patterns.

It may be obvious, but a car's surface changes continually. It's always good to observe the reflections dancing over the surface of a real car to see how they react to changes in direction, indentations, and the overall sculpturing. For fun, try to sketch some interesting surface reflections to help you understand the properties of a reflective surface. And definitely try a thumbnail sketch or three until you are satisfied with what you see. Of course, those thumbnails are good for more than reflections—they also help with proportions, placement on the page, backgrounds, and color selections. Thumbnails are included throughout this book to show where the artists started. Check 'em out!

Some artists use a scale-model car as an aid to stage reflections and shadows. Though the model will not provide specific solutions to your problem, it can help in showing how objects close to the car will reflect on its surfaces, or how its windshield will reflect into the hood. But don't be tied to this method—you may not always have a toy car handy to figure things out.

To make that car in your drawing look cooler, or to make your furry freak look more frantic, you want them in the perfect environment—and that may be somewhere that is almost unreal. If you want to show off particularly filthy teeth, or some unique feature of your hot rod, you may want to render it in some unique way to highlight these characteristics. It may mean adding warmer colors to the teeth to help pop them out from the monster's head, or running a certain reflection over a portion of the car that you want to stand out.

Stylized, somewhat simple reflections work best—don't overpower or draw the eye to a fussy, complicated reflection. Keep your reflections and shadows clean and simple, and your drawing will be too. Certain situations in the real

▶ I plotted the shadow for this roadster with red lines at key points to give an idea of why it requires this configuration. Obviously, the light source would be very low and to the right to create such a long shadow. Tire shadows are represented by ellipses and tend to run parallel to the world, which in most cases will be the top and bottom edges of your paper. The reason there are two ellipses for each rear tire is because the front and rear sidewalls and tread surface all create the shadow profile—so two ellipses represent each sidewall and a line representing the tread runs parallel to the top and/or bottom tread of the tire. The shadow on top of the far rear tire cast from the rear fender is completely incorrect, but I think it looks more real than the proper shadow would look.

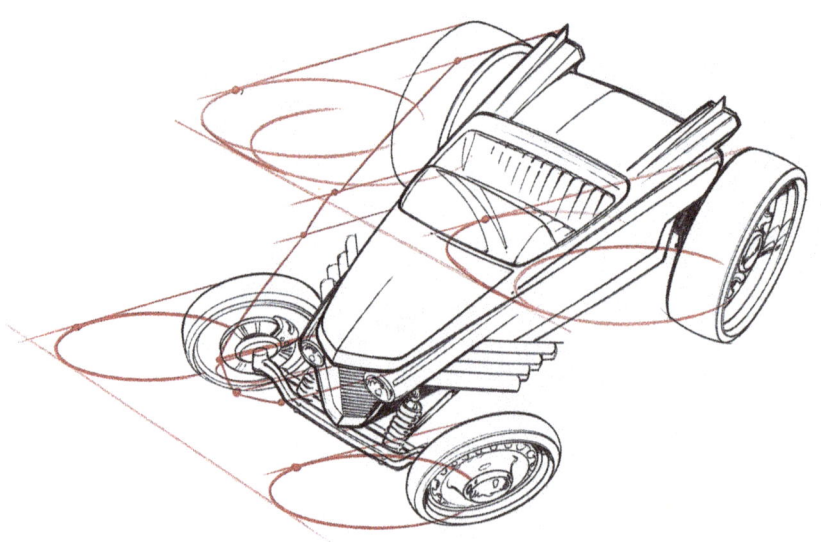

94

◀ Notice that the placement of the wheels and shadow relative to this Mercedes give the illusion that it's bombing through the desert, flying over railroad tracks. Without plotting it, Dave Deal got a fairly accurate shadow, picking up the profile of the body and passenger-side tires. Where is the light source in this drawing?

world cause interesting, complicated reflections, but it is usually best to simplify that situation for your drawing.

Like reflections, shadows need to follow the contours of the monster and car, and other elements, such as smoke. Look at the way we plot the shadows in some of the examples included here. You don't have to go to this extent in your cartoon, but it gives you an idea of why shadows cast the shapes they do. I like to do ground shadows in a dark color or black, but you need to consider the impact of your shadows. If your layout dictates that the shadow would realistically become a very large "patch," you may want to lighten its value or slightly reduce its size to keep it from overpowering the composition. This may take a little practice, so experiment on overlays. If you must have the shadow actual size, there are some tricks to visually cheat the size down, like adding a texture or directional surface lines suggesting faint smoke trails or ribbed asphalt.

Don't be afraid to throw in some color, maybe even an unreal color, to help pop your drawing off of the page. Red tires and shadows against a black car are especially cool-looking. Use your imagination, and go for something wild!

▼ Here's a Weesner painting where he uses a darker value of ground for his shadow, but also for the far rear tire. Because that far tire is a lighter value than the other tires, it helps to visually push it back into the perspective space.

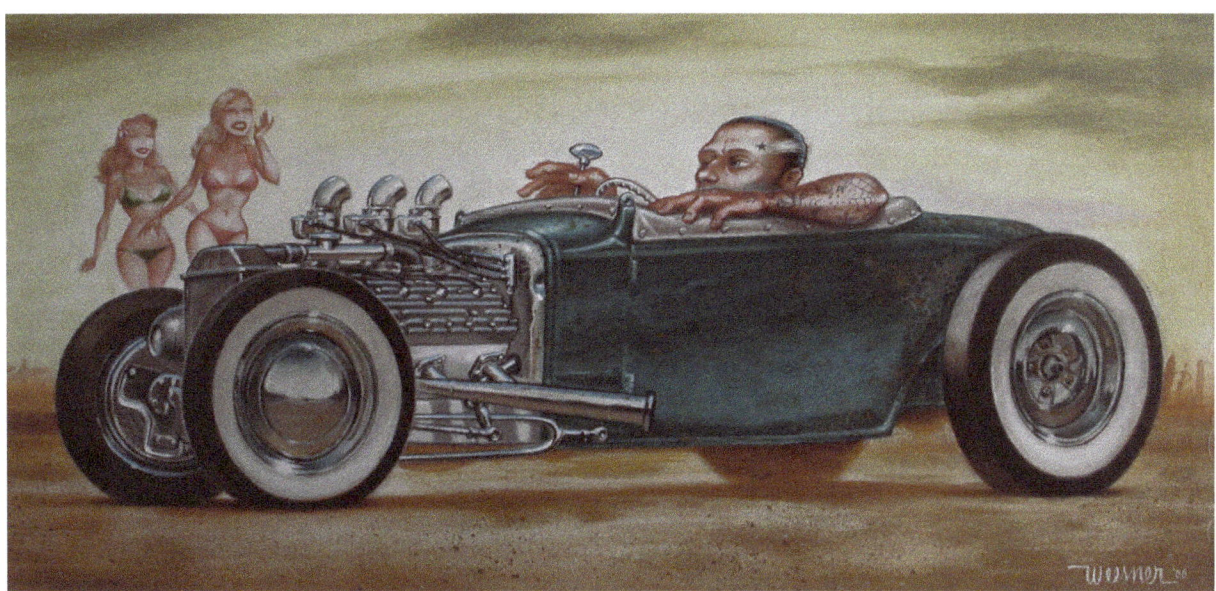

▶ If you're still not comfortable designing your shadows, here's an example of how to vignette or fade the shadow as it moves away from the object creating it so you don't have to define it. In fact, sometimes this works better than a distracting, complicated shadow outline.

▲ Think of the side of your car as a giant, slightly convoluted mirror that reflects everything around it. This becomes another element of the space you create for your monster and car. Where are they? What is sitting around that would reflect into the car? Where is the light source? You set the stage for your car and monster to best define them in your drawing.

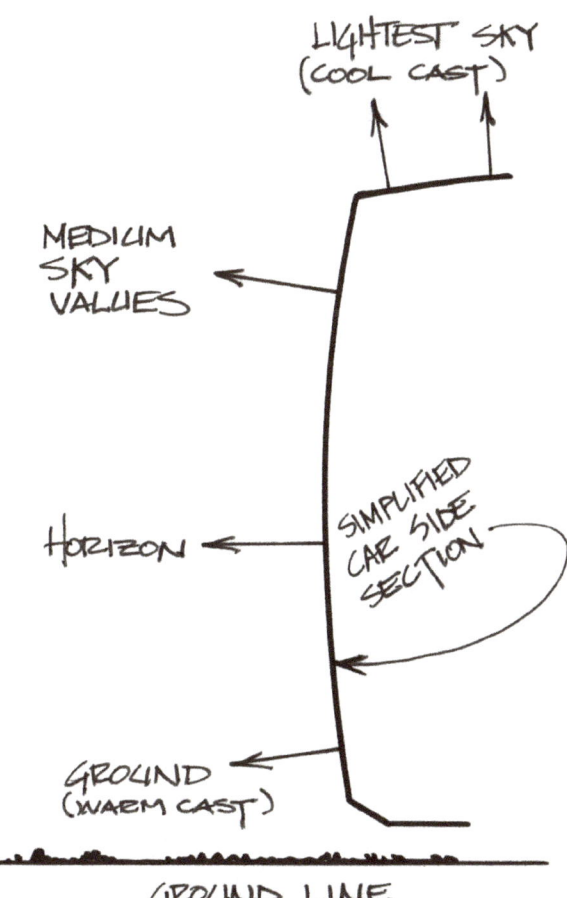

▸ Our high Hummer has surface changes that pick up conditions within its environment from all different directions. Not only does it pick up reflections, it picks up cast colors like cool shades from the sky, warm colors from the ground, and highlights from the compression of the light source at surface changes.

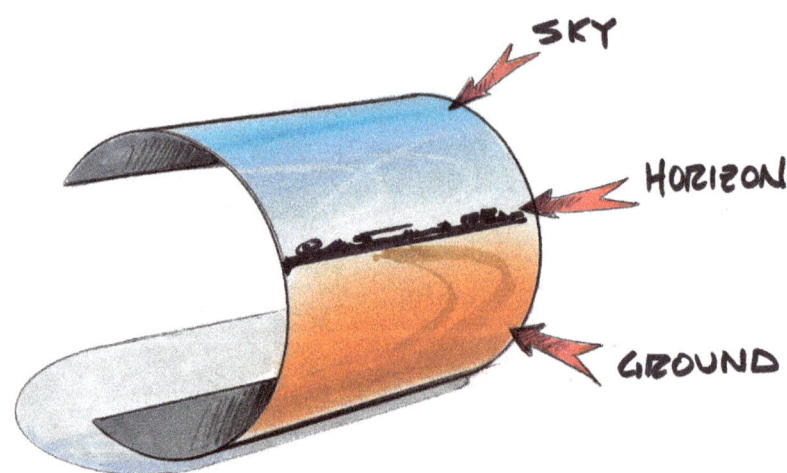

▲ So, what is reflected onto your car? All of what is shown here and more. Anything you wish to reflect is fair game—just make sure you don't confuse the viewer, or your car will end up looking like the dinner in Fluffy's cat bowl. Most of the examples in this book tend to simplify the scene. A car's body will usually compress and stretch out reflections so that the horizon becomes merely a thin, dark area reflected onto the side of the car.

▲ A gradually curved surface will pick up the "perfect" sky, horizon, and ground setup like this. But we usually aren't reflecting a perfect world—normally, a lot of objects and obstacles get in the way. Still, this perfect setting makes for a more believable scene reflecting into your car.

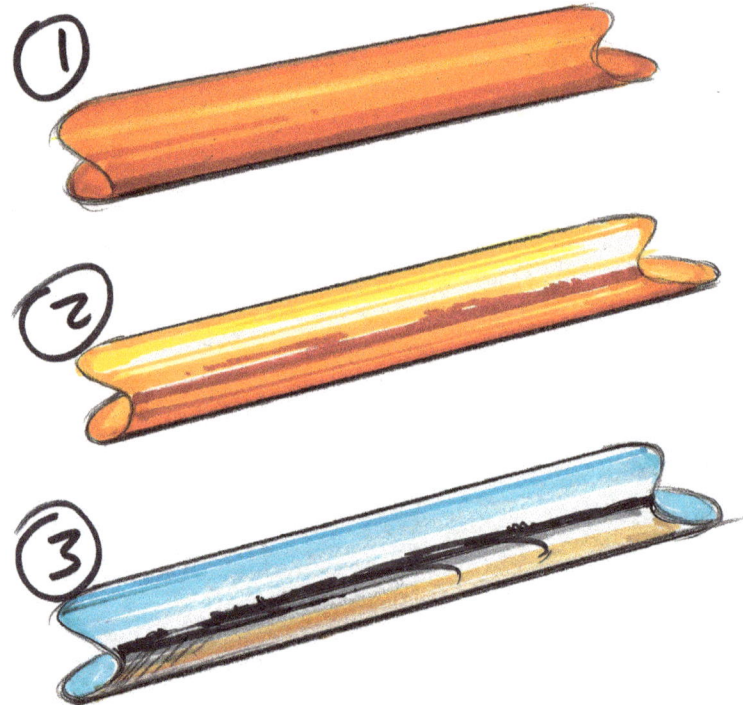

▶ No. 1 represents a simplified example of what would be reflected onto a slightly dulled or less-reflective finish. No. 2 takes that same tube, in the same color, and gives us a sample of a much more highly reflective finish. The reflections now have more contrast, and the horizon is slightly more detailed. No. 3 represents a chromed finish. Chrome is much more like a mirror—there is no color tint, so the reflected colors appear much like they really are. Since our drawings will tend to be done on paper slightly larger than this page, such reflections will be a few simple indicated lines.

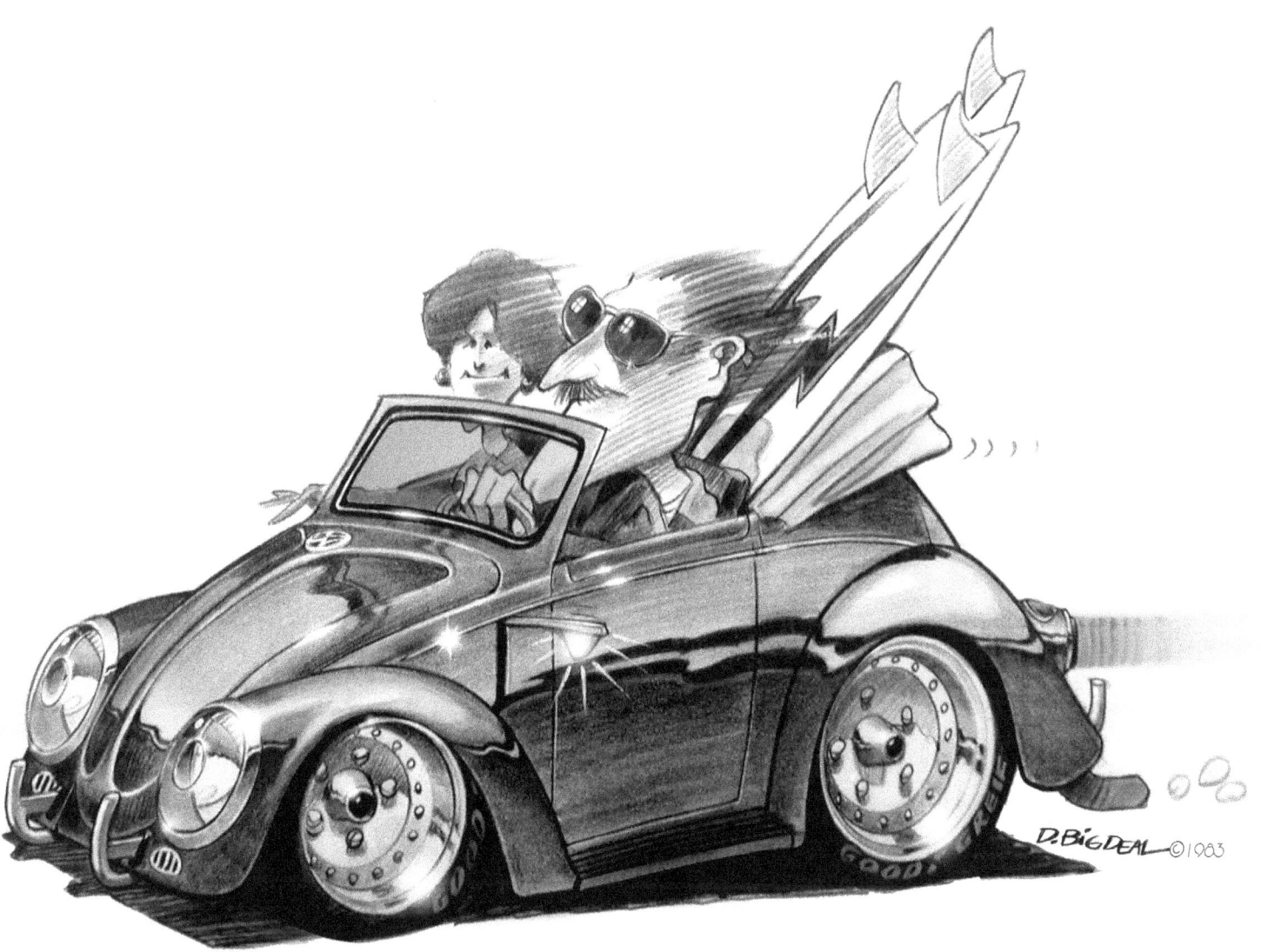

▲ With mad monsters and crazy cars, we don't get into reflection too much, because with fire, smoke, huge tires, and action taking place in our drawings it is hard to add yet another element. This Big Deal sketch handles the reflections in an easy-to-understand fashion. The horizon and ground reflected into the Bug are sketched from the middle of the body down, and the area above the horizon reflects sky—a lot like chrome but subdued a bit. Notice that the windshield also reflects down onto the hood, the folded top reflects down onto the rear fender, and that by drawing the horizon lower on the fenders, Dave helps to trick the eye into seeing those fenders protruding from the car—which they do in real life. Do you see where the semaphore light is reflected on the body?

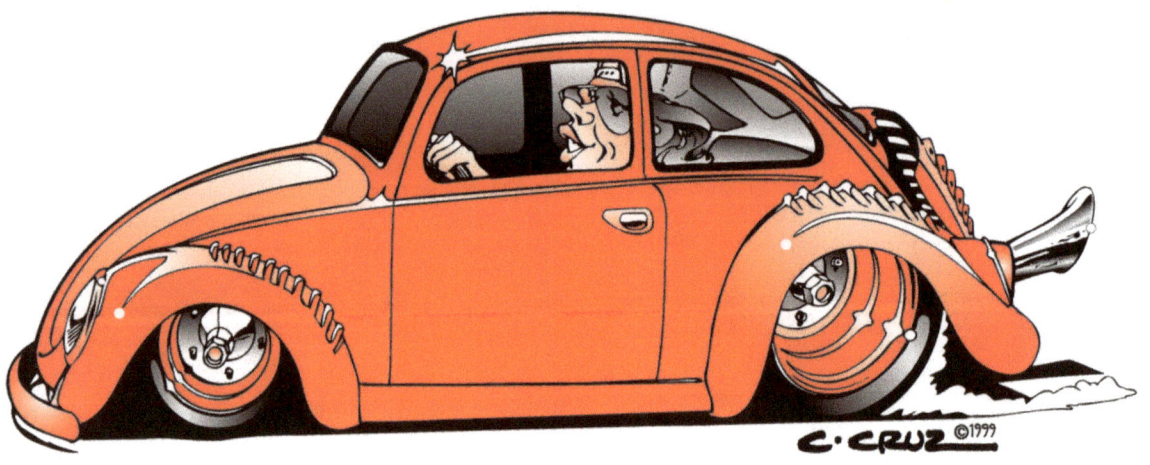

▲ If you're a little freaked out about reflections you can choose to omit them when starting out and just deal with the core values that define the overall shape. This is a cool C. Cruz drawing because it uses simple color placement and no reflections. He knows where the reflections go—he just chose not to use them.

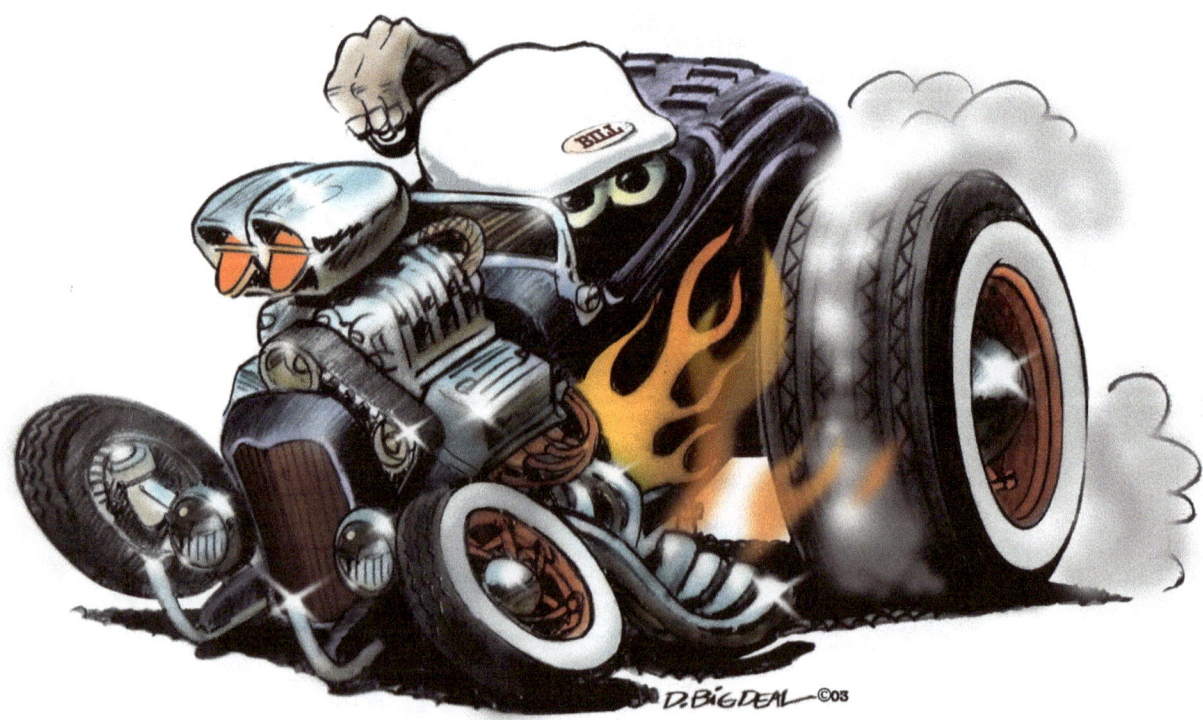

▲ I like this Dave Deal sketch for its simplicity of color placement, but the reason I'm including it here is because, like C. Cruz, Dave chose not to complicate the drawing with reflections. With the little amount of body that is showing (and what is showing is covered with louvers or flames), why try to do too much? In this case the drawing reads well without any reflections. Also note that the shadow below the right tire makes the roadster look like it is hooking up, which adds action to the drawing.

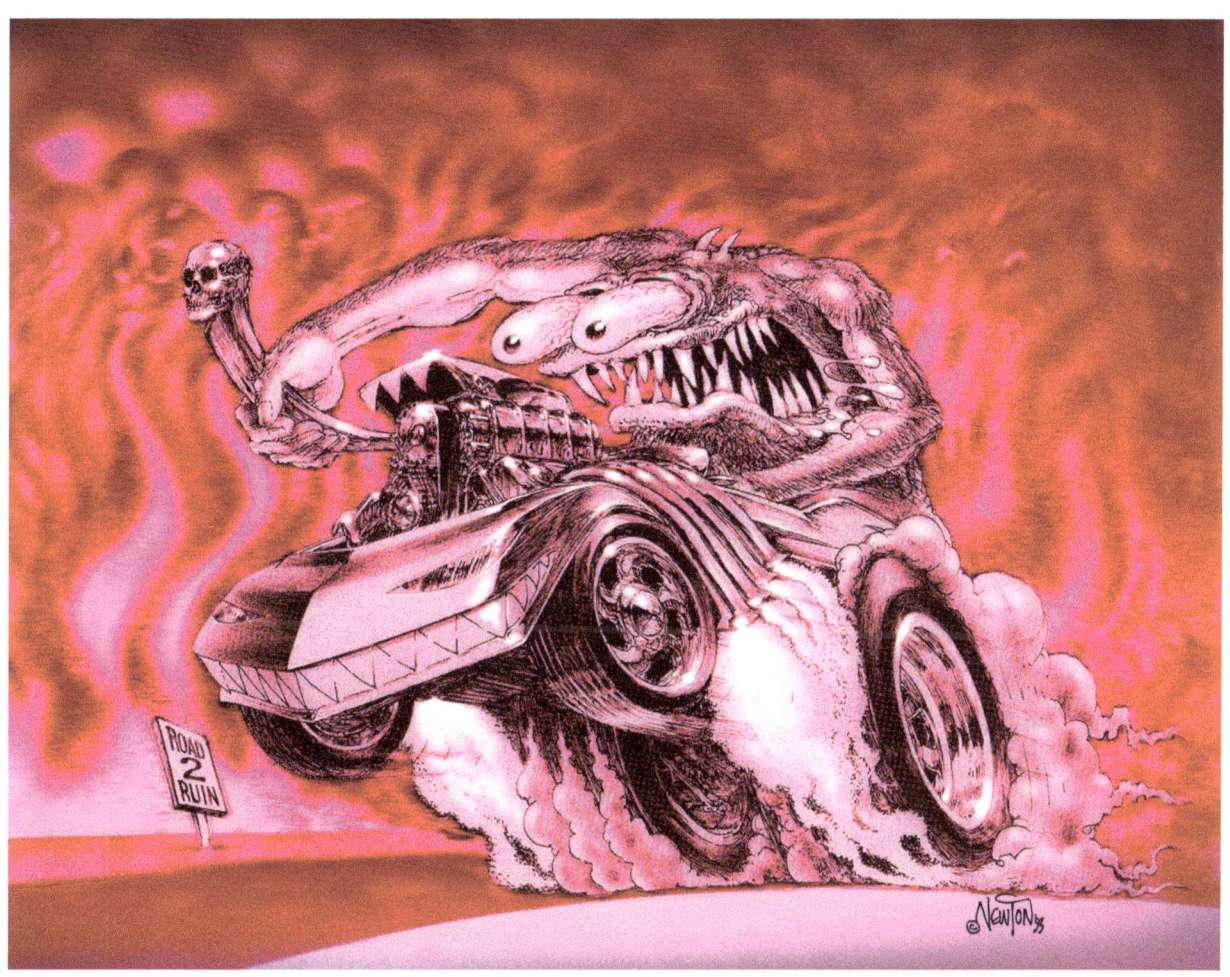

▲ This Newt illustration proves that you don't need a bunch of color for a bunch of impact—but that's not why it's here. The red tones can help show you how light source affects the car and monster without confusing you with lots of colors. The light source is probably just over your left shoulder, so observe how everything is lighted to be consistent to that source. You can see how he handled the medium value of the car, the lighter value of the monster, and dark values like the tires. Even really light objects like the eyeballs and smoke have tonal value to give them shape and substance. Everything has been sculpted on paper in essentially one color.

CHAPTER EIGHT

Color & Chrome

This is fun stuff, messin' with color and chrome, but as with other applications there are some rules—well, let's call them guidelines—that you have to think about when you're ready to plug in color. Let's start with chrome.

The illustrations that accompany this chapter get into the specifics of "juicy" chrome. Much like the body of a car, chrome is just like a mirror reflecting back what it picks up in its surfaces, or what it "sees." Unlike a car body, you're not dealing with a color that affects the reflection—you're literally dealing with a mirror, albeit one that is bent, crowned, round, or wavy.

So the general application is a horizon line through the middle of the chrome object, with sky reflected into the surfaces facing up, and ground tones for surfaces

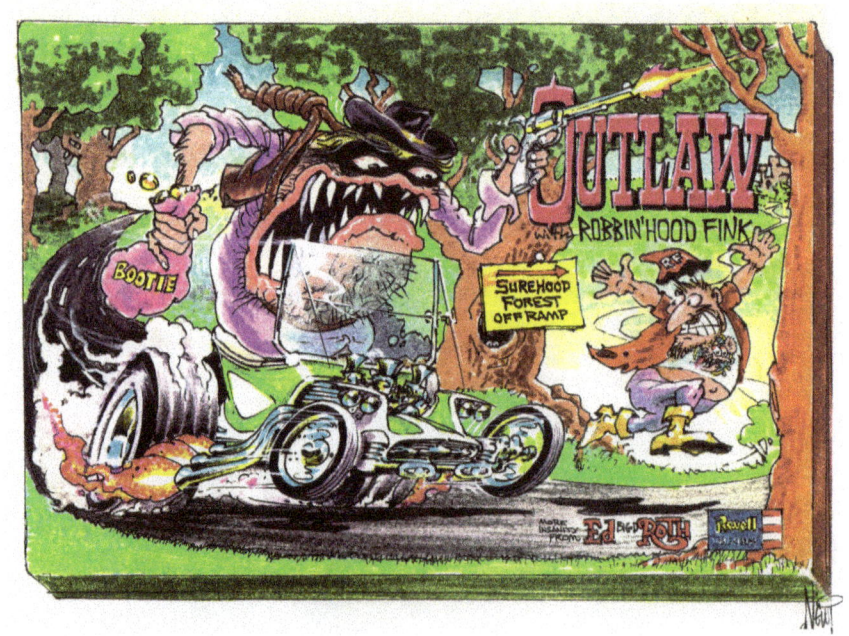

▶ Newton drew this sketch for Revell Models in 1964 when he was designing Roth's monster model kits for them. Color is used in such a way as to play off of itself. In other words, a limited amount of colors are repeated throughout the design so that your eye moves all around the scene. The green in the car is also used as background and ground, and the purple and pink in the monster are also used in the poster on the tree. It all works together.

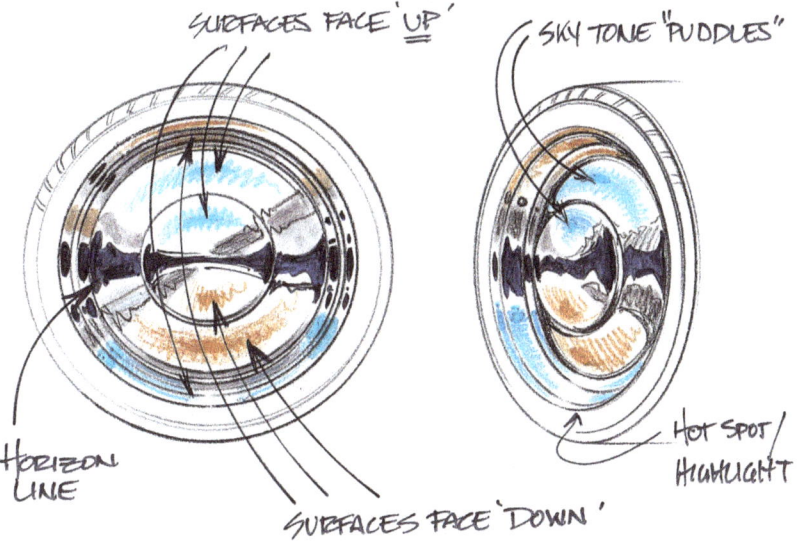

▸ Here's some simplified chrome indication. There are at least a million other ways to indicate chrome, and you should try experimenting yourself, but this example can get you going. Surfaces facing up reflect sky tones, and those facing down reflect a ground tone, with the horizon line splitting the two halves—it's fairly easy.

facing down. If the ground is green grass, or some surreal landscape with a red ground, then that ground tone reflected into the chrome becomes green or red. The same holds true for a nuclear sky or colored overhead lighting—surfaces facing these unnatural situations will reflect those colors.

Don't get too tricky or complex with your reflections, or you'll end up with trim or bumpers looking like they were bathed in barf! No kidding! For the most part stick with sky blue and a light orange-ish brown for your stylized chrome.

▾ A Dave Deal sketch of Big Deal himself. This is an example of his more recent drawings in which he uses less pencil shading so that he can show more variation in the applied color. Also notice that the reds closest to the viewer have a bit of orange blown in to warm them up and visually pull them closer to you, while the body surfaces turning away on the hood and trunk are slightly cooler to help them move away from the viewer. In this case, the color is actually doing two things for Dave.

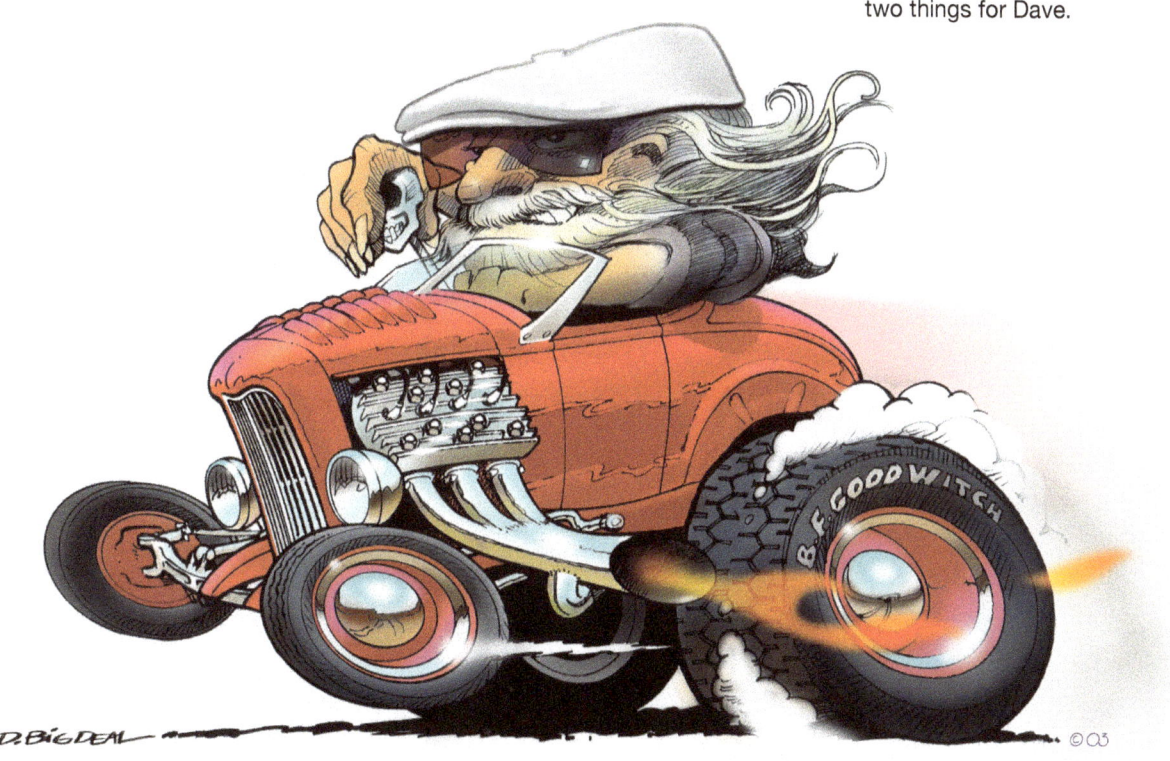

▲ I talk in the copy about sometimes using complementary colors to punch color into your drawings. Here's an example. A contrasting color to orange is green. Notice how I've snuck some green into the shadows, and also in the window reflections. Although there are very few colors in this sketch, the green adds interest to the drawing and squeezes a bit more brightness out of the orange. That's what complementary colors are supposed to do! Really, there are very few colors used in this sketch.

Another point is that as these chrome objects make a sharp turn inward or out, the reflected color compresses and looks more concentrated. So in some cases you'll indicate sky or ground merely with a pencil line of color. Check out some of the examples to see what I mean.

Also notice that whether it is the sky or ground that is reflected into the chrome, the color is usually not consistent—it varies or gradates. So there is typically a more concentrated amount of sky or ground in certain areas of the chrome, which blends out to almost no color at all. This is called "puddled" color because usually the color concentrates in the middle of the surface, like a water puddle, and gradates out in all directions.

One more thing to consider is that, particularly with a wheel, some of the chrome reflects into itself, so that an amount of gray should be used to approximate this effect. But you don't want your chrome to be blue, gray, and brown—you need some white to indicate all of those bright areas that reflect the light source and make chrome look like chrome. Again, observe different chrome applications in real life and try to mimic what you see. It's not hard to do—actually, it's a lot of fun making a few lines become brilliant chrome with a dark horizon line and some blue and brown thrown in.

As you can see, color enriches a sketch with added interest and dimension. It's an eye-grabbing tool that pulls the eye into your drawing, thanks to a few simple tricks. However, color can just as easily ruin a sketch if overworked or used in the wrong manner.

You'll need a good range of colors, whether they are markers, pencils, chalks, acrylics, or cel paint blown through your airbrush. If you're low on bucks, try and start with a good range of one or two colors, then slowly build your palette from there. Layering your work with a similar color usually works much better than a bunch of different colors scattered around.

There are color theories, such as the classic Munsell and Ostwald color systems, as well as considerations like tinting, contrasting, and complementary colors. But for drawing sick monsters and ripped-up cars, who needs theory? Let's concentrate on the most basic of color instruction and leave the other information for another time and another book—maybe one at your local bookstore or library, if you're interested.

"Cool" colors like blue, purple, and green tend to recede or go back into a perspective sketch. Conversely, "warm" colors like yellow, red, and orange come forward. One trick is to use warmer colors for the areas closest to the viewer. To push objects back into the perspective space you have created on your paper, use a cooler version of the color for the car body or monster's head.

▲ Here I could only use a few colors, but wanted to liven up the drawing, so I added a cool color to the normally dull shadows and tires. Since we don't need to deal with realism, we should use the latitude that is available to tweak reality!

▲ This is obviously a blue Honda, but to get the surfaces to read I have four different blues as well as black. Even though this is a bit much, it does add dimension to the car's paint job. But watch out so that you don't overdo your color application or your drawing will look overworked.

▶ If you need examples of lots of chrome, look no further. This more recent spraycan-airbrush, ink, and marker piece by Newt has "juicy" chrome the way he likes to do it. Even if you look at this from a distance it reads as chrome.

▼ Keith Weesner uses an equal amount of dark, medium, and light values to define chrome, while using a veiled amount of blue and brown. But when he uses a dark value, he places it next to a very light value, which makes the chrome indication very punchy and chrome-like. Compare his indication to others to see the similarities and differences in chrome indication.

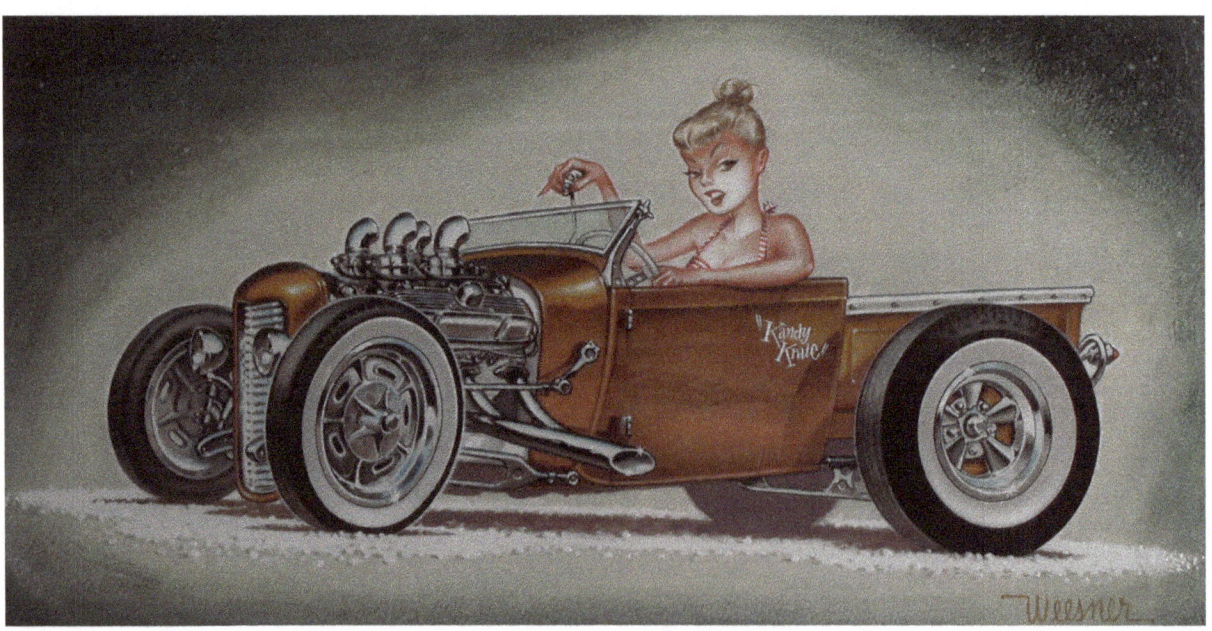

▲ Even a white car on white paper needs a little color dusted in to make the surfaces turn up—to give the car volume—as though it's solid. Just don't overdo it, or the car will look blue instead of white.

Another trick is to go with a lighter version of the color as you go back into that perspective space. This change in color should be very subtle. If the color change is too obvious it becomes distracting—it might even be construed as a car painted in a blend of one color into another, or skin going from green to yellow, or even zebra stripes.

Here's another color trick: Since a car is almost always viewed outdoors, the sky casts a subtle blue over the surfaces that face upward. But don't forget that those surfaces pointing up also get lighter, as in the one-, two-, three-box examples we talked about earlier. And just as the sky reflects from above, the ground reflects into the lower surfaces of the car. Blowing in cool and warm colors will start to give your drawing some real-world characteristics. And though we're dealing in a cartoon world, the objects we're drawing are based on real-world things, so to give them a sense of realism—read as cars, trucks, or living freaks—we need to include these tricks.

There are some pitfalls, however. Too little reflected or "bounced" color will hardly be noticed, while too much will turn your drawing into a circus poster. Also, if the overall color you applied is too timid, it gives the illusion of tinted glass—of being visually almost lighter than air. So when you are laying in color, remember to keep volume in the drawing. The car is a heavy object, and so is your monster if he or she is thrusting through the top, so you want them to have weight.

Finally, you will find that in some cases, two colors used in equal amounts are so bad together that they can scare you. Yet, using one of those colors in a small amount next to the other in a larger amount can actually punch up the intensity of the dominant color. For instance, if you are drawing a green car you might want to consider placing something purple around it—like a background, heavy outline, or component; or if it is a monster, maybe a purple tongue, hair, or teeth. Or maybe you have a blue car and you want to pop it off the page. Try an orange line around the car, or maybe as a tint in the windows, and watch the intensity of the blue scream at you. Together, the right colors can make for a more dramatic piece of art.

There is a lot to think about when using color, but that is because there are so many colors and so many things you can make color do for you. Colors are fun, but they are also tools that offer a lot of tricks you can play on your viewer. You may want to refer back to this chapter once you begin to lay in the color.

▲ Here's an example of how one piece of art can be utilized in two different ways, and also an example of the effect that color has on black-and-white imagery. The color image was created using the black-and-white art — except for the black field in the oval, no black was lost for the color rendering. A little bit of blue really helps the black read as black, while the red really contrasts with the black to grab your attention.

◀ Here are six examples from Newt incorporating gobs of color and chrome. These cars may look familiar, as they were done for Mattel's Hot Wheels line. Really, all of the tricks described in this chapter are represented in these designs.

109

▶ Now let's take a step-by-step look at the process I went through to complete the drawing you see on the cover of this book, with special emphasis given to how I handled the color. Here's the final pencil sketch that I will use as an underlay. I've played around with values and tried to put in as much as I plan on using in the final color art—maybe even a little too much. Perhaps I'll use it all or eliminate a few things—we'll see.

▶ The first step with color is to define your lines. Some artists do the lines in black, and some do them as the corresponding color, which is what I do. These will be my guides and were easy to come up with—because I did a tight pencil rough, I didn't have to figure anything out.

◀ Now we'll start to color this dude in with markers, although markers aren't essential! This step can be done with any number of media. These will be the background colors beneath any other secondary colors we may add later. As you fill in your drawing, think about what you plan on laying over these initial colors to help define each of the surfaces they depict. I have defined the one-, two-sides of the transmission and oil pan, and am starting to figure out the smoke with the marker.

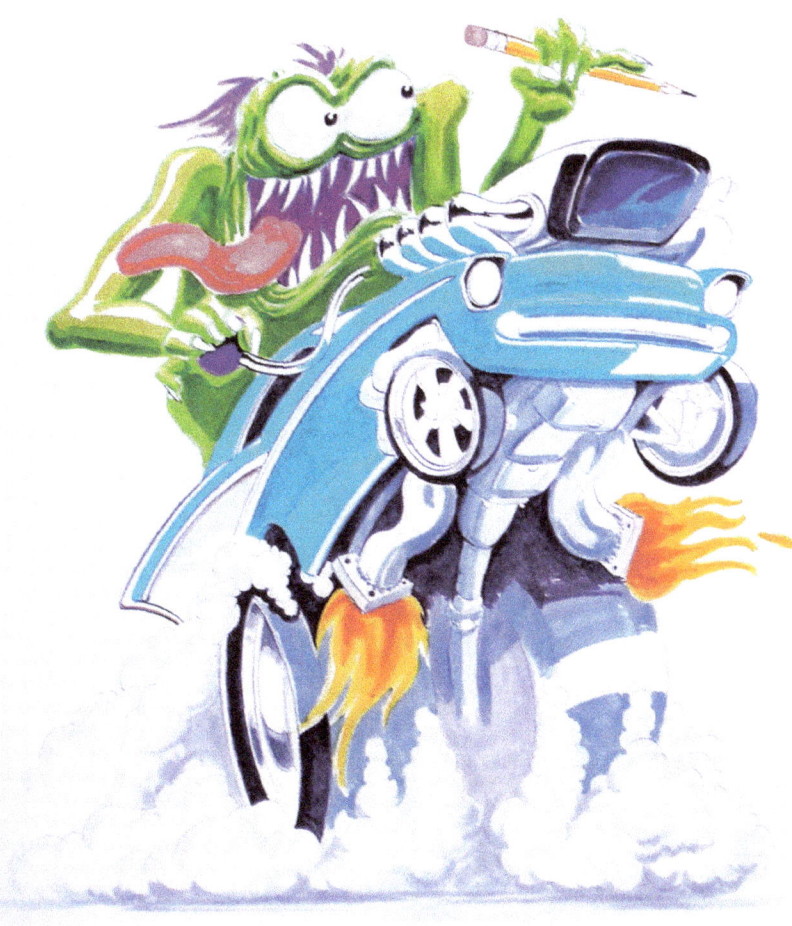

◀ Next, I start to add secondary colors to the monster's skin, his tongue, the side of the car, the tires, and the fire. I build up the color, starting with the lightest values first, then slowly work in the darker values.

▶ Darker and more defined is what I'd call this stage. The mouth, eyes, and skin are getting more detail, folds, and shadows. The fuel injection and car body are getting more detail, too. This step goes slower because you're noodling the shadows and details. It takes more time, but have fun with it.

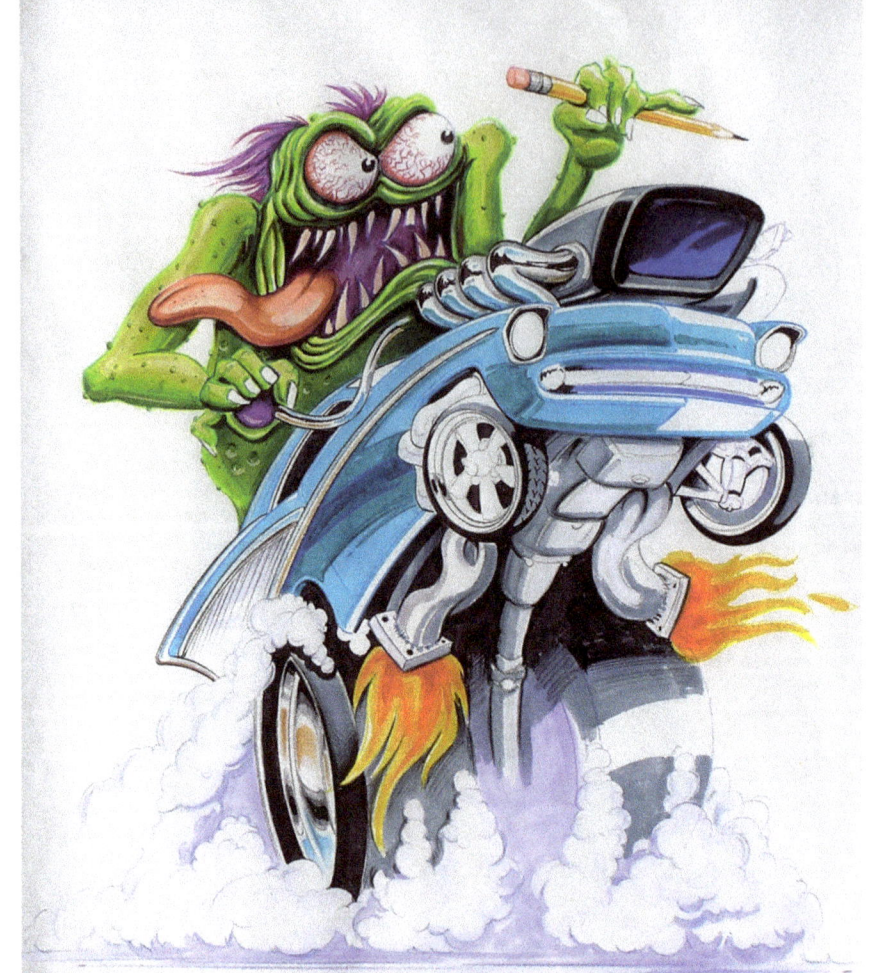

▶ All of the chrome is now detailed, including the headlights, and basically the rest of the drawing is finished. This is the last stage before I come back in with some white gouache for highlights or to correct some mistakes.

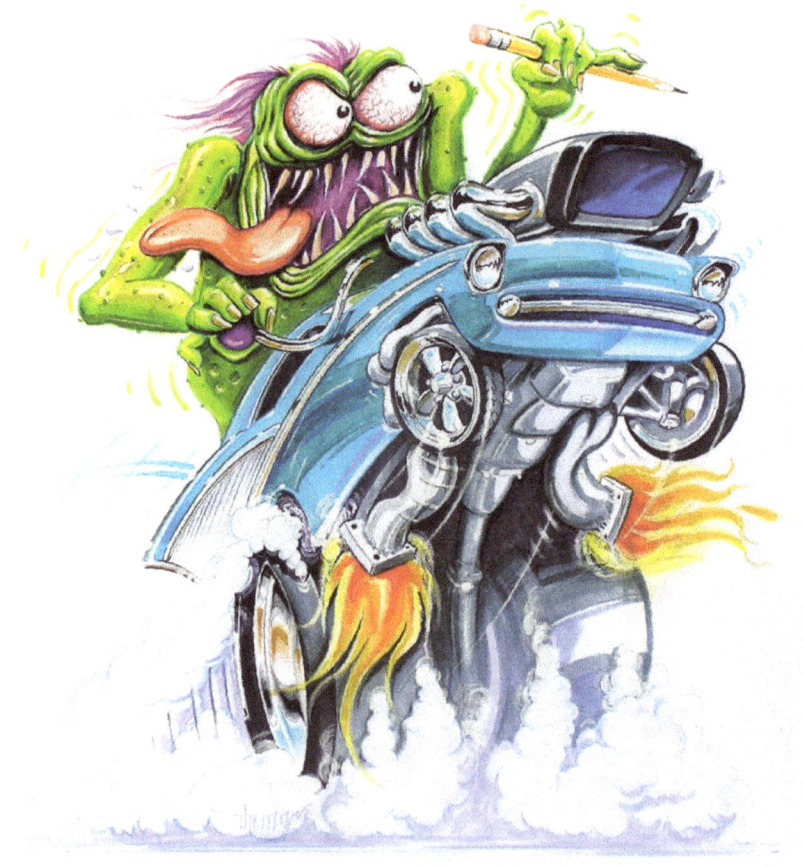

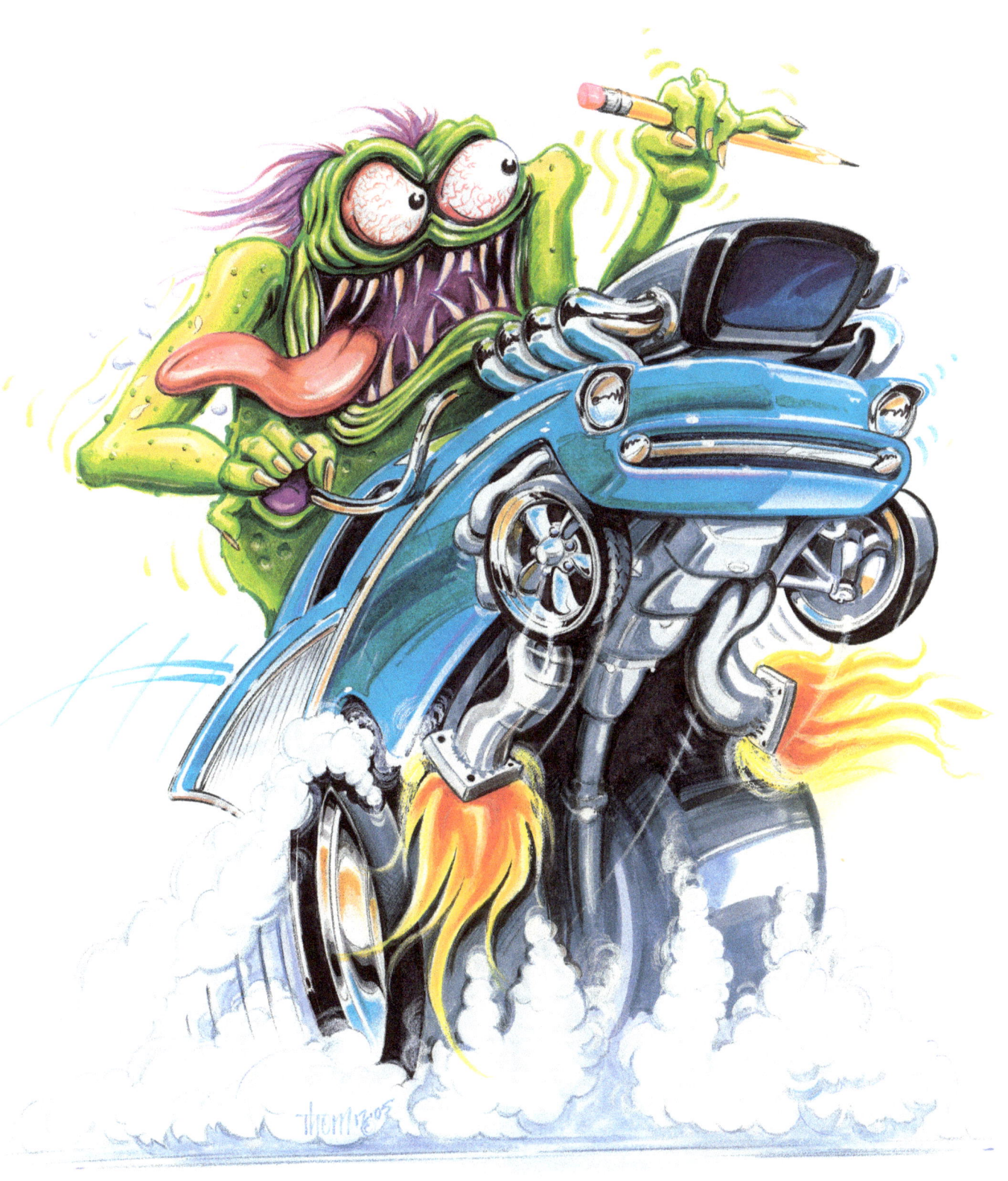

▲ With the highlights in place and any mistakes I may have overlooked corrected, I have arrived at the final drawing. As mentioned elsewhere, when you've arrived at what you believe to be your final, it is sometimes helpful to tack it up on a wall and come back to it a couple of times over the course of a few days. Sometimes fresh eyes detect those anomalies you missed previously.

CHAPTER NINE

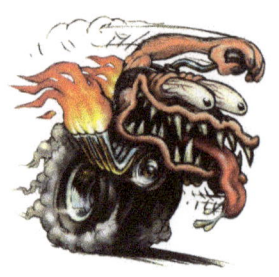

Smoke, Flies, Warts, Drool & Bloodshot Eyes

How many shirt monsters will fit on the head of a pin? None, because they're too big and hairy, and they hate fairies. But forget pins—you can chop them down to size with your trusty pencil. All you need is to pay attention to some basic principles of anatomy. Yeah, I know, we don't need no stinking anatomy—they're monsters! Well, our monsters are not alien octopuses from Star Warts or amoeba-men from some superhero comic. We need bug eyes to see what we're running over and muscled arms to slam shifts and steer thousands of horses into possible oblivion. So, in a way, these are sort of conventional weirdo monsters

▶ A drawing of Newt by Newt. Since this is almost a side view, you can see how the body relates to the car, and the kinetic energy that's built into the whole layout. You want your monsters to shift through the gears hard, while pushing their faces forward against the wind generated from all of that speed. This is marker and gouache with no preliminaries used.

114

▲ A very similar setup to the previous drawing. Note the muscles in this monster's body as opposed to Ed's scrawny arms in the previous design. As with faces and cars, there is an infinite variety of anatomical features you can incorporate into your creatures.

that have at least a primate look to them. They might have anywhere from one to a half-dozen eyes and a wretched mouth with bad fly breath, but more than two gnarly arms would just get in the way, so we'll deal with the classic monster, no matter how much of an oxymoron that might sound like.

Before we address anatomical attributes, we need to establish a relationship. No, nothing personal, dude—just a reference to the melding of raging monster and screaming car. When dealing with an object in motion, certain visual dynamics come into play. Let's assume that the car is blasting forward at a couple hundred miles an hour. Any more and the driver would have a hard time slamming second gear. Plus, pressure piling up inside his gaping mouth would probably pop his gourd. (Now there's an idea!) Anyway, we need to capture some of that kinetic motion on his body parts. If we think really hard about how air and

▲ Newt says, "This airbrushed 'street shirt' was a 'name only' shirt that the customer never picked up. So I buried the name with monster hair and painted a grizzled face underneath, and we were able to sell it later for the going rate instead of merely tossing a 'ruined' shirt."

motion will affect him, his torso should be bending backward at the center of the spine, but with a neck thrusting forward—he will strain and lean into the wind to keep from being snapped backward like a straw in a hurricane. Plus, his arms may be bowed slightly from atmospheric pressure, so all clothing and accouterments should be flowing backward from his rippling skin.

This tortured torso follows the natural curve that should correspond with the thrusting motion of the car itself. Unless your idea is to depict a relaxed monster saying hello to opposing traffic with his gentle green-light wheel stand, our deranged driver must look like he's at one with the roaring machine. So, following the primary lines of motion, the mass of the figure needs to look like it's actually occupying the vehicle instead of glued to the roof.

◀ **This page and facing page:** John Bell loves to sketch, and one of his subjects is odd people and aliens with attitudes. The only way you get good is by trying things and sketching over and over. These are just some among the multitude of beings John has added to his bag of tricks. Almost all are done with a No. 2 pencil, including the tonal values.

As far as the driver's musculature and features, you can pick anything between superhero sinewy to Rat Fink rotund—it's all good. Just try to use basic circles, ovals, and lots of "weenie sections" to construct your flailing freaks, as those shapes work better than boxes and cylinders. Once you get the general shape going, the next step is the, ugh, anatomy. I know this can be tricky, but by knowing how the muscles work in the human body you can apply all of the basic principles to pretty much any monster of your choice. Hey, it wouldn't hurt to know the way bones go together, either. If you want a scary skeleton driving a Hemi-powered hearse, you don't want your bad, boney boogieman to look like some tired Tinkertoy. The more you know about human mechanics, the more effective your presentation will be. When your car is exploding off the page and the maniac behind the wheel is reaching for the too-tall shifter, how cool is it to have his dynamically poised hand just inches away from the shift knob like some fat five-legged spider ready to pounce? And leave room for some choice vein interchange on those arms, but don't get carried away. For instance, a little hair goes a long way—otherwise your lean and mean madman might end up looking like a steel wool fur-ball.

▲ Wishbone was one of the Ed Roth cars of the 1960s that Newt had a hand in designing. For this design he has used the W in the word "Wishbone" as antlers for the monster. Also, the monster's mouth makes up the entire top half of the torso. Notice that drawing the front wheels so out of perspective gives the car a twisting look. Cheating the rules can sometimes make for a better design, but you need to know the rules first! This piece is ink, marker, and gouache on paper.

When all these things are put into play, you'll find that your plush-mushy monster will suddenly acquire the attitude of a junkyard dog with maggots in his brain. You'll also find that all the rules you've learned up to this point for monsters and hot rods apply to the small, simple details that can really make your mad monsters: smoke, flies, warts, drool, and bloodshot eyes, of course. You still must concern yourself with which direction the light is coming from, how it affects the object—including the shadow it may or may not cast—and using color to make it seem like water in the case of drool, skin in the case of warts, and so on.

continued on page 126

▲ Not all monsters need skin, drool, or bloodshot eyes. Here, Dave Deal created a monster skull with a contemporary look to it, along with a later-model car and clean colorized computer application.

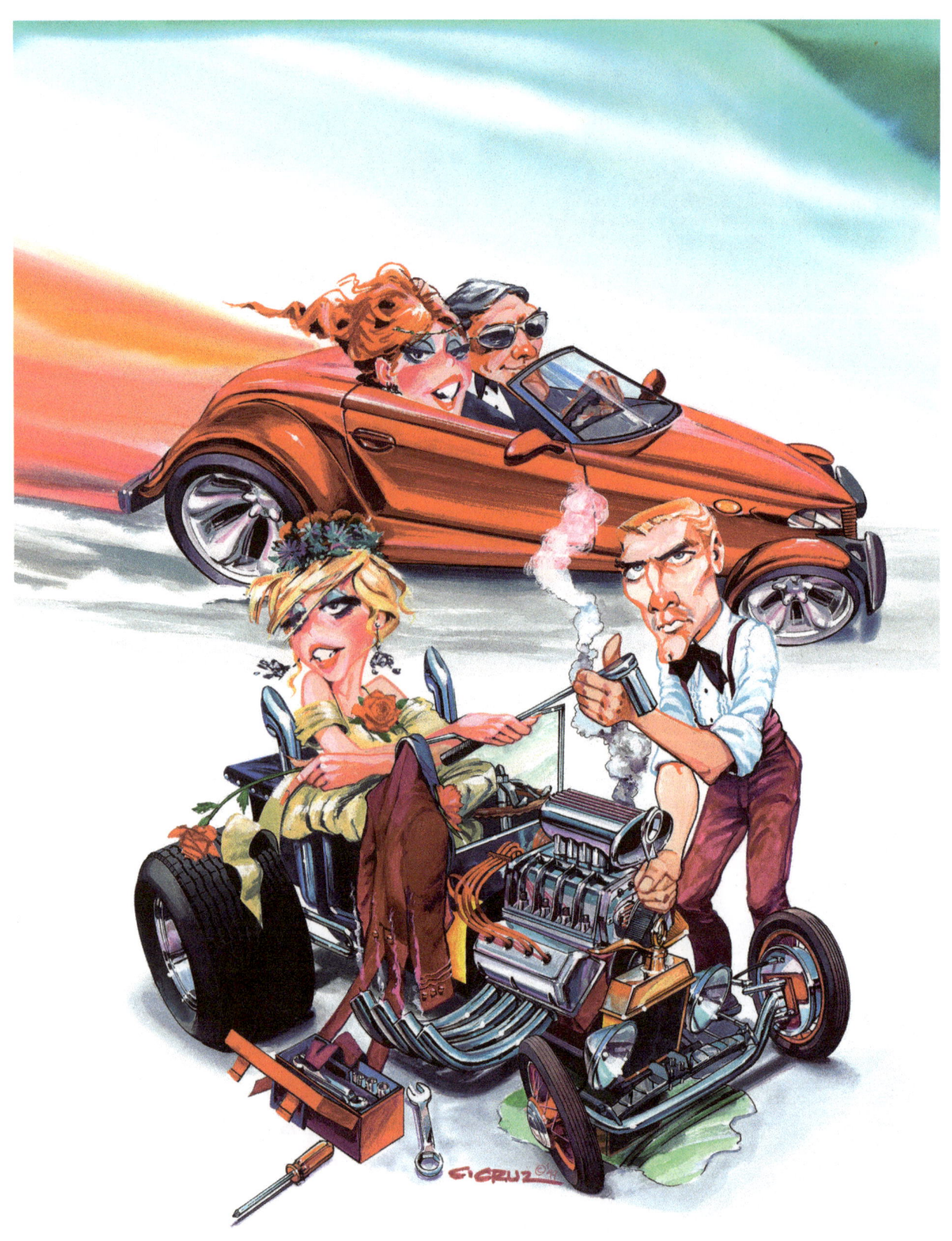

▲ More exaggerated people from C. Cruz. He created a story for this design, which is sometimes a good idea to help spark a cool drawing. Notice that even the colors Cruz uses in his people are exaggerated, yet still read as flesh, hair, etc.

▲ Dave Deal incorporates people into most of his drawings, always exaggerated, and with some funny expressions. The driver of this Manx is definitely reacting to his airborne adventure. Check out some of the other faces and figures in this drawing.

◀ This drawing has everything that our chapter title promises and more. Rat Fink was one of the original grotesque creatures, so he's got to have all of the bad details to really get the point across to the viewer. You've got to smell, hear, and feel him coming at you! This was done with marker and a bit of gouache while sitting in Roth's booth at the Cincinnati car show in 1993.

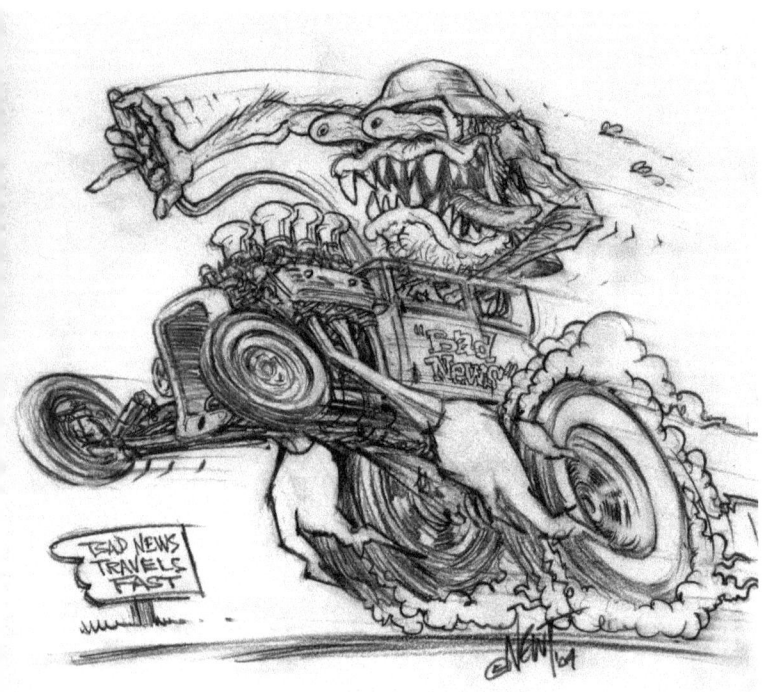

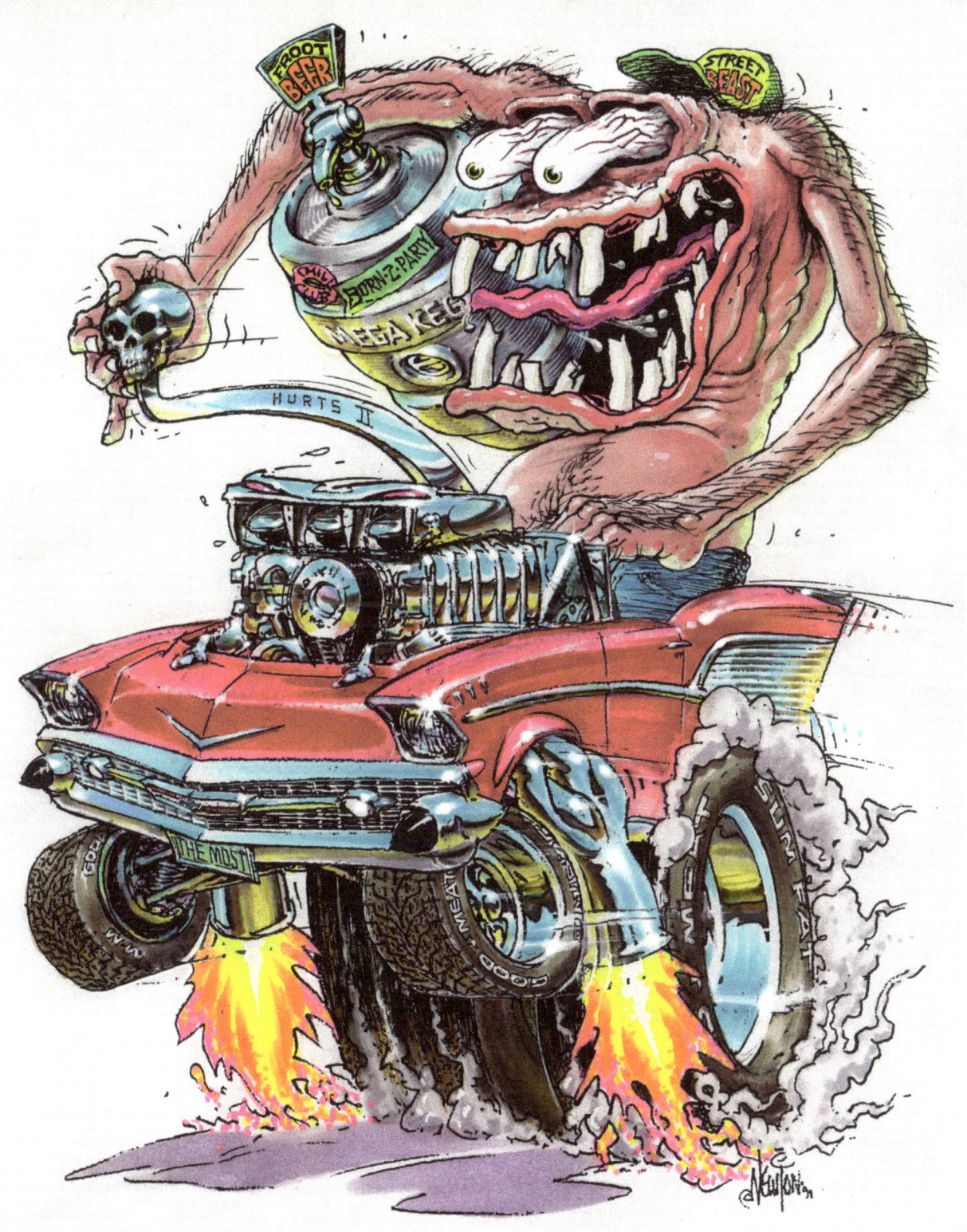

▲ This illustration was intended to be in color from the start. Newt started with simple, clean, and concise lines, then colored it in with a wash. Notice that the colors are not shaded in a gray or a wash of black, but are layered with a darker version of the surrounding color. As a result, in the body of the monster, everything is very defined and the color is layered from a light to medium or dark value so the colors stay clean and the sketch isn't muddied by grays and blacks. Also note that there's a gang of different colors—Newt likes to throw color around!

◀ This series of sketches and the final were made for a prominent car club in Southern California. The designs were meant to have the feel of Newt's 1960s art. The final image incorporates all of the bad nasties that make up a truly disgusting monster. There are plenty of designs in this book to help you along your way to depravity.

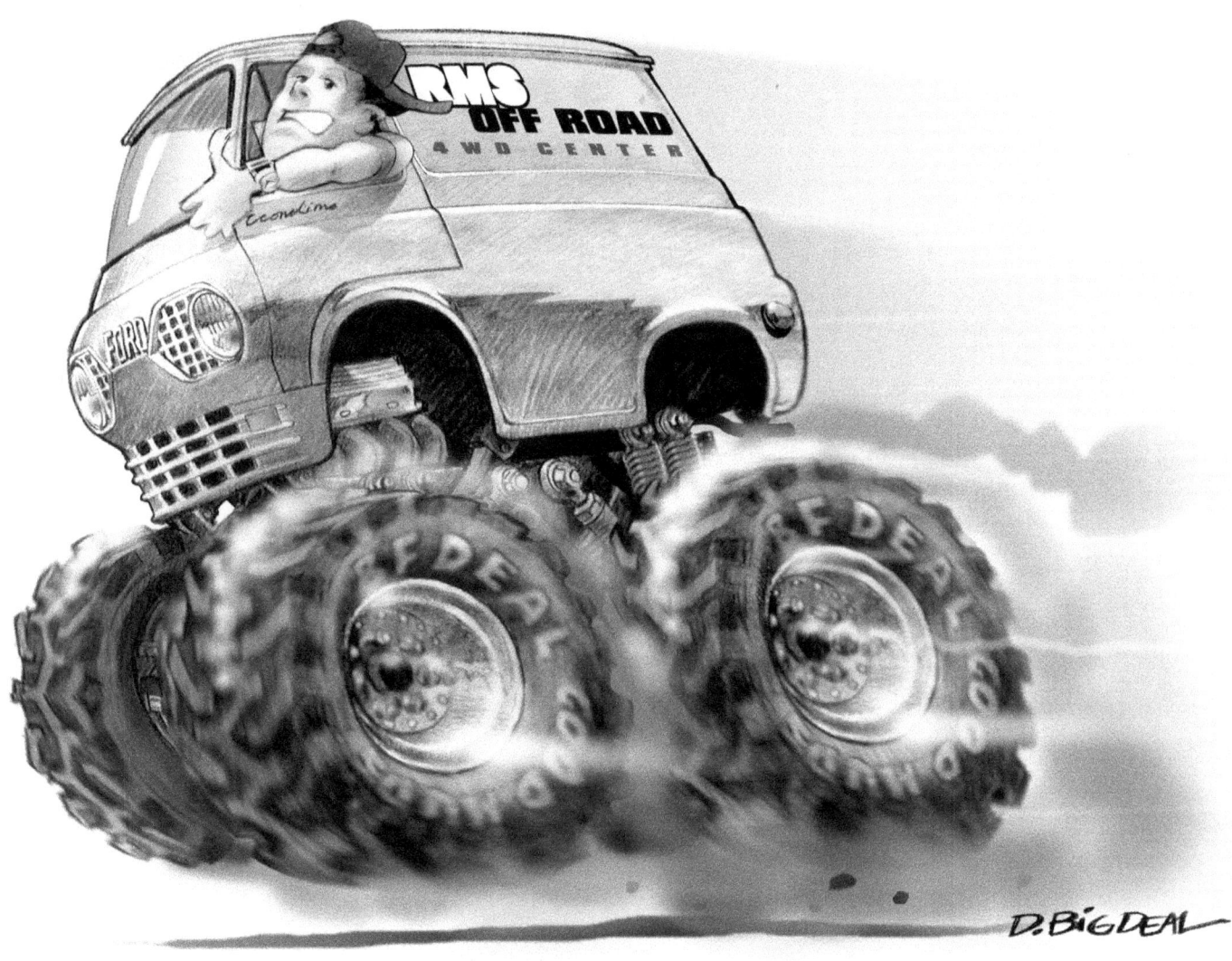

▲ Dave Deal went back into an old sketch with his Mac and created new, more realistic smoke, tracers, highlights, and speed lines, adding new life to vintage Big Deal drawing.

Continued from page 118

This is one area where the more repugnant and nauseating your imagination is, the better. I mean, we're dealing with vile, beastly creatures, so why be shy? Add some character to your characters! Each one of these extra-special little details says something extra special about your creature. Flies and yellow, broken, or missing teeth indicate a total lack of hygiene and a strong odor; warts and wrinkles give a more freakish look than smooth skin; and drool shows a total lack of bodily functions. Now that's a lot of bad for so little effort! However, if you exhibit any of these traits yourself, please disregard the above paragraph. But rather than doing some drawings, might I suggest you take a shower and go see a dentist? Right now!

Follow along as I focus on each of these small grotesqueries and see if you can't add a new dimension of your own to make them especially disgusting! Double points if you make your mom or girlfriend *urp!* in her mouth.

CHAPTER TEN

Composition & Movement

When you get ready to create a never-before seen monster driving your new and improved righteous ride, how do you pick an angle that nobody's used before? Well, you don't. Almost every angle that's worth considering has already been used. More important, when you are getting your feet wet with monster slobber and melting asphalt, use an angle and composition that feels comfortable to you. Allow the main image to float to create the illusion that the viewer is peeking through a portal at a moment frozen in time. The subject may be balanced on the paper to allow the eye to circle it without running off the page, but that moving car must have directional power. If the wheels are high off the ground, you may want to add something interesting in the space under the front wheels, as long as it doesn't distract or compromise your primary focus and intent, which is to properly emphasize and display your monster and off-the-hook hot rod.

That's why preliminary sketches are so important. The pros would be lost without this step. They not only need a conceptual thumbnail to sell the idea, but to help them develop a balanced composition to manipulate various elements in their presentation. It's easy to determine the important things like flow and movement of major components when you're working "small and sketchy." Sometimes a down-and-dirty sketch can give you mountains of insight into a proposed masterpiece. When you see tiny concept sketches by professional artists in all kinds of disciplines, you realize that although the little sketch may be crude, everything is there—all the important proportions, rhythms, contrasts, and spatial relationships reflected in the finished art.

As indicated elsewhere in this book, our monster needs to be hooked up with his ride. It's both

▼ The rhythmic, flowing musical notes and lettering in this more recent Newton design give an added dimension of movement. Notice how this later creation has completely lost the monsters with their shifting arms and hands.

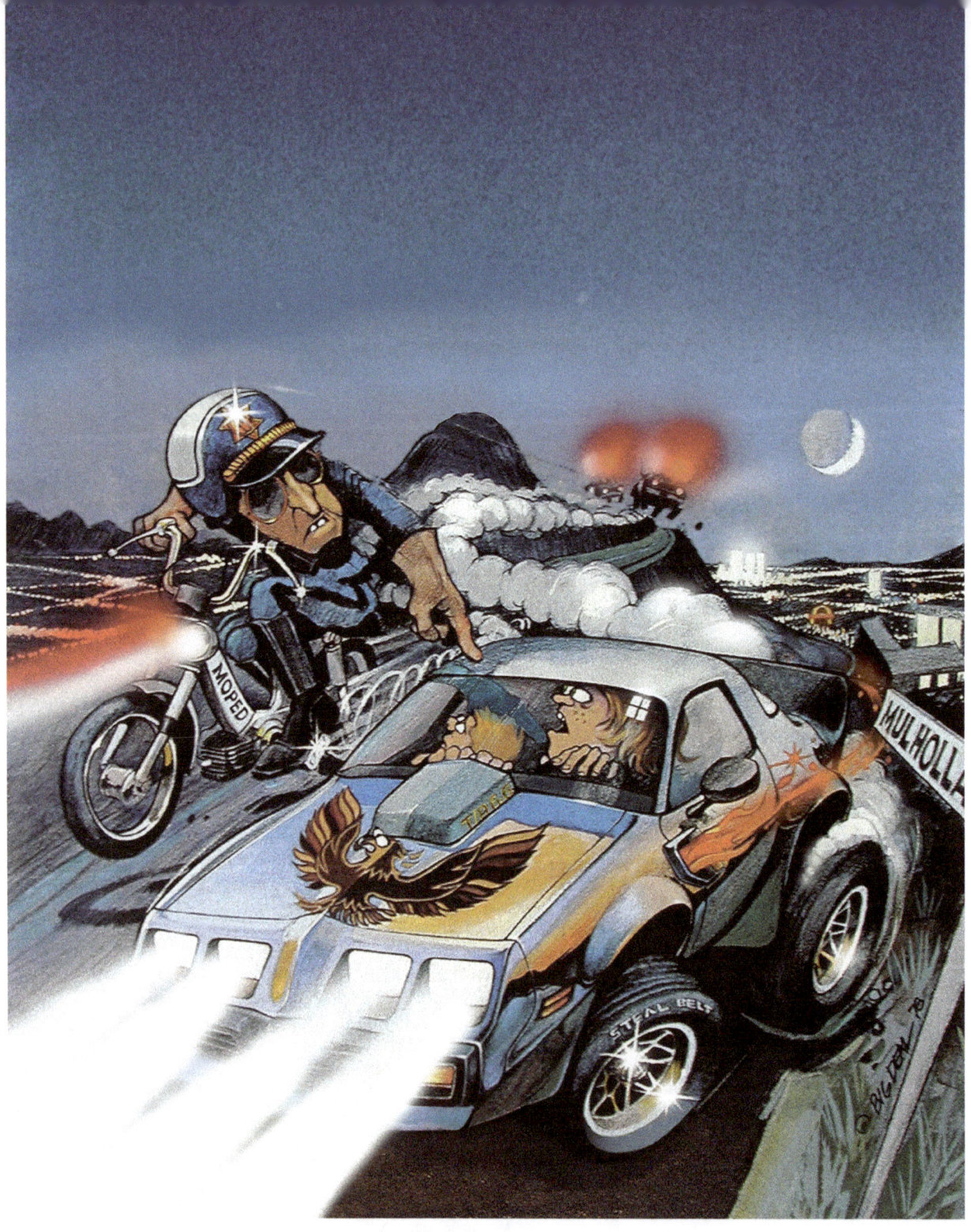

▲ Big Deal has created a lot of action and movement in this drawing from the late 1970s. The shadow under the motorcycle, location of the tires on the Firebird, smoke, and police cars in the background all add to the dynamics. Dave went back into the drawing years later to burn in the lights with his Mac.

a symbiotic and synergistic relationship—mentally for the artist and physically for the subject matter. Make your monster look as if he's a cowboy totally in charge of a radically bucking bronco, his cobra-like torso lunging out of the sunroof, straining as if his foot is flattening the gas pedal. The central core of thrust moves from his head through his curving spine like a soft S into the car. That car may be arched like a leaf spring anchored to the ground via those giant smoking meats. The results should look like the monster-motored car-beast is turning the earth. You can create this illusion by making the ground shadow appear as if it were on a ball the size of the Epcot Center sphere instead of the earth.

Stare at those preliminary sketches. If you're trying to create something special like a club logo or shirt design, you may decide that a unique border will enhance the concept. Allow yourself some options. It's better to explore various alternatives at this stage than after you've spent hours rendering your artwork, resulting in a Coulda-Woulda-Shoulda Special.

If you're satisfied with the overall dynamics but feel that the image appears too flat, maybe a change in the primary or secondary values (the range of darks and lights on a gray scale that determine the intensity of various portions of your composition) will help the subject come alive. If that's not enough you may need to alter other items in the field of view. This may include enlarging or reducing items supplementary to the main image. Hey, creating exceptional art is not always easy, but that's what makes it fun.

This is where the plot thickens—or sickens. How do you make your effort unique? If you crown your presentation with a title and some lettering, you can

◀ For inspiration you may envision a theme or story. In this case Newt depicts a young shirt painter airbrushing a giant image about to run him over, with the same image on the back of his shirt, applying infinite versions of the design.

▶ The action in this Newt drawing is enhanced by the lettering that pulls the truck up and flattens out at the bottom. Action also results from the truck being drawn up in the air and from the open mouth.

▶ This is a modified portion of art created for a Sega Genesis game package. To further emphasize the speeding motion, Newt added the palm trees. Background distortion can be a good tool for accentuating your art in a number of ways.

▲ In this side view you can see how Dave Deal leans the Ranchero forward and follows suit with the wheels and tires. These combined tricks give a lurching, thrusting movement to the drawing. Deal colored in his sketch using Photoshop.

develop an entire theme around the name. But if you want to only feature the artwork, you may still want to add some drama. Maybe there is an empty gas can in one hand, and the driver is hurrying to a gas station before he runs out of gas. It doesn't even have to make sense. Maybe you have lettering on the door of your roaring rig that says "The Road Kill Special" and your monster is just trying to kill the road. It's your world. What do you wish to say?

Remember to take comfort that this is not rocket science. We're talking about a cartoon nightmare with a car and a freaked-out speed fiend moving at an obscene velocity—all frozen in time on the window-shaped space of a page. This is a kick in the butt, not a cure for cancer. Have fun. Think of something humorous or relevant to you or your friends. The elements you pick don't have to directly relate to one another, as the power of the image is sometimes the only point to make. But if you want to be more thematic, you can choose support objects and

◀ Newt scanned the sketch on the top of page 96, refined the lines, and filled in the color. The indicators of forward motion are plentiful.

▶ To get movement and action into this sketch, I leaned the grille and tires in the direction that the car is moving. Even the perspective has been altered to tip the tire closest to the viewer up into the turn. I'm trying to force as much illusion of movement into the drawing as possible.

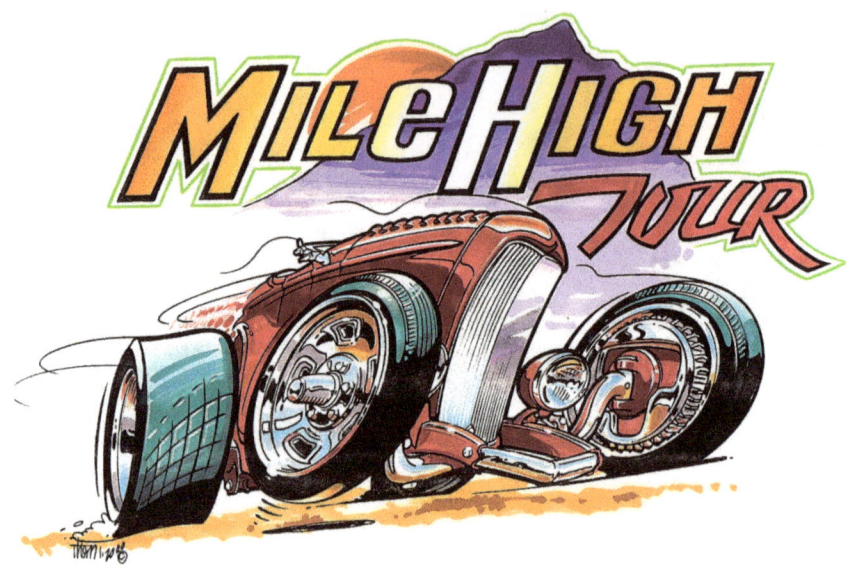

accessories that tell the story of something more subtle than blood, sweat, and gears. Not sublime but subtle. Like, what is your demon driver's relationship with the car and surroundings? Or what is the reason the freaking monster is driving so recklessly? Is there something in the smoke behind him or does he merely have a death wish? Cause and effect.

In the old days it was "Booze is the cause, insanity is the effect!" Who knows what is relevant today? In the imaginary universe of motor-minded monsters, maybe ecology is their enemy—it's obvious that political correctness sure is.

▶ This pencil sketch was one of over 50 that Newt created for Ed "Big Daddy" Roth in 1991. There is a lot of kinetic energy in both the Rat Fink and the car. They mutually launch the action forward.

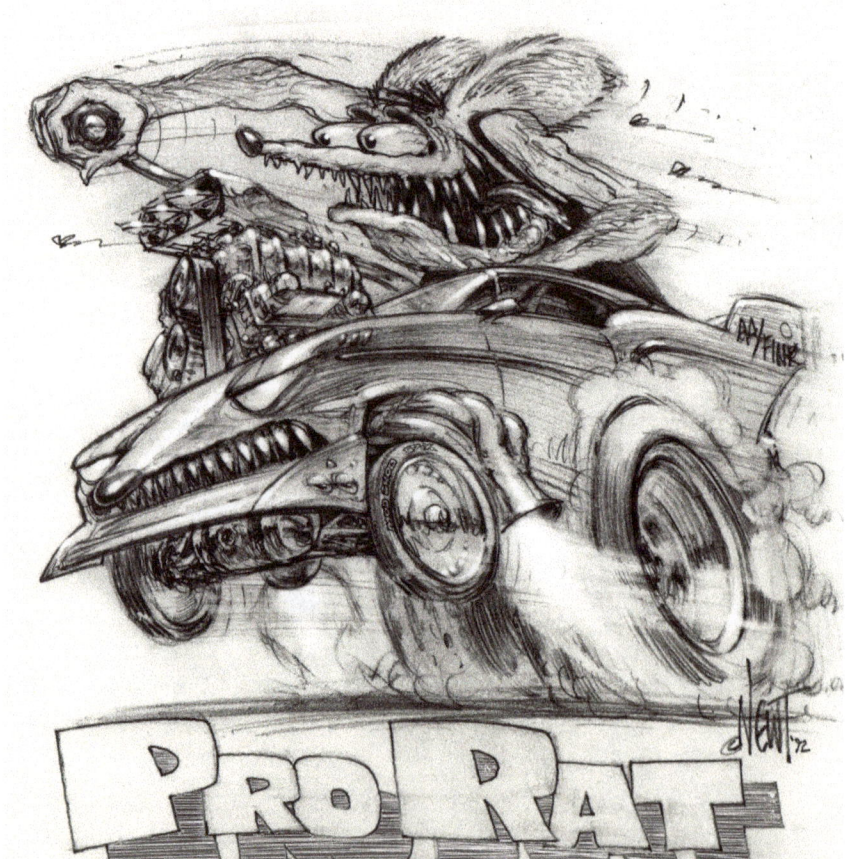

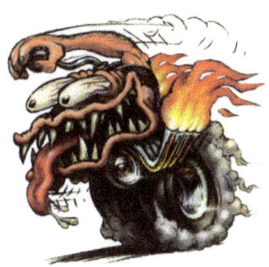

Chapter Eleven

Computers

At the risk of raising some eyebrows, we'll venture to say that just because you use a computer, it doesn't make you incapable of "old school" art. You can have your monster cake and eat it too! But don't fool yourself into thinking that the computer will do all of your stuff for you. The computer is merely a tool, just like a pen or brush. Nice that it is also an airbrush and almost any other kind of brush you want.

The trouble is that when you're done with your masterpiece, all you have is an electronic image. That is your original. Hard copy is a function of your printer—not that it means a lot in these days of Internet commerce and instant everything, but some people think that there's got to be something weird about an old-school monster-car popping out of cyberspace.

The most popular programs for creating graphics and artwork are Photoshop and Illustrator. We won't be getting specific here, like some TV video professor, but for those who want to take advantage of computer technology there are some generalized tips on using computer programs to help create weirdoes on wheels. Let's face it, there are some really cool things about graphics programs, the primary advantage being that handy little "undo" feature. Make a mistake, and with the touch of a button your glaring graphic sin is vanquished! To take that one step further, you have the ability to create duplicates of your work and save them at various stages of development. In this way you can experiment with lots of techniques and design changes, and if those variations or color selections don't work out, you can still select or return to a previous stage whenever you wish.

Those of you already familiar with graphic arts tools will find that a graphics tablet is a handy accessory for your computer but not an absolute necessity. As mentioned, a computer is a wonderful tool, but if you want to capture the essence of mad monster–driven cars, you might want to use it in conjunction with analog methods. However, if you do, you'll need a good scanner.

The ideas and tips expressed in previous chapters will remain valid if you use analog tools such as pencils, pens, or brushes to create preliminary art. You can then scan your line art and save it for further manipulation. This method has the advantage of allowing you to retain at least a sketch or black-and-white line art as an authentic "original." Plus, those of you who have already developed some

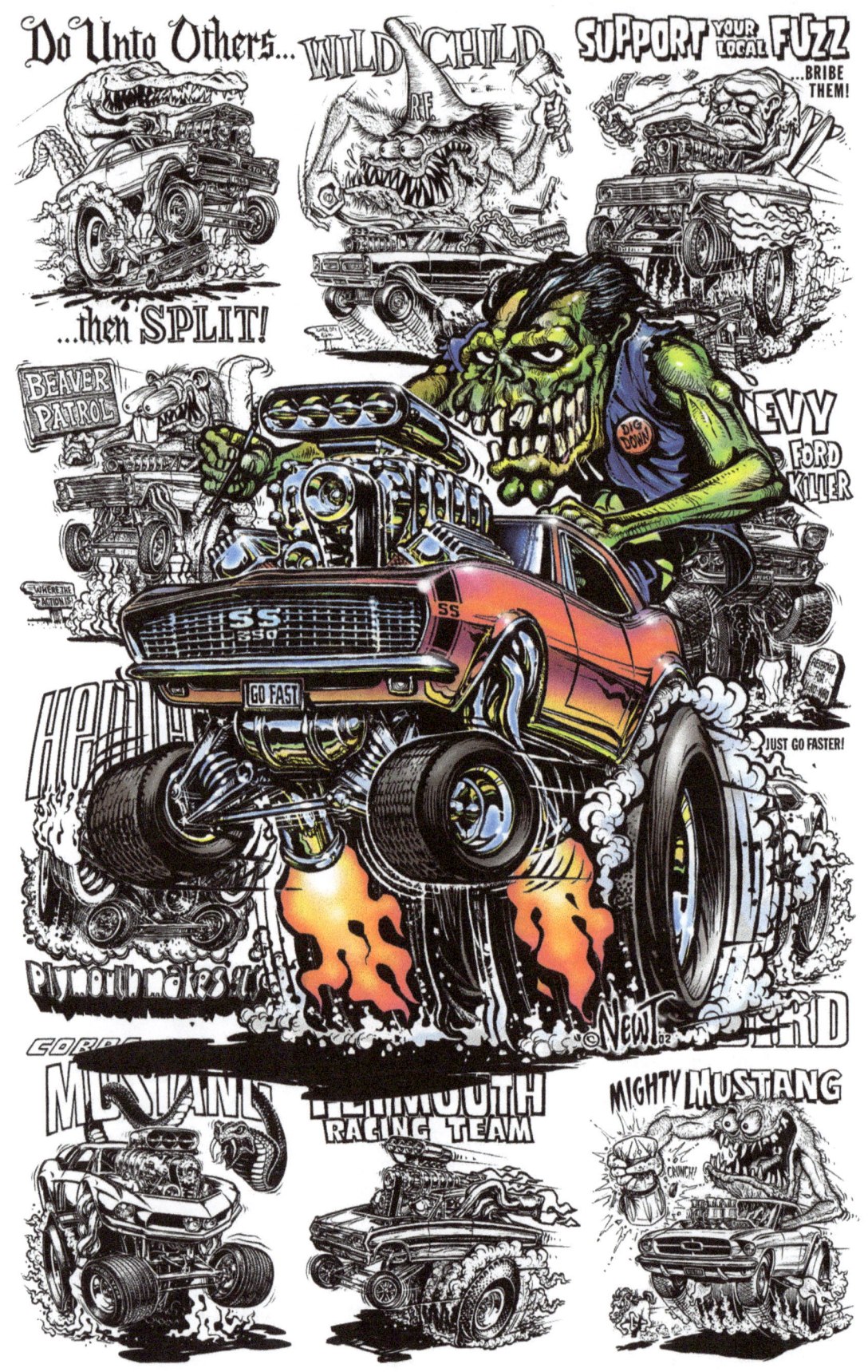

▲ All of the art used to create this design was taken from art Newt originally drew at Roth Studios in 1966. He assembled the designs as a wallpaper background to help push the computer-colorized Camaro art off of the page. Newt has colorized a few of his Roth-era pieces and finds the end results hold together very well considering they were never intended to have color added to them.

DRAGMASTER

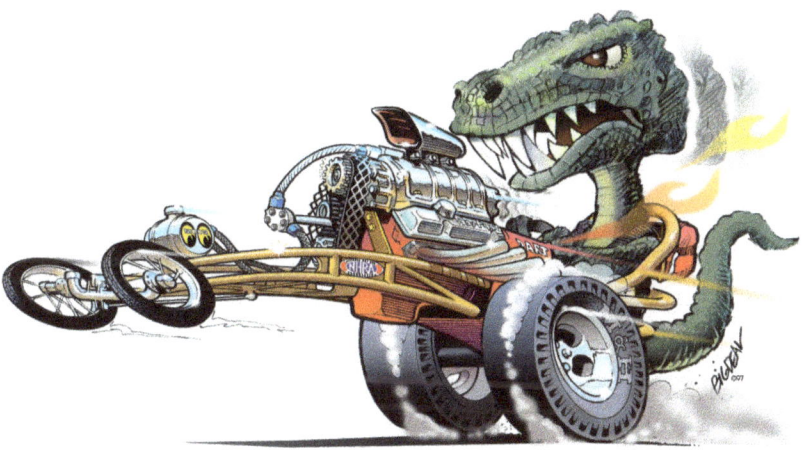

� This is one of Dave Deal's newer drawings, done on and for the computer. Most all of his tonal variations are achieved with color and little or no crosshatching. Compare this to some of his earlier drawings in this book.

drawing skills can use your experience with a familiar tool (like the pencil) to maintain a higher level of proficiency when creating your initial drawings.

On the other hand, if you are already familiar with graphics tablets, you may feel more comfortable using a wand and having your art fully contained within your computer. Whichever you choose, the next steps will remain essentially the same.

If you scan your analog design into your computer at a high resolution, you can use a number of tools to refine your design. If the art is strictly black and white, you can use any appropriate digital tool (pencil, pen, brush, or airbrush) to clean up the resulting line work. However, if you choose to retain a tone background,

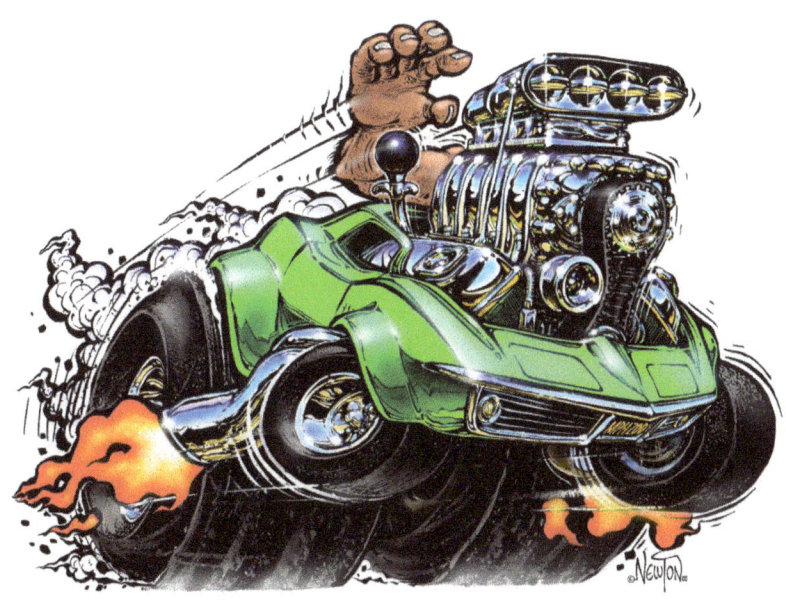

� This is a black-and-white design drawn in 1969 that Newt wanted to update by adding color. "The original version represented the evolutionary period of development of the 'cartoon monster and distorted car' imagery where the big monster had all but disappeared from the design," Newt remembers. "By 1970 not even the shifting arm would be visible in this form. Apparently, with the suppression of the muscle car in 1971, art followed suit."

135

▲ "I've always liked Lance 'Mr. Distortion' Sorchik's chopped 1934 three-window, Jersey Suede," Newt says, "so it was natural for me to snap a photo when I had the opportunity and try my hand at tweaking it into a leaping asphalt animal."

then you might find that a cloning version of your airbrush (medium profile or 1-pixel edge) will do the job better than matching the adjoining line or background with a selected pigment version of the tool. Remember, the idea is not to clean up or change the image so that it looks like it was created on the computer. Just correct the really rough or obviously clumsy areas, retaining that handcrafted look. If you initially create a high-resolution design from scratch with your computer, you will probably be able to skip the clean-up step.

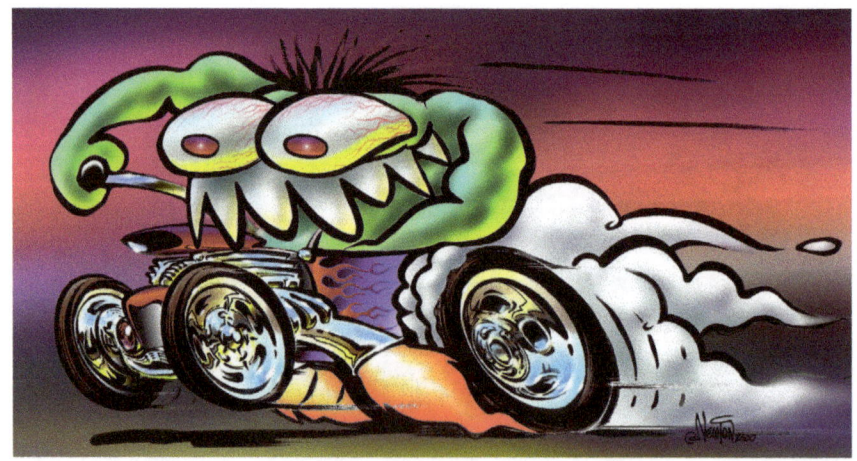

▶ Here is an experiment in coloring a scanned pencil sketch using primarily the Painter program's "magic wand" tool and "fill" feature. Not the method I would recommend for a clean, finished piece, but it shows what can be done very quickly and without careful masking.

▲ This is what you could do freehand with a $250,000 graphics system in 1986! This took some time, and there was no chance for a preliminary sketch, or "blocking in."

After this point has been reached, you can create channels or masks, layers or floaters, to define areas for further modification. The depth of this area of enhancement is truly mind-boggling and will probably become even more astounding in the future, so it must be pointed out that since there are so many different ways to further improve your design, we won't be able to cover the variations. However, these are the methods that will allow your line art to be surface-developed, defined, shaded, highlighted, and colored with a wide variety of effects and textures. And there it is, brave computer dude. The monster and car shall now be born again with new levels of style and vigor. So go forth, and make your victims sick with envy!

Ed Newton Bio

He's a modern-day Dr. Frankenstein, piecing together ghoulish creatures that carom through the streets in wild, nasty old cars belching smoke and fire, evading the Law, and spreading terror wherever they breathe. They exist on people's backs, in car windows, on notebook covers, as plastic models and plush toys, on posters, as Halloween masks, and wherever kustom car culture and lowbrow artists frolic. So much uniquely twisted imagery has come from this man it is hard to describe—from fiendish pavement-pounding car-monsters ripping apart or eating other cars to drooling demon drivers chasing future road kill, all for the sake of road-rageous humor and the selling of asphalt anarchism at illegal speeds to innocent minds.

He's Ed Newton, and he's been entertaining and amazing us for more than 40 years, first as the shirt artist and designer for Ed "Big Daddy" Roth, then with Roach Studios, and finally on his own, creating original art and design for big corporations and small startups alike. Although he didn't invent the genre, he brought the art of mad, tortured monsters and crazy, twisted, smoking hot rods to glorious new heights—to such an extent that no one has really captured the look he devised in the early 1960s, when his hand-painted shirts first hit the beaches of Waikiki.

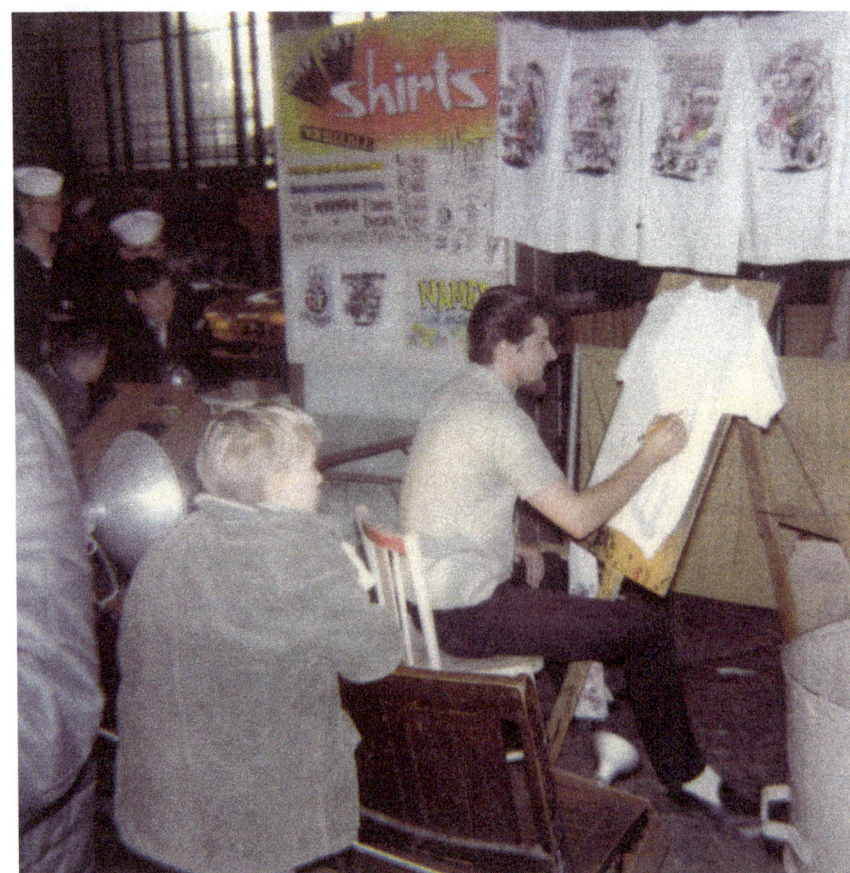

▶ Caught here using a pencil to block out his weirdo design, Newton instead drew a crowd at the Oakland Roadster Show in 1965. Although he was working full-time at Roth Studios, "Big Daddy" didn't mind if he booked certain top car shows during the mid-1960s under his old business banner, "Way Out Shirts by Newt." Newt's only competitor at this show was none other than Mouse, who tried his luck on the other side of the arena floor. Mark Briggs

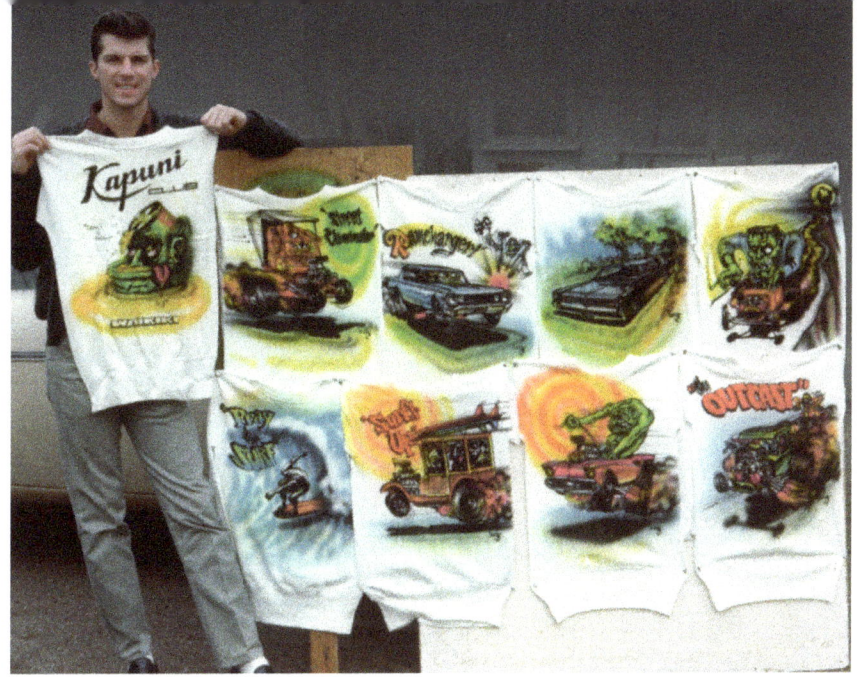

▲ A typical workday in beautiful Hawaii, circa 1962. Rick Ralston and Newt painted airbrushed shirts for customers right on Kalakaua Avenue near Waikiki Beach. Jack Newton

Though you would think otherwise from the gruesome scenes he's produced, Newt grew up in a normal family as a normal kid in San Jose, California, pounding out cool car drawings and fun cartoons with his older brother, Jack. This was in the early 1950s, when cruising and car shows were first showing up in the Bay Area and having a dramatic impact, especially on Ed.

He was always a gifted artist, so it was no surprise when he received a scholarship to UCLA to study art. His goal was car design, and after two years he left UCLA to attend the prestigious Art Center College of Design, also in Los Angeles. This was ground zero for budding car designers, and Ed was right where he needed to be.

A fellow classmate, Rick Ralston, had been spending his summer vacations on Catalina Island, airbrushing shirt designs to bring in much-needed cash, and in 1962 he convinced Ed to give it a try with him in Hawaii for the summer. This totally original American art form had been slowly gaining a following, but a lot of people were still blown away and completely in awe of the work these two artists created right on the street. Everyone was having great fun seeing the images that Rick and Ed conjured up, but no one more than Rick and Ed themselves! After four months of blowing paint, Ed was able to pay for an entire year's worth of Art Center tuition, and he continued to produce hand-painted shirt designs on the side as "Newt the Crazy Painter."

Newt regularly plied his talent on the weekends at local car shows until one show in 1963 when he was stopped dead in his tracks by a wild hot rod builder, T-shirt painter, and overall genius. Ed "Big Daddy" Roth was to debut his latest creation, *Road Agent*, at the San Mateo Car Show, and he was given exclusive rights to T-shirt painting at the show. Newt was out, unable to book a booth for

▼ These shots are from the Rat Fink Reunion in 1979. In the background are Robert Williams (right), who also worked for Roth Studios in the mid-1960s, and the late, great Rick Griffin (left). The airbrushed van shirt is what he was creating in the photo. Tom Davison

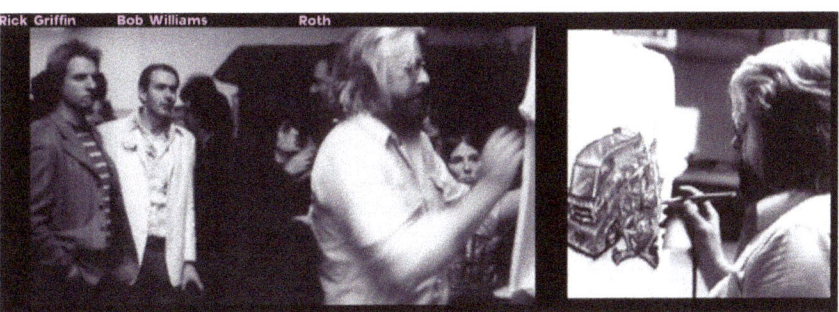

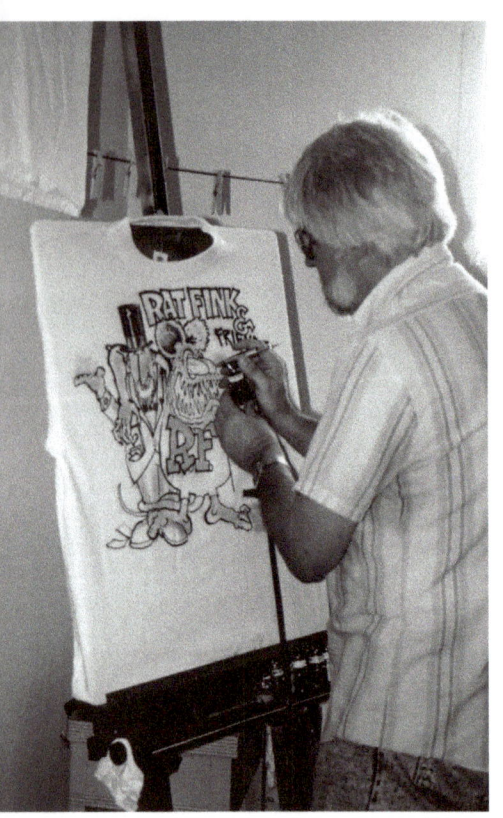

▲ Newt dusted off his airbrush for a Roth retrospective in September 1990 at New Langdon Arts in San Francisco. Both he and Roth took turns airbrushing shirts for the sizable crowd.

himself. His only alternative was to approach Roth with a proposition to team up to produce airbrush creations at the show together. This initial pairing turned into a frequent partnership of the two Eds, ultimately landing Newt a full-time gig at Roth Studios in Maywood, California, just outside Los Angeles.

The house of Roth was Big Daddy's headquarters, where he created his wild show cars and line of silk-screened crazy monster T-shirt designs—you know, from all of those ads you saw in magazines like *Hot Rod* and *Rod & Custom* back in the 1960s. The designs were drawn up by different *CarToons* magazine artists working on the side but always signed by Roth. Besides selling his shirts and a small line of custom car accessories, Roth booked car shows throughout the country to exhibit his latest custom hot rods—which he was hatching at a prolific pace of more than one a year.

Big Daddy's custom creations were more than just literal vehicles—they were Roth's vehicles to publicity and a draw to his show booths, where he would airbrush custom, one-off shirts for attendees or sell one of his preprinted shirt designs. The cars fed off of Big Daddy, and vice versa. It was a great gig!

In addition to painting shirts with Big Daddy at shows, Newt's duties initially were to design Roth's classic Rat Fink logo and all of his advertising, and to dream up wild show cars for Big Daddy to build, like the *Surfite* and *Bike Truck* (actually called *Captain Pepi's Motorcycle and Zeppelin Repair Service*), but it turned into much more. Roth was able to use Newt's talents to provide art and designs for his licensees, such as Revell, Testors, Capitol Records, and Universal Studios, and to secure outside illustration and design jobs—even magazine illustration gigs that Roth brokered for Newt.

But Newt's main function, it turned out, was to create a style of shirt designs like the "anti-Disney" images he and Roth had been originating at the shows, in silk-screened versions that held lots of detail yet were bold enough to make the silk-screen process easy without the ink bleeding together or plugging up the screens. Because the designs had to thwart the idiosyncrasies of the various Roth shirt printers and their abilities (or lack thereof) while satisfying Roth's quality concerns, Newt perfected his style to make them "dummy-proof." He would go

▲ Another shot from the New Langdon retrospective with Big Daddy. Newt and Roth enjoyed their reunion here so much that they teamed up for old times' sake at a few car shows in the early 1990s.

on to produce hundreds of designs for Roth, both in the initial two years he was employed by Big Daddy, and through the end of the decade as a freelancer.

After Roth closed down in 1970 to pursue his chopper interests, Newt accepted an offer as creative director for Roach Studios in Columbus, Ohio, at one time the largest iron-on transfer manufacturer in the world. As with Ed Roth, Newt produced hundreds of shirt designs for Roach, as well as designing and overseeing the creation of one of the wildest show cars ever: the *RoachCoach*. Built to resemble a giant cockroach with two huge red eyes that acted as windshields, the *RoachCoach* was the ultimate show car company advertisement.

Other wild, themed show cars from the 1970s that Newt designed include the string of California Show Cars vehicles: the *Adam and Eve Bathtub* car, *Pink Panther Limo*, *Sand Draggin'*, and *Redd Foxx Wrecker*, the *Ice Truck* for Dan Woods, Tom McMullen's *Big Twin* Harley trike, the *StratoTaxi* three-wheeler, the *Magic Carpet* car, and the *StageFright* for Jack Keef and Danny Eichstadt, which later became a Hot Wheels toy car. A decades-long personal project of Newt's, his tube-framed roadster with a blown mid-engine and full independent suspension sits patiently in Ed's garage, almost ready to tear up the highways.

When Roach ceased operations in the mid-1980s, Ed pursued his freelance career full-time, which continues right up to today. He's done work for movie studios, the music industry, and toy and model car companies, as well as limited edition prints and his own experiments in surrealistic oil painting.

Ed has always kept a low profile, always letting his art speak for him and itself. Many don't realize that most all of those great Roth Studios designs, though signed and promoted by Ed Roth, were actually Ed Newton's work. Since Newt has always been the guiding light when it comes to this type of art, he's really the only person from which to learn the secret and not-so-secret methods that have kept him at the top for more than 40 years.

DRAW A MONSTER!

FIRST SCRAWL A CIRCLE . . .

DRAW IN ANY CONVENIENT AMOUNT OF EYEBALLS . . .

MAKE A GAPING MOUTH, PUFFY LIPS, AND A FEW THOUSAND WRINKLES . . .

THROW IN SOME WILD HAIR AND ROTTEN TEETH . . .

ADD DECAYED EARS AND SHADING, AND . . . ECCH! . . . A ROTH-TYPE MONSTER!

▲ Done as a joke for a 1965 Roth coloring book, 40 years later Newt spills the beans on what it takes to do mad monsters and crazy cars!

Appendix

John Bell
www.johnbellstudio.com

Dave "Big" Deal
www.bigdealart.com
www.bigdealtees.com
www.koolart.com

C. Cruz
www.automotivegraffiti.com

Ed Newton
P.O. Box 1034
Dublin, OH 43017
newtinator@gmail.com
www.newtzart.com

Thom Taylor
hotrodthom@cox.net

Keith Weesner
www.keithweesner.com

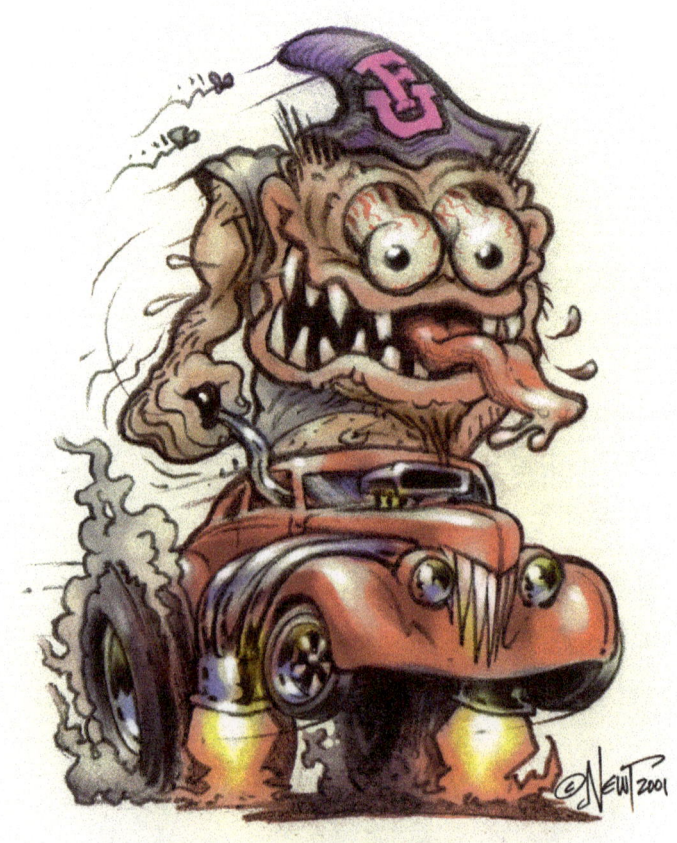

Index

3-D, 88, 89

Adam and Eve Bathtub, 141
Airbrushes, 15
 External mix, 15
 Internal mix, 15, 16
Anatomy of monster, 114–126
Angles, 20
 Viewer's, 30
Ash, Richard, 9, 11
Atmosphere, 31
Axes, 57–65
 Major, 58
 Minor, 30, 58, 60, 61, 63, 65

Barris, 13
Beatnik Bandit, 13
Bell, John, 80, 117
Bestine, 17, 20
Bike Truck, 140
Brushes, 16

Captain Pepi's Motorcycle and Zeppelin Repair Service, 140
CarToons, 140
Catallo, Chili, 13
Chrome, 102–113
Color, 25, 26, 102–113
Change, 107
Cool and warm, 105, 107
Composition, 127–132
Computers, 133–137
Cozier, Bud "The Baron," 11
Crazy Shirts of Hawaii, 11
Cruz, C., 40–42, 50, 78, 84, 85, 100, 120
Cylinder, 58

Davis, Jack, 12
Deal, Dave "Big," 39, 49, 79, 95, 99, 100, 103, 119, 121, 126, 128, 131, 135
Degrees, 59

Detrick, John, 88, 89
Doug, Dirty, 64
Drafting tape, 21

Eichstadt, Danny, 141
Ellipses, 47, 57–65
Erasers, 18, 21

Fixative, 17
French curves, *see* Sweeps
Frisket, 21
Fuller, Ed, 64

Gammell, Doyle, 13
Griffin, Rick, 139
Guidelines, 33

History, 9–13
Horizon line, 27–31, 36, 38, 40, 43, 102, 103
Hot Rod magazine, 140

Ice Truck, 141
Invasion of the Killer Monster-Cars, 43

Jeffries, Dean, 11

Kaparich, Chuck, 88, 89
Keef, Jack, 141
Killer Plymouth, 10

Light source, 90–101
 Artificial, 93
 Placement, 91, 92
Lighting, 18
Line quality, 66–89
Line weight, 67, 69, 72

Mad, 12, 13
Mad Mac, 11
Magic Carpet, 141
Markers, 15, 21
Martin, Don, 13
Masking tape, 21
McMullen, Tom, 141
Miller, Andrew, 88, 89

Miller, Stanley "Mouse," 7, 9, 11, 138
Movement, 127–132

Newton, Ed, bio of, 138–141
Newton, Jack, 139

Olsen, Gary "The Crazy Arab," 11
Orbitron, 56
Outlaw, 92

Paper, 21
Pencil sharpener, 18
Pencils, 14, 21, 23, 25
Pens, 14
Perspective, 27–43, 107
 Angular (two-point), 28, 31, 42
 Parallel (one-point), 28, 36, 41
 Three-point, 29
Perspective lines, 38, 40
Pink Panther Limo, 141
Proportion, 44–56
 One-box, 44
 Three-box, 44, 45
 Two-box, 44, 45

Ralston, Rick, 11, 139
Redd Foxx Wrecker, 141
Reference material, 19
Reflections, 90–101
Rendina Studios, 11
Roach Studios, 6, 77, 141
RoachCoach, 8
Road Agent, 139
Rod & Custom, 140
Roth, Darryl, 75
Roth, Ed "Big Daddy," 6, 7, 11–13, 22, 48, 64, 68, 88, 123, 132, 138–141
Roth Studios, 6–9, 11, 64, 69, 88, 134, 138, 140, 141

Sand Draggin', 141
Santa and Rudolph the Red-Nosed Snowedster, 25
Shadows, 90–101
Silhouette, 92
Sketching, 66–89
Sorchik, Lance, 136
 Jersey Suede, 136
Sports Illustrated, 11, 13
StageFright, 141
StratoTaxi, 141
Surface, 18
Surfite, 140
Sweatin' Bullets, 76
Sweeps, 17, 20

Technique, 66–89
Templates, 20
 Circle, 20
 Ellipse, 16, 20
Tools, 14–26

Value, 31, 69, 90, 91, 106, 110
Vanishing point, 27–31, 39–42, 60
View, 29
 Worm's eye, 30, 31
Vignette, 96
Von Dutch, 7, 11, 12

Watson, Larry, 13
Weesner, Keith, 36, 85, 91, 95, 106
Wheelbase, 45, 47
Wild Thing, 26
Williams, Robert, 139
Wishbone, 118
Wite-Out, 25
Wolverton, Basil, 12
Wood, Wally, 12
Woods, Dan, 141

X-ACTO knife, 19, 21

Other MBI Publishing Company titles of interest

How to Draw Cars Like a Pro, 2nd Ed.
ISBN 0-7603-2391-7

How to Draw Choppers Like a Pro
ISBN 0-7603-2260-0

How to Draw Cars the Hot Wheels Way
ISBN 0-7603-1480-2

How to Design Cars Like a Pro
ISBN 0-7603-1641-4

Hot Rod Pin-ups
ISBN 0-7603-2109-4

Sundays with Von Dutch
ISBN 0-7603-2626-6

The Hot Rod World of Robt. Williams
ISBN 0-7603-2660-6

Hot Rods by Ed "Big Daddy" Roth
ISBN 0-7603-2893-5

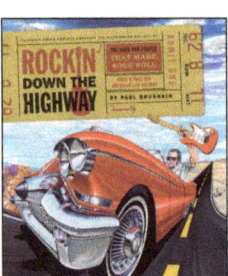

Rockin' Down the Highway
ISBN 0-7603-2292-9

Find us on the internet at www.motorbooks.com or at 1-800-826-6600

www.ingramcontent.com/pod-product-compliance
Lightning Source LLC
Chambersburg PA
CBHW040225010226
38598CB00010B/6